GERHARD RICHTER

Robert Storr

GERHARD RICHTER OCTOBER 18, 1977

The Museum of Modern Art, New York
Distributed by Harry N. Abrams, Inc. New York

Published on the occasion of *Gerhard Richter: October 18, 1977* at The Museum of Modern Art, New York, November 5, 2000–January 30, 2001, organized by Robert Storr, Senior Curator, Department of Painting and Sculpture. *Gerhard Richter: October 18, 1977* is part of a larger exhibition, *Open Ends,* which is in turn part of a series of exhibitions featuring works from the Museum's collection titled *MoMA2000.*

MoMA2000 is made possible by The Starr Foundation.

Generous support is provided by Agnes Gund and Daniel Shapiro in memory of Louise Reinhardt Smith.

The Museum gratefully acknowledges the assistance of the Contemporary Exhibition Fund of The Museum of Modern Art, established with gifts from Lily Auchincloss, Agnes Gund and Daniel Shapiro, and Jo Carole and Ronald S. Lauder.

Additional funding is provided by the National Endowment for the Arts, Anna Marie and Robert F. Shapiro, NEC Technologies, Inc., and by The Contemporary Arts Council and The Junior Associates of The Museum of Modern Art.

Education programs accompanying *MoMA2000* are made possible by BNP Paribas.

The interactive environment of *Open Ends* is supported by the Rockefeller Brothers Fund.

Film programs during *Open Ends* are supported by The New York Times Company Foundation.

Web/kiosk content management software is provided by SohoNet.

Produced by the Department of Publications, The Museum of Modern Art, New York.

Edited by Harriet Schoenholz Bee
Designed by Gina Rossi
Layout and composition by Emsworth Design, Inc.
Production by Marc Sapir
Tritone separations by Martin Senn Digital Studio
Printed and bound by Dr. Cantz'sche Druckerei,Ostfildern, Germany
Printed on 150 gsm PhoenixMotion Xenon

Library of Congress Catalogue Card Number: 00-107665
ISBN 0-87070-023-5 (MoMA, T&H)
ISBN 0-8109-6104-0 (Abrams)
ISBN 3-7757-0976-2 (Hatje Cantz)

Published by The Museum of Modern Art, New York
11 West 53 Street, New York, New York. (*www.moma.org*)
Distributed in the United States and Canada by Harry N. Abrams, Inc. New York
(*www.abramsbooks.com*)

Distributed outside the United States and Canada by Thames & Hudson, Ltd., London

Distributed in Germany, Switzerland and Austria by Hatje Cantz Publishers, Ostfildern

Cover: Detail from Gerhard Richter. *Funeral (Beerdigung).* 1988.

Printed in Germany

GERHARD RICHTER: OCTOBER 18, 1977 (18. OKTOBER 1977). 1988.

Fifteen paintings, oil on canvas, installation variable. The Museum
of Modern Art, New York. The Sidney and Harriet Janis Collection,
gift of Philip Johnson, and acquired through the Lillie P. Bliss Bequest
(all by exchange); Enid A. Haupt Fund; Nina and Gordon Bunshaft
Bequest Fund; and gift of Emily Rauh Pulitzer

OCTOBER 18, 1977

Youth Portrait (Jugendbildnis). 1988. Oil on canvas, 28½ × 24½" (72.4 × 62 cm)

Arrest 1 (Festnahme 1). 1988. Oil on canvas, 36½ × 49¾" (92 × 126.5 cm)

Arrest 2 (Festnahme 2). 1988. Oil on canvas, 36½ × 49¾" (92 × 126.5 cm)

Confrontation 1 (Gegenüberstellung 1). 1988. Oil on canvas, 44 × 40¼" (112 × 102 cm)

Confrontation 2 (Gegenüberstellung 2). 1988. Oil on canvas, 44 × 40¼" (112 × 102 cm)

Hanged (Erhängte). 1988. Oil on canvas, 6' 7⅛" × 55⅛" (201 × 140 cm)

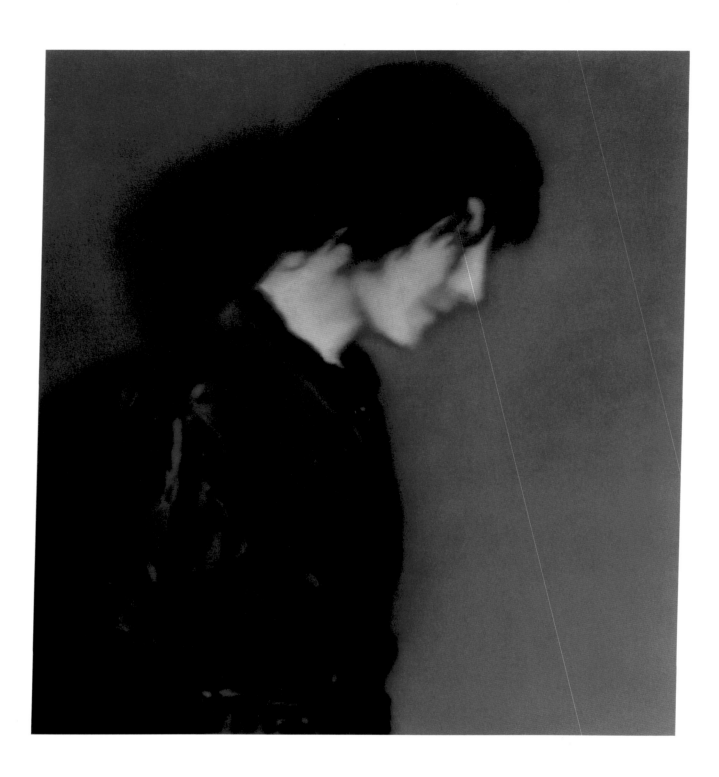

Confrontation 3 (Gegenüberstellung 3). 1988. Oil on canvas, 44 × 40¼" (112 × 102 cm)

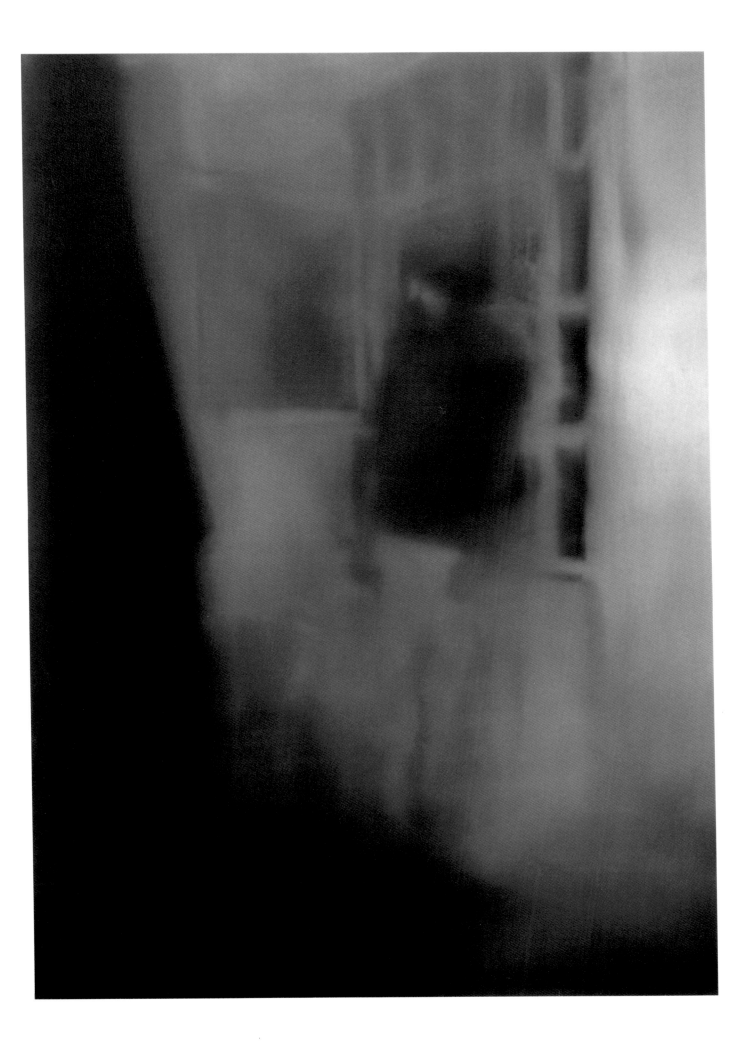

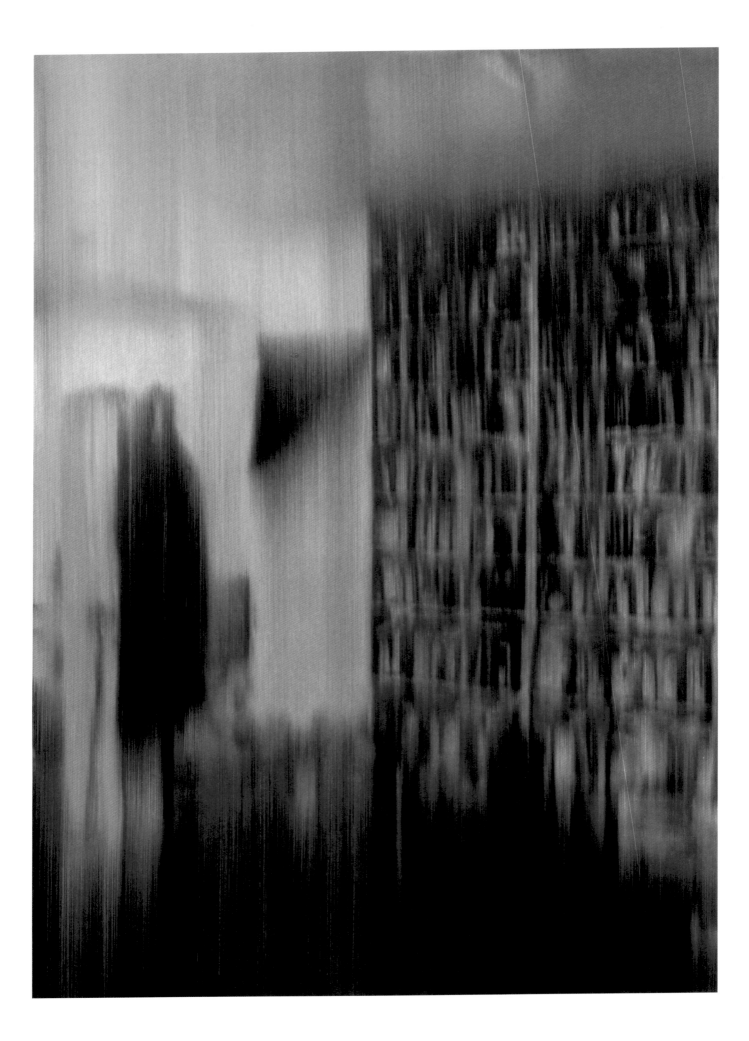

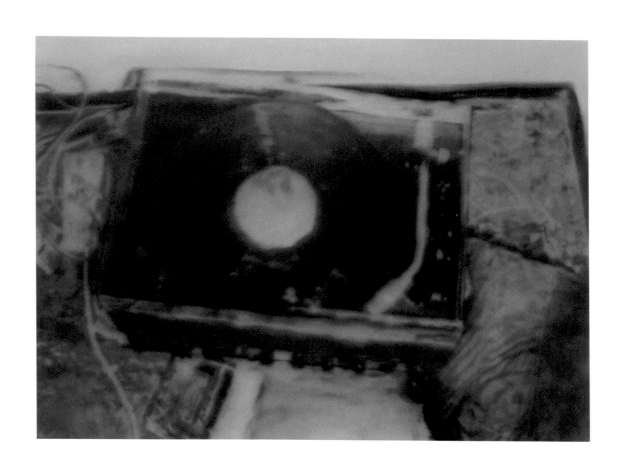

opposite: **Cell (Zelle).** 1988. Oil on canvas, 6' 7 1/8" × 55 1/8" (201 × 140 cm)
Record Player (Plattenspieler). 1988. Oil on canvas, 24 5/8 × 32 3/4" (62 × 83 cm)

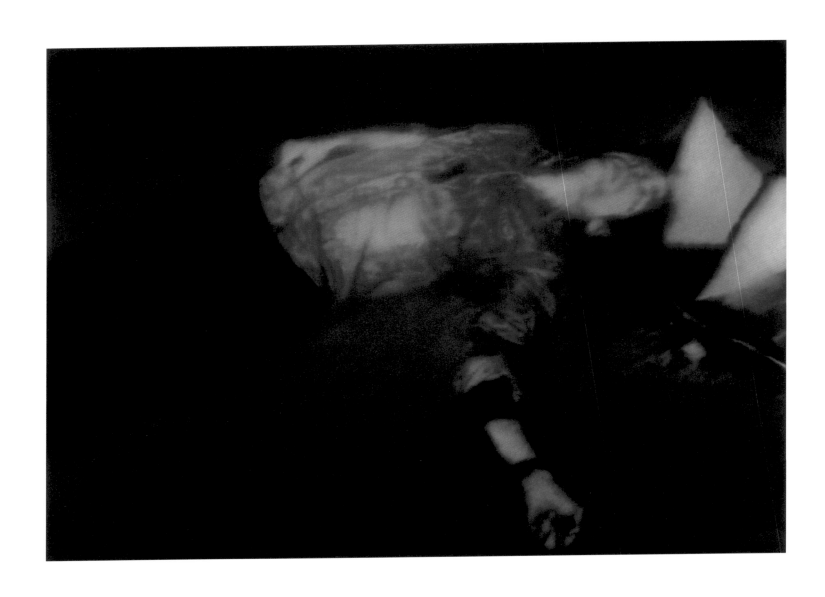

Man Shot Down 1 (Erschossener 1). 1988. Oil on canvas, 39 ½ × 55 ¼" (100.5 × 140.5 cm)

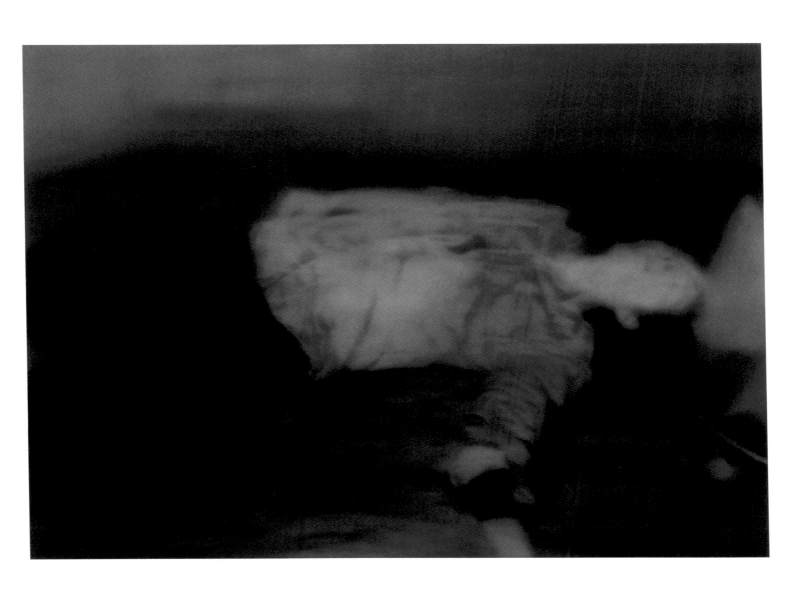

Man Shot Down 2 (Erschossener 2). 1988. Oil on canvas, 39½ × 55¼" (100.5 × 140.5 cm)

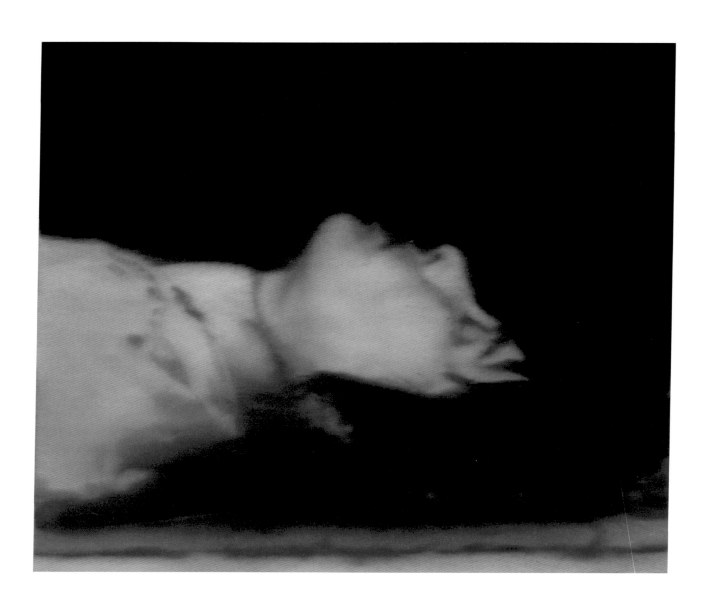

Dead (Tote). 1988. Oil on canvas, 24 ½ × 28 ¾" (62 × 73 cm)

Funeral (Beerdigung). 1988. Oil on canvas, 6' 6¾" × 10' 6" (200 × 320 cm)

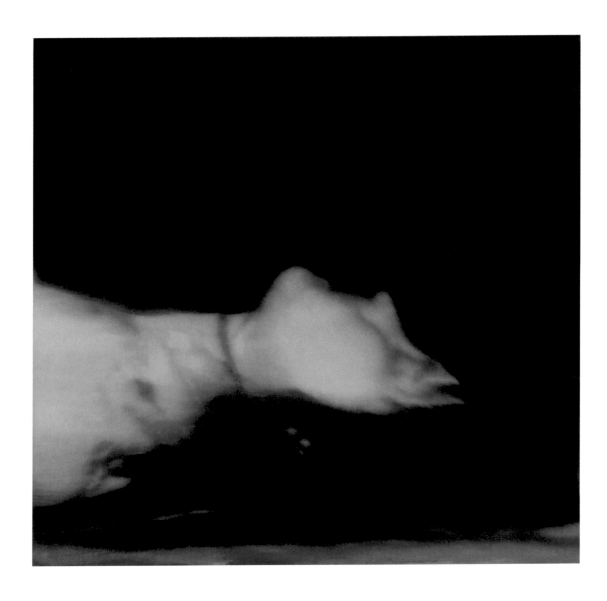

Dead (Tote). 1988. Oil on canvas, 24 $\frac{1}{2}$ × 24 $\frac{1}{2}$" (62 × 62 cm)

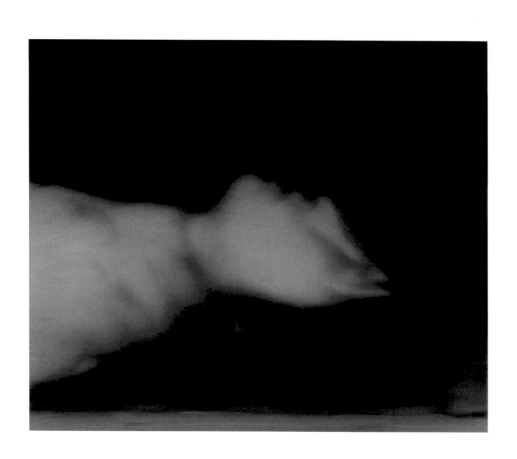

Dead (Tote). 1988. Oil on canvas, 13 ¾ × 15 ½ " (35 × 40 cm)

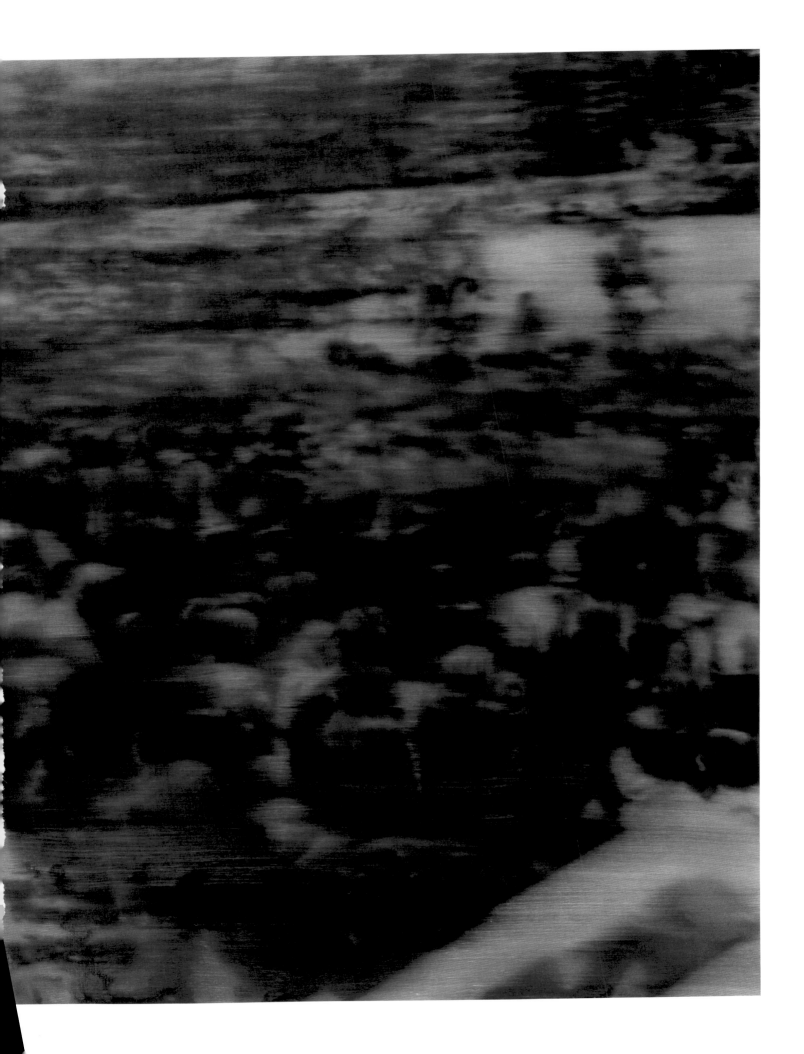

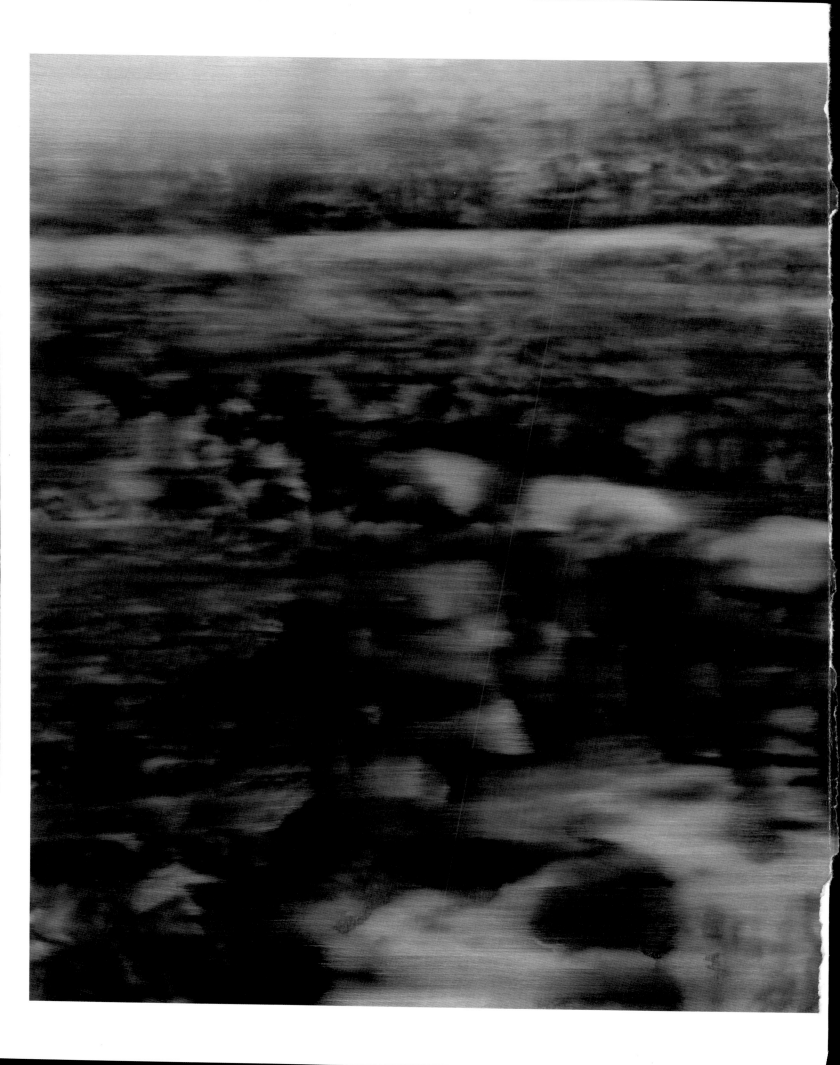

Contents

INTRODUCTION: SUDDEN RECALL

Gerhard Richter, Cologne, 1988

In mid-winter 1989 a quiet tremor shook Germany. Judged from the outside, the extent of its impact might initially have seemed out of all proportion to the actual cause. But as a long delayed and wholly unexpected aftershock to the much greater upheavals of a decade earlier, the jolt caught people off guard, and reawakened deep-seated, intensely conflicted emotions.

The epicenter of this event was in Krefeld, a small Rhineland city near Cologne where, between February 12 and April 4, 1989, a group of fifteen austere gray paintings were exhibited at Haus Esters, a local museum designed in 1927–30 as a private residence by the modernist architect Ludwig Mies van der Rohe. The author of these works was the fifty-seven-year-old painter Gerhard Richter, well known for the heterogeneous and enigmatic nature of his art, which ranged from postcard-pretty landscapes to minimal grids, alternatively taut or churning monochromes to crisp color charts, and heavily textured, even garish, abstractions to cool black-and-white photo-based images. The ensemble on view at Haus Esters belonged to this latter genre, which had preoccupied Richter from the outset of his career in 1962 until 1972 but which he had seemed to abandon since then. However, the subject of the new paintings was unlike anything he had addressed before. Both the subject and the fact that an artist of Richter's indisputable stature had chosen to paint it stirred Germany and, in short order, sent reverberations around the world.

Richter's theme was the controversial lives and deaths of four German social activists turned terrorists: Andreas Baader, Gudrun Ensslin, Holger Meins, and Ulrike Meinhof. The collective title, *October 18, 1977*, commemorates the day the bodies of Baader and Ensslin—along with their comrades, the dying Jan-Carl Raspe and the wounded Irmgard Möller—were discovered in their cells at the high-security prison in Stammheim, near Stuttgart, where they had been incarcerated during and after their trials for murder and other politically motivated crimes. Almost exactly three years earlier (October 2, 1974) Holger Meins had died from starvation during a hunger strike called by the jailed radicals to protest prison conditions. Ulrike Meinhof had been found hanging in her Stammheim cell (May 9, 1976) shortly before she and the others were sentenced to life terms. Her death was ruled a suicide, as were those of Baader, Ensslin, and Raspe the following year (October 18, 1977), although there was widespread suspicion that the four had been murdered.

The fifteen paintings in the cycle *October 18, 1977* comprise four pairs or suites of images and five canvases that stand alone within the larger group. Although the works have no fixed installation order, the first painting in the series in terms of the chronology of the story is a likeness of the young Ulrike Meinhof (*Youth Portrait*), and the last is a panorama of the public burial in which Baader, Ensslin, and Raspe were interred in a common grave (*Funeral*). The three other individual canvases depict, first, a coat and bookshelves in Baader's empty prison quarters (*Cell*); second, a spectral figure of Ensslin dangling from the bars of her cell (*Hanged*); and third, a 1970s LP on an inoperative turntable inside which Baader was supposed to have hidden a smuggled pistol with which it was said he shot himself (*Record Player*). Meins's earlier capture by police, during which he was forced to strip, with an armored-car training its gun on him, is shown in two sequential paintings (*Arrest 1* and *Arrest 2*); and a likeness of Baader lying dead on the floor appears twice, with subtle but significant differences in the way the photograph on which it was based has been translated into paint (*Man Shot Down 1* and *Man Shot Down 2*). Three other paintings are glimpses of Ensslin's passage before a camera on her way to or from confinement after her arrest, and another three progressive smaller canvases portray Meinhof laid out after she was discovered hanging in her cell with the rope still around her neck.

The contrast between the starkness of the reality Richter chose to describe and the lack of definition resulting from his technique—feathering the edges of his forms or dragging his brush across the wet, gray pigment-loaded surface of the canvas so that shapes and spaces elide—created a muffled dissonance between what the viewer can make out "inside" the picture and what he or she actually perceives as an otherwise visually accessible painting. So far as the explicit but obscured subject is concerned, it is as if an all but unbearable truth had suddenly been brought forward into the light only to be screened by shadows in a condition where the impossibility of seeing clearly is both frustrating and a kind of reprieve. Thus each canvas is an insistent reminder of what one may have forgotten or heretofore successfully avoided paying attention to as well as a refusal to satisfy simple curiosity or the naive satisfactions of supposing that tangible "facts" speak unequivocally for themselves. Studied separately, but even more so together, the fifteen paintings are among the most somber and perplexing works of art in modern times.

Richter's cycle appeared on the walls of Haus Esters without warning and without fanfare. In deference to the families of the deceased and to avoid further sensationalizing the story of the so-called Baader-Meinhof group (for years a staple of print and media journalists, whose photoarchives Richter had drawn upon in selecting the images he finally painted), strict limits were placed on what paintings could be used to accompany articles on the work. For example, the six harrowing images of the dead that dominated the series could not be reproduced out of context. In the same reticent and respectful spirit, no celebration for the unveiling of the new paintings was held. At the time, the artist noted: "The relatives and friends of these people are still alive. I neither wanted to hurt them, nor did I want an opening with people standing around chatting and drinking wine."[1] Richter also made it clear that the paintings were not to be sold piecemeal as might be the case with those in an ordinary exhibition. Moreover, he declared that he had no intention of selling them at all in the near term, and that at such time as he thought it appropriate to let go of them they would be destined for a museum rather than any private collector.[2] In every way, Richter signaled that *October 18, 1977* had special standing within his overall body of work, and a status of its own within postwar German art. Though essentially intimate in scale, and anti-rhetorical in their mode of pictorial address, these paintings were public works not only because they described well-known incidents of

the recent past but because they in large part depended for their meaning on the horrid fascination, anxiety, ambivalence, and denial experienced by the nation that had lived through them, and by a generation worldwide for whom Baader, Meinhof, Meins, Ensslin, and the others were emblematic of the reckless idealism and bitter failure of youthful revolt in the Cold War era.

Critical response to Richter's emphatic and elusive suite of paintings was immediate, far-flung, and divided. Those divisions not only followed obvious political and aesthetic fault lines within German society, but also the subtler cracks that radiated from them and separated one camp from another within the larger groupings. Thus Ingeborg Braunert, reviewing the show in *Die Tageszeitung*, a left-wing national newspaper founded in the aftermath of the crisis of the German Autumn of 1977—a time of kidnappings, hijackings, and heightened terror that polarized the country—emphasized the uncanny feeling engendered by these partially abstracted reworkings of images made familiar by the media, but fixed her attention on the jarring first impressions of encountering them in the serenely bourgeois surroundings of Haus Esters: "The beautiful space, the elegant and interested visitors, the friendly personnel—in the service of virtuoso oil paintings on the subject of Stammheim—do not fit our memories."[3]

The German-born, American-based writer Benjamin H. D. Buchloh also made an issue of the show's location but noted an incidental fact that

Gerhard Richter. *Confrontation 2.* 1988. Detail

lent the site a positive importance: "That this group of paintings was first exhibited in a building by Mies van der Rohe seems an appropriate historical accident, for Mies is the architect who constructed the only German contribution to public monumental sculpture in the twentieth century, devoting it to the memory of the philosopher Rosa Luxemburg and the revolutionary Karl Liebknecht, both of whom had been murdered by the Berlin police. This coincidence establishes a continuity between a bourgeois architect in the Weimar state of the 1920s and a bourgeois painter in West Germany of the 1980s. And indeed both artists differ from most of their contemporaries in their ability to tolerate, in public view, the challenges to the very political and economic system with which they identify as artists."[4]

Early reactions to *October 18, 1977* often centered on the irony of an established painter setting out to represent the fate of enemies of the society in which he thrived. Some on the Left challenged his right to do so, and some questioned his timing and professional motives. Thus, the critic Sophie Schwarz attacked Richter for not choosing sides when doing so was consequential: "There is a puzzling timidity to his approach. In the case of the prison deaths, no one really believes in the suicide hypothesis anymore, and as shocking, accusatory images, political images, the works arrive too late, too blurred, fitting into Richter's total oeuvre with too facile a logic. . . . The quality most evident in Richter's treatment of these still disturbing images is a dark and totally staged pathos."[5] Others, accepting his attempt in principle, pondered the contradictions this match of artist and subject raised. Speculation about the degree of sympathy Richter had for the individual members of the Baader-Meinhof group, despite his explicit rejection of their theories and acts, is a common feature of these articles. As a middle-aged German with firsthand knowledge of the totalitarian orthodoxies of both National Socialism and Eastern Block Communism, Richter was adamantly anti-ideological almost in inverse proportion to the dogmatism of the members of the Red Army Faction (RAF)—as the larger entity to which the Baader-Meinhof group belonged called itself—yet he appeared to relate to them in certain respects, especially with the women, and with Ulrike Meinhof, who was only two years younger than he, in particular.

How much sympathy, and, as a political litmus test of that sympathy, how much resistance to the official version of the Stammheim deaths Richter's painting actually showed were other topics of intense disagreement. From that vantage point the theater director Hansgünther Heyme was perhaps the most critical of the initial commentators: "Revelation is needed, not mourning or the over-painting of that which remains unclear but the opening of wounds. Not clemency. . . . People's opinions are being influenced. Etched into our minds are the verdicts of the media. Art has to confront these distortions of reality, should reveal not conceal."[6] Answering this insistence that art undo the lies and evasions of the media were those critics who perceived Richter's cycle not as historical document but as something almost opposite; for these interpreters the work was a complex and thoroughgoing demonstration of the limitations of traditional history painting in the modern age, and of difficulties inherent in trying to resolve social contradictions by aesthetic means. At this point Buchloh reenters the fray. The political underpinnings of his argument are strictly partisan. Flatly declaring the deaths of the RAF members in the small hours of the morning of October 18, 1977, to have

been "murders," he also maintains that the group's "supposed crimes remained to a large extent unproven," although hard evidence, probability, the rationale of their manifestos, and the political logic of their courtroom defense make this technical exculpation seem pointless.[7] Buchloh's primary aim, however, is to make the case for the paintings on the grounds that they reverse the national tendency to repress knowledge of damning historical episodes, and stand in accusatory contradistinction to what he calls the "polit-kitsch" of other contemporary artists involved in the recovery and reconstruction of the buried past.[8] In spite of these views, however, Buchloh concludes that the larger and perhaps more lasting significance of these works is their role in the terminal crisis of painting, in which they and the artist's production as a whole are a last effort at demonstrating the reach and power of an art form that has lost its cultural function.

In a 1989 essay, Stefan Germer essentially concurred with Buchloh, carrying the argument a step further without Buchloh's polemics against other artists or his defense of the RAF. Following Richter's lead, Germer pinpoints the tension between distance and empathy as the basic dynamic of the paintings: "It is a matter of recognizing something of oneself in others, but relying neither on pre-existing interpretations nor on a naive desire for identification in responding to that recognition. For this reason, Richter defines his artistic procedure as a dialectical mediation of proximity and distance, which follows the logic of remembering, repeating and working through."[9] In the final analysis, though, Germer fastens on Richter's chosen mode of expression and its predicament as the defining issue of the works, which embody a compound failure to transcend or bring to closure a chain of disasters that still resists all social remedies. He writes: "These paintings shockingly reveal that painting is dead, incapable of transfiguring events, of giving them sense. Painting in the present tense becomes the victim of the historical reality that it had sought to examine. They state pictorially that any attempt at the constituting of meaning via aesthetic means would be not only anachronistic but cynical. . . . If nothing can be altered, because all representation must necessarily end up asserting the inadequacy of the medium, what is the point of these paintings? In Richter's work history paintings must be seen as monuments of mourning: as a lament for loss, which paintings cannot alleviate or even soothe, but must rather assert in its full brutality."[10]

That these paintings had international, as well as national, importance was apparent from the moment they were first exhibited in Krefeld. Their potential impact elsewhere was promptly confirmed by the fact that the cycle subsequently traveled for two years, first to one other stop in Germany, the Portikus gallery in Frankfurt, and then to the Institute of Contemporary Art in London, and from there to Museum Boijmans Van Beuningen in Rotterdam, the Saint Louis Art Museum in Saint Louis, the Grey Art Gallery in New York, the Musée des Beaux-Arts in Montreal, the Lannan Foundation in Los Angeles, and the Institute of Contemporary Art in Boston. After the tour, Richter's paintings were deposited at the Museum für Moderne Kunst in Frankfurt as a ten-year loan; and the Frankfurt museum has lent the works for special exhibitions in Madrid, Jerusalem, San Francisco, and Berlin.

Critical response abroad generally echoed the initial reactions in Germany in range and intensity, though in most cases without the same lingering political partisanship. Indeed, confusion about the people and incidents

Richter had painted began to cloud descriptions of the work—in several articles Ensslin is mistaken for Meinhof or vice versa—inadvertently pushing the discussion away from matters of dramatic reportage toward a more general meditation on political violence in the confrontations between rebellious youth and conservative authority in the 1960s and 1970s. That shift in interpretation played a crucial part in deciding the ultimate destination of the paintings.

In June 1995, to the surprise of close observers of the scene as well as to the public at large, it was announced that *October 18, 1977* had been acquired by The Museum of Modern Art in New York for an undisclosed sum. The paintings, by a readily reached agreement between the artist and The Museum of Modern Art, were to remain in Frankfurt until the end of the ten-year loan, in keeping with Richter's original commitment. The eventual expatriation of the works caused almost as much of a stir in Germany and in the art world generally as had their debut exhibition. Once again, skeptics questioned the artist's good faith, some of them inferring American money had lured him into a deal that effectively deprived his country of part of its historical and cultural heritage.[11] Initially, Richter had indicated that he expected the cycle's permanent home to be a German institution. "Yes, I think it is better," he told Gregorio Magnani, who interviewed him for *Flash Art* in 1989; and the director of the Frankfurt Museum für Moderne Kunst, Jean-Christophe Ammann, had often expressed his strong desire to have the paintings.[12]

Gerhard Richter. *Man Shot Down 1*. 1988. Detail

However, according to Richter, no concrete offer from Frankfurt was forthcoming.[13] Not only did Frankfurt lack the funds necessary, they had trouble raising them because of the RAF's history in that city, where second-generation members of the group—that is to say, members who took action after the arrests of Baader, Meinhof, Meins, and Raspe—were responsible for the 1977 murder of Jürgen Ponto, head of the Dresdner Bank, a major patron of the museum, which withdrew its support when *October 18, 1977* was accepted as a loan. In addition, Alfred Herrhausen, head of Deutsche Bank, another of the museum's corporate sponsors, had been killed in 1989, just as the paintings were being exhibited in Krefeld.

Richter's change of heart was based less on these practical difficulties than on the issue of the appropriate political and aesthetic context for the work. Ammann, speaking after the decision to send them to New York had been made, protested that their relocation to America would render the paintings "ineffective," a sentiment shared by a considerable segment of German opinion. Others, including a journalist from *Die Tageszeitung* who interviewed the artist on the occasion of The Museum of Modern Art acquisition, questioned the American public's ability to grasp the meaning of the paintings, given its lack of knowledge of the RAF, its supposed obsession with 1980s-style "political correctness," and the hostile response of right-wing commentators. Such voices were audible.[14] "MoMA Helps Martyrdom of

Gerhard Richter. *Hanged.* 1988. Detail

German Terrorists," was the title of neoconservative critic Hilton Kramer's article on the purchase in *The New York Observer*, in which he rambled on about curatorial folly and "liberal guilt among the affluent," and ended with the pointed suggestion that the Museum benefactor whom Kramer assumed had paid for the work was, "precisely the kind of figure who would have been earmarked for assassination by these terrorists in their heyday."[15] David Gordon, writing in the international edition of *Newsweek*, challenged what he perceived as the Museum's dubious emphasis on the ambiguity of the pictures, and he chastised Richter on the grounds that if he "had truly wanted to take a neutral stance, he might have included portraits of the Baader-Meinhof victims."[16] Richter took this attack philosophically, telling another interviewer, Hubertus Butin, that "it would be rather un-normal, even awful, if complete praise erupted over there."[17]

In fact, reception of the cycle during its 1990 tour of the United States had been good. In *The New York Times*, Michael Brenson seized upon Richter's desire "to paint the unpaintable" and upon an essential conceptual aspect of the work to which conservatives and leftists were both willfully blind: its fundamental critique of the temptation and ultimate price of ideology, a temptation to which the Baader-Meinhof group succumbed and for which they paid a high price.[18] In *Art in America*, Peter Schjeldahl drew the connection between Richter's "Saturnian gravity" and Warhol's obsession with death and disaster, concluding that "Richter's distinctive tone—a depressive density resulting from a head-on collision of irresistible estheticism and immovable moralism, the fire of the voyeur and the ice of the puritan—may baffle American viewers, who tend to be relatively untroubled by pleasures of the imagination."[19] Perhaps more gratifying still were the comments made to critic Michael Kimmelman by Richard Serra (whose aestheticism and moralism are a match for Richter's) when Serra saw the *October 18, 1977* cycle on exhibit in New York just after it had been acquired and before it was returned to Frankfurt for the duration of the loan: "I don't think there's an American painter alive who could tackle this subject matter, and get this much feeling into it in this dispassionate way.... These paintings aren't like late Rembrandts, exactly, but they're disturbing in a way the Rembrandts are. There's despair in them. And both the Richters and the late Rembrandts are about people recognizing their own solitude through the paintings, which is what we respond to in them."[20]

Richter had come to think of America as a hospitable environment for his paintings, rather than an alien one, in several unanticipated but significant ways. The fact that The Museum of Modern Art had sought out the paintings mattered to him a good deal. "The address," Richter said, "was certainly a decisive issue."[21] What he meant was not institutional prestige but the breadth and depth of the collection of which *October 18, 1977* would become a part, and by so doing enter into a complex art-historical discourse. All along, Richter's hesitation about finally committing them to a German museum had been based on his fear that in such a context they would always be regarded as of interest more for their topicality than for their status as works of art. This was especially true in Frankfurt, where so much RAF history had taken place. In this respect, he was worried not only about short-term prospects but about long-term ones as well. "The meaning of the paintings will only develop in an art context," Richter said shortly after he had made up

his mind. "This means that they are documents and they are not illustrative materials. . . . The reviews [in the United States] were inspiringly different from the German ones. Here one was so affected by the subject matter that the paintings were almost exclusively viewed in political terms—or even as a kind of family affair. . . . People abroad did not let their expectations and bias obscure their view of the paintings."[22]

Furthermore, contrary to the assumption of some German observers—and quite a few Europeans generally—that the American experience of the period was so different from theirs that they could not fathom the true historical meaning of these images, Richter considered that relative difference a positive advantage. Speaking to Butin, who had raised doubts about the American readiness to deal with the work, Richter took a much broader view: "Due to their distance from the RAF, maybe the Americans can see the overall aspect of the subject that affects almost every modern or even non-modern country: the general danger of belief in ideology or fanaticism or madness. This is a current [issue] in every country, including the United States that you so lightly call conservative. But I can also see a direct relation between the United States and the RAF, not only the Vietnam War against which Baader and Ensslin protested in 1968. . . . I also see a relation between the American influence on the attitude and the beliefs of the so-called 68ers. Even their anti-Americanism was not only a reaction to American influence; to a certain degree it was itself imported from the United States."[23]

The nuances apparent in this retort should prompt caution in Europeans who persist in treating the Atlantic as a fundamentally unbridgeable cultural divide, and also serve as a warning to Americans who underestimate European attentiveness to the paradoxical love-hate relations this country inspires in them and others. Certainly Richter has a fine appreciation of such critical ironies, and at no time were these ironies more in evidence, more convoluted, or more influential than during the years when the drama of the RAF played itself out to its awful end.

Yet, it remains true that on the whole Americans are unaware of the specifics of what happened in Germany and elsewhere on the Continent in the 1960s and 1970s, and they are fast forgetting—if they are old enough to have known—what went on in their own backyards during the same period. Indeed, Richter is one of the very few artists who has made it his business to force remembrance of this acrimonius and still undigested era. Although the video artists Dennis Adams, Dara Birnbaum, and Yvonne Rainer have each made works that refer to the Baader-Meinhof episode, the dearth of art that attempts an appropriately disabused reexamination of the social, political, and cultural conflicts of that period is striking. From the Left there is weary silence; from the Right hollow harangues. Denial is not just a German problem, however, it is a German painter who has best shown how denial dissolves in the face of images that forswear traditional rhetoric.

When *October 18, 1977* was shown at the Lannan Foundation and the Grey Art Gallery in 1990, separate spaces were devoted to photo albums and texts narrating and analyzing the history of the RAF. Precisely because the paintings are *not* mere documents, such information is needed if one is to fully understand them and absorb their impact. After all, the events they describe occurred over two decades ago. More than one generation has come of age since then, and it cannot be assumed that they have learned

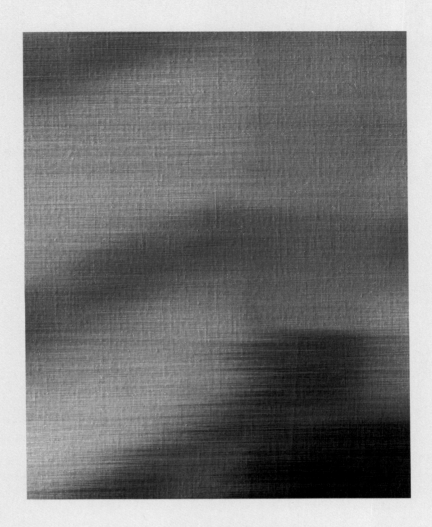

about what happened in any degree of detail, if at all. Nor can it be counted on that all of those who witnessed the turmoil of those days, and should remember it with some vividness, still do. For these reasons, Richter accepted the existence of the study rooms and provided his source notebooks for display, but he wryly noted: "The only disadvantage is that people spend more time reading than looking at the pictures."[24]

For The Museum of Modern Art's presentation of *October 18, 1977*, the publication of this volume is partly aimed at preempting any contest in the galleries between printed words and photographs and Richter's evanescent paintings—between declarative sentences and uncertain perceptions, between apparently clear-cut images and assertively ambiguous ones, and between the easy work of assimilating facts and the hard intellectual, emotional, and poetic labor of imagining how faint, imprecise tones and tints spread over fifteen canvases can encompass realities that seem irretrievably remote from contemporary existence. And yet, like a hecatomb of burnt-out car wrecks in a placid lake, these realities sit close to the surface of our collective consciousness and are perilous to anyone who, ignorant of their presence, dives in deep.

Gerhard Richter. *Arrest 1.* 1988. Detail

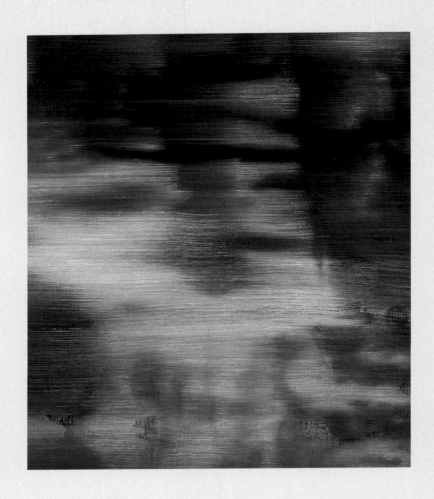

Gerhard Richter. *Funeral.* 1988. Detail

NOTES

1. Gregorio Magnani, "Gerhard Richter: For Me It Is Absolutely Necessary that the Baader-Meinhof Is a Subject For Art," *Flash Art,* international edition 146 (May/June 1989), p. 97.

2. Peter Ludwig, the prominent German collector, had approached Richter about acquiring the paintings, but the artist pointedly refused the offer.

3. Ingeborg Braunert, in *Die Tageszeitung* (March 18, 1989), p. 20.

4. Benjamin H. D. Buchloh, "A Note on Gerhard Richter's *October 18, 1977,*" *October* 48 (spring 1989), p. 93. Buchloh's link between Richter's October cycle and Mies van der Rohe's 1926 Liebknecht-Luxemburg monument in Berlin is double-edged insofar as Mies van der Rohe's essentially apolitical dedication to modernist architecture led him to look for accommodation with National Socialist cultural policy after Hitler came to power in 1933; with roughly the same professionalism he accepted the Communist's commission for the 1926 project. The aesthetic and moral distance that Richter takes from partisan politics is of another order altogether. It is inconceivable that he would accept commissions from or work around the ideological strictures of any party, Left or Right. Unlike Mies van der Rohe's project, Richter's *October 18,1977* paintings were made without a patron, in response to the artist's own need to make them. For a detailed discussion of Mies van der Rohe's political views, see Richard Pommer, "Mies van der Rohe and the Political Ideology of the Modern Movement in Architecture," in Franz Schulze, ed., *Mies van der Rohe: Critical Essays* (New York: The Museum of Modern Art, 1989), pp. 96–145; and Elaine S. Hochman, *Architects of Fortune: Mies van der Rohe and the Third Reich* (New York: Weidenfeld and Nicholson, 1989).

5. Sophie Schwarz, "Gerhard Richter: Galerie Haus Esters, Krefeld," *Contemporanea* 3 (May 1989), p. 99.

6. Hansgünther Heyme, "Trauerarbeit der Kunst muss sich klarer geben," *Art: Das Kunstmagazin* 4 (April 1989), p. 15.

7. Buchloh, "A Note on Gerhard Richter's *October 18,1977,*" p. 105. In a footnote to this article Buchloh names Anselm Kiefer as one of the most prominent exponents of a group of artists he accuses of making "polit-kitsch." In the body of the text he cites Richter's paintings as an implied

criticism of "the irresponsible dabbling in the history of German fascism with the meager means of generally incompetent painting." Jean-Christophe Ammann, however, argues that Richter and Kiefer are, to the contrary, *de facto* collaborators in the project of reinterpreting the past. Of the October cycle he writes: "This painting is intimately linked to World War II and the history after World War II. . . . Thus it is a work about Germany itself. . . . There are three oeuvres in German art that I see in this way: the oeuvres of Beuys, Kiefer, and Richter." See Ammann, "Das Werk als Menetekel," *ZYMA* 5 (November/December 1989).

8. Ibid.

9. Stefan Germer, "Unbidden Memories," in *18. Oktober 1977* (London: Institute of Contemporary Arts and Anthony d'Offay Gallery, 1989), p. 7.

10. Ibid., p. 8

11. In June 1995 The Museum of Modern Art announced the acquisition of *October 18, 1977* for an unspecified price, rumored in the press to have been three million dollars. Earlier, in the spring of that year, the author had made inquiries about the status of the works through Richter's New York dealer Marian Goodman, who came back with the surprising news that Richter had not as yet promised them to any institution and would indeed be interested in discussing their possible acquisition by MoMA. One of the first questions asked by the author during those conversations, which took place in the artist's studio in Cologne, was whether Richter had any lingering doubts about the paintings leaving Germany, since the author and the Museum, which he represented, had no desire to take the works to the United States if there was any question of that altering or clouding their meaning. Richter insisted that it would not and that in many ways their presence at The Museum of Modern Art might clarify their content. The artist did, however, ask that MoMA respect the ten-year commitment he had made to the Museum für Moderne Kunst in Frankfurt, and that was agreed to without hesitation.

12. Magnani, "Gerhard Richter," p. 97.

13. The Diözesanmuseum in Cologne had approached Richter with a serious offer, but the artist had declined it. See Stefan Koldehoff, "Stammheim in New York," *Die Tageszeitung* (Berlin) (October 28/29, 1995), p.15.

14. Ibid.

15. Hilton Kramer, "MoMA Helps Martyrdom of German Terrorists," *The New York Observer* (July 3–10, 1996), p. 23.

16. David Gordon, "Art Imitates Terrorism," *Newsweek,* Atlantic edition (London) (August 14, 1995).

17. Hubertus Butin, in *Neue Zürcher Zeitung,* International edition (October 23, 1995), p. 25.

18. Michael Brenson, "A Concern with Painting the Unpaintable," *The New York Times* (March 25, 1990), pp. 35, 39.

19. Peter Schjeldahl, "Death and the Painter," *Art in America* 4 (April 1990), pp. 252, 256.

20. Michael Kimmelman, "At the Met and the Modern with Richard Serra: One Provocateur Inspired by Another," *The New York Times* (August 11, 1995), C26.

21. Koldehoff, "Stammheim in New York."

22. Butin, in *Neue Zürcher Zeitung.*

23. Ibid.

24. Stefan Koldehoff, "Stammheim in New York," *Die Tageszeitung* (October 28/29, 1995), p. 15. Lisa Lyons, who organized the Lannan Foundation presentation of *October 18, 1977,* had a notably different take on the audience reactions to the paintings and the supplementary materials. "I've noticed that there is a lot of chatter in the galleries where the photographs and documentation of the gang are displayed, but when people see the paintings there is total silence. These paintings are just overwhelming." Suzanne Muchnic, "A Showcase for Controversial Art in Marina del Rey," *Los Angeles Times* (July 10, 1990) p. F1.

Anarchistische Gewalttäter
– Baader/Meinhof-Bande –

Wegen Beteiligung an <u>Morden</u>, Sprengstoffverbrechen, Banküberfällen und anderen Straftaten werden steckbrieflich gesucht:

Meinhof, Ulrike,
7. 10. 34 Oldenburg

Baader, Andreas Bernd,
6. 5. 43 München

Ensslin, Gudrun,
15. 8. 40 Bartholomae

Meins, Holger Klaus,
26. 10. 41 Hamburg

Raspe, Jan-Carl,
24. 7. 44 Seefeld

Stachowiak, Ilse,
17. 5. 54 Frankfurt/M.

Jünschke, Klaus,
6. 9. 47 Mannheim

Augustin, Ronald,
20. 11. 49 Amsterdam

Braun, Bernhard,
25. 2. 46 Berlin

Reinders, Ralf,
27. 8. 48 Berlin

Barz, Ingeborg,
2. 7. 48 Berlin

Möller, Irmgard,
13. 5. 47 Bielefeld

Mohnhaupt, Brigitte,
24. 6. 49 Rheinberg

Achterath, Axel,
15. 4. 35 Hannover

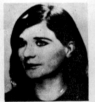

Hammerschmidt, Katharina,
14. 12. 43 Danzig

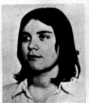

Keser, Rosemarie,
24. 8. 47 Ebersberg

Hausner, Siegfried,
24. 1. 52 Selb/Bayern

Brockmann, Heinz,
1. 3. 48 Gütersloh

Fichter, Albert,
18. 12. 44 Stuttgart

Für Hinweise, die zur Ergreifung der Gesuchten führen, sind insgesamt **100 000 DM** Belohnung ausgesetzt, die nicht für Beamte bestimmt sind, zu deren Berufspflichten die Verfolgung strafbarer Handlungen gehört. Die Zuerkennung und die Verteilung erfolgen unter Ausschluß des Rechtsweges.

Mitteilungen, die auf Wunsch vertraulich behandelt werden, nehmen entgegen:

Bundeskriminalamt – Abteilung Sicherungsgruppe –
53 Bonn-Bad Godesberg, Friedrich-Ebert-Straße 1 – Telefon: 02229 / 53001
oder jede Polizeidienststelle

Vorsicht! Diese Gewalttäter machen von der Schußwaffe rücksichtslos Gebrauch!

I: WHAT HAPPENED

Perhaps you should attempt to see the whole movement as a totality. You have to see it as a whole story, as the story that started after the second World War, in all its breadth.

Michael "Bommi" Baumann[1]

When Michael "Bommi" Baumann, an independent activist and sometime ally, but later severe critic, of the Red Army Faction, wrote the words above, he was speaking for a generation. The German Extraparliamentary Opposition (APO)—a loose amalgam of student organizations, counterculture groups, political factions, and anarchists in which Baumann played a prominent role—was in many respects identical in its origins and makeup to other emerging constituencies that exploded into rebellion in France, Great Britain, Italy, Japan, Mexico, the United States—all those places where broad challenges to established institutions and governmental systems were mounted with near revolutionary intensity during the 1960s and 1970s. There was one exception: only in Germany did those in youthful revolt against entrenched authority confront elders over whose heads hung direct knowledge of, and possibly direct responsibility for, the century's most horrifying totalitarian regime. Only there did a largely unspoken legacy of incalculable suffering and moral corruption connect the first half of the century to virtually every aspect of the second, like an invasive thornbush.

In 1959, when the first signs of restlessness with Germany's postwar status quo began to register, the twelve-year Reich had been a thing of the past for longer than it had lasted. Germany had been a nation defeated, occupied, partitioned, and impoverished. It was also a nation shamed.

Wanted poster: "Anarchist Violent Criminals—Baader/Meinhof Gang," c. 1972

The economic and administrative recovery of the western sector of the country had come with remarkable speed, in large measure because the victorious allies had learned from the harsh treaties that ended World War I that political humiliation and punitive reparations were a recipe for future instability in Europe. Hitler had exploited Germany's sense of victimization at the hands of the victors in that conflict; the second time around, those on the winning side in the West were determined not to make the same mistake, especially with their former comrade-in-arms (but future adversary) the Soviet Union looming large in the eastern zone. By the time the Federal Republic of Germany was founded in 1949, currency stabilization had been put in place to avoid inflation of the kind that had stampeded many Germans into the ranks of National Socialism after World War I, and the Marshall Plan was in full swing helping to rebuild the nation's industrial infrastructure. Meanwhile, after a period of highly selective "denazification," governmental bureaucracies were back in operation, and a new constitution on an American model had been drawn up. Based on an essentially two-party electoral system, the Left was represented by the Social Democratic Party (SPD) and the Center/Right by the Christian Democratic Union (CDU), buttressed by the more right-wing Christian Social Union (CSU).

The figure who oversaw this first phase of normalization was the Christian Democratic leader Konrad Adenauer. The mayor of Cologne until he was forced out of office by the Nazis in 1933, Adenauer had stepped back from active politics for the duration of the Third Reich and reemerged in 1945 to play the role of "honest broker" for a new deal for a country bent on restoring its economic self-sufficiency, while being equally determined to evade becoming the battleground in a Cold War turned hot. With the Soviet blockade of Berlin in 1948–49, and the construction of the Berlin Wall in 1961 by the communist German Democratic Republic, the prospect of a land war breaking out on German territory seemed at times all too probable. The "economic miracle" that made West Germany an industrial and financial power by the early 1960s was the product of Adenauer's single-minded policy of combining national recovery with political restructuring.

At the same time, ambivalence about the country's pivotal position in the worsening confrontation between the NATO nations and those of the Warsaw Pact prompted the SPD to adopt a friendly but arm's-length stance toward the United States and to cautiously oppose expansion of foreign, in particular American, military presence, especially the stationing of nuclear missiles. Under Adenauer, the Christian Democrats pursued economic independence through accelerated growth—high employment, high productivity, and high consumption. At the same time the Social Democrats pushed for greater geopolitical sovereignty under Kurt Schumacher (head of the party from 1945 to 1953), and, later, under its most popular leader Willy Brandt, who, having gone into exile in Sweden during the war, was also uncompromised by the Nazi era. By 1966, the two primary parties plus the smaller CSU formed a Grand Coalition with Kurt Kiesinger, representing the CDU/CSU as chancellor, and the dynamic and gregarious Brandt as his deputy and foreign minister. This coming together of the traditional Left and Right was the political predicate for the rise of a new radical opposition.

National rehabilitation was a conservative process in every sense of the word, based on shunning political extremes, reestablishing prewar hierarchies

(albeit in a modern guise), and, when necessary, deferring to the authority of the great powers, principally the United States, which, particularly under president Dwight D. Eisenhower, was going through its own phase of conservative social consolidation and economic, political, and military expansion. The result was a Germany in many respects rigidly stratified, rule-bound, and aggressively materialist. A dozen or so years after the extreme deprivations of the postwar years, the country was well on its way to becoming a fully developed consumer society on the American model, to which Germans had been exposed by an influx of films, goods, and tourists as well as by the presence of occupation troops. In Gudrun Ensslin's scornful phrase, it had become "the raspberry Reich."[2]

Voluntary collective amnesia was at the heart of that process. Although Roberto Rossellini had titled his searing documentary drama of Berlin in 1945, *Germany Year Zero*, resetting the clock in this manner was a half-truth. Germans were not starting from scratch, and they were certainly not beginning again with a clean slate. Nevertheless, citizens were encouraged to place heavy emphasis on taking positive steps away from the desperate situation of 1945, with the bare minimum being said along the way about what had brought disaster down upon them. Historians and journalists showed scant enthusiasm for revisiting the Nazi years, much less investigating their connection to the present; school curricula minimized the period, and people generally held their tongues, except in the company of those who had shared their experiences and outlook, and even then little was said. Until Israel tried Adolf Eichmann for war crimes in 1961, and Germany followed suit by bringing a group of Auschwitz guards before the courts in 1963, public acknowledgment of the Holocaust was fitful at best, and individual admissions of complicity, much less atonement, were all but unimaginable. The proverbial question children asked their parents, "What did you do in the war?" was for the most part met with evasion or silence. Returning to Germany, her homeland, in 1950, the Jewish philosopher Hannah Arendt, who later covered the Eichmann trial, and explained the massive slaughter supervised by that self-effacing "little man," as paradigmatic of "the banality of evil," wrote, "Everywhere one notices that there is no reaction to what has happened, but it is hard to say whether that is due to an intentional refusal to mourn or whether it is an expression of a genuine emotional incapacity."[3]

For many years the voices raised against this silent majority were few and far between, while active opposition to national consensus politics was marginal. The Cold War had much to do with this. Although some Germans—including important cultural figures like playwright Bertolt Brecht—cast their lot with East Germany, the Communist Party in the West was isolated and then outlawed in 1956, while the increasingly centrist SPD gradually retreated from its traditional socialist agenda. Except for scattered remnants of the old-school Marxist tendencies, university-based entities such as the Socialist German Students' Association (SDS) (originally a branch of the SPD), and the anti-atomic weapons movement that had flourished in the 1950s with its roots in Protestant and Catholic churches, resistance to the course Germany was taking lacked an organized center of gravity.

In addition to widespread resistance to reexamining National Socialism, there was a quiet reassertion of power by former members of its elite. In order to staff the renovated system, Adenauer turned a blind eye to the war

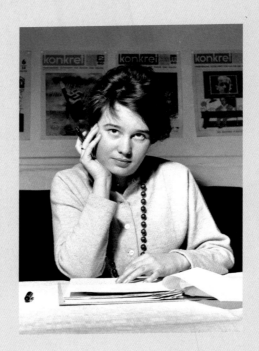

records of many of those on whom he relied for their technical skills, administrative abilities, and wealth. It was not just a matter of demobilized soldiers or lower-echelon servants of Hitler's regime being called back to rebuild their country but, rather, of the return to prominence of many who had been intimately involved in the Nazi project, if not deeply committed to Nazi ideals. Thus, key posts in the diplomatic corps, courts, medical profession, educational system, business world, and many other strata of society, reaching even into the chancellor's office itself, were re-entrusted to men loyal to the old ways as well as to the old guard, and more or less overtly unsympathetic to the democratic principles of the new Germany.[4]

For example, Hanns-Martin Schleyer, taken hostage in 1977 by members of the RAF in the hope of gaining the release of Baader, Meinhof, Raspe, Ensslin, and the others held in Stammheim prison was, among several high posts, on the board of trustees of the Daimler-Benz Company, and president of the Federal Association of German Employers at the time of his kidnapping. What was not generally known at the time he was seized, but quickly became so, was that Schleyer had joined the Nazi party at sixteen, had been head of the Nazi student movement in Innsbruck, Austria, was the senior SS officer in Prague responsible for subordinating Czechoslovakian industry to the German war effort, and may have commanded an SS unit in the massacre of forty-one Czech men, women, and children in the final days of the conflict.

To mention Schleyer's murky and, insofar as they can be verified, unforgivable activities of the 1930s and 1940s is in no way intended to justify his execution by the RAF but, rather, to make specific the degree to which the "hiddenness" of the past was, in reality, an open secret and a crucial factor in the political choices made by the children whose parents cheered, or at least tolerated, Hitler. At the funeral, attended by leaders of government and commerce, including not only the SPD chancellor Helmut Schmidt but anonymous men of military bearing with dueling scars on their faces, many who mourned Schleyer's death might well have been those whom Arendt had earlier described as demonstrating an "intentional refusal to mourn" the

Ulrike Meinhof in the editorial department of the journal *Konkret*, March 1962

catastrophe of National Socialism or "a genuine emotional incapacity to do so."

Although the principals of the Baader-Meinhof group had no direct role in the decision to take Schleyer hostage and later to kill him, there is a striking contrast between their backgrounds and his. Both of those who gave their names to the group, Andreas Baader and Ulrike Meinhof, as well as Gudrun Ensslin, the driving force in the group's radicalization, came from families that had repudiated Hitler. And all three came of age aware of that dissidence and convinced that even greater defiance was necessary.

Ulrike Meinhof, the oldest of the three, was born in eastern Germany in 1934. Her father, Dr. Werner Meinhof, was the curator of the Jena Municipal Museum, a position he held from 1936 until his death in 1940. Coming from a long line of Protestant theologians, Dr. Meinhof belonged to a religious community that had objected to state control of church affairs since the time of Bismarck, and at considerable risk, continued to do so under Hitler. After his death, his widow, Ingeborg Meinhof, studied to be an art historian and—to supplement a meager stipend from the city for which her husband had worked—took in a lodger, a dynamic and independent-minded young historian named Renate Riemeck. Ingeborg Meinhof and Riemeck had similar anti-Nazi sentiments, pursued their academic ambitions in tandem, and together moved, with Meinhof's two children, from East Germany to the West, shortly after the war ended. Both joined the SPD as soon as political freedom was restored. When Ingeborg Meinhof died in 1949 of complications from cancer, Riemeck became a foster mother to Ulrike and her elder sister, Wienke, and in her unconventional manner, passion for ideas, and increasingly outspoken socialist views she became Ulrike's primary role model.

Gudrun Ensslin, the fourth of seven children, was born in 1940, and also came from a principled, staunchly Protestant family. Her father was a minister and her mother "a strong character inclined to mysticism."[5] Having tended his parish in a predominantly Catholic town from 1937 through 1948, Pastor Ensslin was calmly but stubbornly nonconformist. A subscriber to left-wing religious journals that argued for a reconciliation between East and

Gudrun Ensslin and Andreas Baader, Paris, November 1969

West and for a ban on rearmament, he took heart in his daughter Gudrun's leadership in bible-study classes and youth groups. He encouraged her to go to the United States in 1958, where, at age eighteen, she spent a year with a Methodist community in Pennsylvania. She was dismayed at the lack of political sophistication and engagement of her hosts, which was typical of a particularly staid and self-involved moment in American social and cultural life. It also indicated something of her own internationalist orientation and intense activism, albeit then still church-bound.

Andreas Baader, 1972

Andreas Baader, the youngest of the three radicals, was born in 1943. His father, Dr. Berndt Phillip Baader, entered military service soon after his son's birth, was taken prisoner by the Russians in 1945, and disappeared. An historian and archivist who had opposed Hitler and spoken of joining the resistance, he was reportedly dissuaded from doing so by his wife, Anneliese, who was said to have feared the consequences for the family. However, after her son's death she told a reporter that Dr. Baader's failure to live up to his convictions was his own. In a strange display of matrimonial contempt and maternal pride, she said: "He was afraid. That was the difference between them. Andreas was never afraid. He went through with everything, right to the end."[6]

From these somewhat congruent beginnings to their encounter on the fringes of the new Left of the 1960s, the paths followed by Baader, Ensslin, and Meinhof differed significantly, but the fact that all of them came from families in which a heritage of dissent was a matter of pride, in a period and situation dominated by political self-effacement and subservience, cannot be stressed enough.

Also significant is the fact that all three leading members of the Baader-Meinhof group were solidly middle-class, as were the majority of those who gravitated to the armed political underground in general, and to the RAF in particular. Some, like Baader, had come from the lower economic strata, and at adolescence had slipped into the free-floating population of urban squatters and counterculture scene-makers. Others, like Susanne Albrecht, who at the height of the RAF's efforts to gain the release from prison of the original Baader-Meinhof group played a pivotal role in the botched 1977 kidnapping and murder of the head of Dresdner Bank, Jürgen Ponto, belonged to the upper middle class. The daughter of a Hamburg lawyer with close family ties to Ponto, Albrecht was admitted into the security-conscious banker's house in the company of two accomplices when she asked to speak to "Uncle Jürgen." This prompted Dr. Horst Herold, chief commissioner of the Federal Criminal Investigations Office (BKA) charged with coordinating the government's counteroffensive against terrorism, to remark: "There is no capitalist who does not have a terrorist in his own intimate circle of friends or relations. I mean that. There are no circles, however high, in our society—and this is the really alarming thing—which do not have people like Susanne Albrecht somewhere in their immediate or more distant vicinity."[7] Herold left unasked, as did so many who witnessed the spectacle of domestic political insurgency from the questionable safety of circumscribed lives, why this should have been so, and why so many, who in theory benefited most from the postwar "German miracle," spurned its comforts and ardently disputed the social contract that had made it possible.

General complacency and an initial failure of the middle class to take the deep disaffection of members of their own milieu seriously greatly exac-

erbated the frustration of those who moved to the Left in the 1960s (especially the young), reinforcing their sense that only categorical distinctions and sharply divisive acts could clarify their positions. The shock to the system resulting from the discovery of just how far such privileged but alienated intimates had in fact moved, while seeming to live parallel lives with their mainstream peers, was all that much more disorienting, and triggered a latent fear not of a foreign enemy, but of neighbors. This paranoid spasm and the exceptional legal measures instituted because of it did much to confirm the Manichean views of idealistic rebels, and, for a while, hardened their conviction that fundamental change was a now-or-never, all-or-nothing proposition. Thus, contrary to standard historical scenarios in which revolutionary momentum builds in response to the grinding oppression of the disadvantaged, this time matters came quickly to a head among men and women who had had some or all of the advantages, and who, as political novices, transposed their expectations of immediate gratification onto a reality that was fundamentally unripe for anything approaching a popular uprising.

It is correspondingly noteworthy that truly working-class youth generally kept its distance from the orthodox Left. Educationally ill-equipped for, or simply mistrustful of, doctrinal debate but strongly attracted to the newfound freedoms and the sex-drugs-and-rock-and-roll hedonism that neo-Marxists like Meinhof disdained—"We never played the Internationale but always Jimi Hendrix," the construction apprentice turned bomb-thrower Michael "Bommi" Baumann tartly recalled[8]—the relatively small proletarian contingent of the underground was every bit as eager for radical upheaval as its bourgeois contemporaries, and much better prepared for physical confrontation. However, previous experience had made them less inclined to romanticize violence and far more realistic about the power of the state. Indeed, Baumann and his equally hard-up and outspoken cohort Hans-Joachim Klein, were among the first members of the armed underground to renounce terrorism in the mid-1970s, and among the most frank and eloquent of those who criticized its use from the perspective of an unflagging refusal to submit to the status quo. [9]

Although students and other radicals were numerous and active throughout the Federal Republic from the mid-1950s through the 1980s, especially in Munich, Hamburg, and Frankfurt, Berlin was the hotbed of postwar German radicalism, the former imperial capital, hub of the Third Reich, and focus of East-West tensions during the Cold War. The city, with the construction of the Wall, became a political island tenuously connected to the rest of West Germany by air, rail, and highway corridors. Its exceptional concentration of young people was owed in varying degrees to its academic institutions, the fact that draft-age men living in this volatile zone were exempt from military service, the availability of cheap housing, and thriving bohemian communities. These circumstances, symbolic as well as material and social, made Berlin the flash point for student protest, and the crucible for countercultural experimentation.

Andreas Baader arrived in Berlin in 1963, quickly developing a reputation as a troublemaker and a charmer who lived at the center of an artistic ménage-à-trois, fathered a child by the woman, teased and rebuffed homosexual men, and engaged in the sport of petty theft. Although he was effectively apolitical, his swagger made him a minor local celebrity on the

Kurfürstendamm, West Berlin's main drag. Meanwhile, Gudrun Ensslin had trained as a teacher, married Bernard Vesper (the maverick son of a well-known literary critic and poet sympathetic to the Nazis), had a child, and, with Vesper, founded a small press that published new literature and essays against the nuclear arms race. In 1965, she moved to Berlin to attend the Free University and participate in an SPD-oriented writer's workshop in preparation for the elections of 1965. Disillusioned by conventional parliamentary politics and dissatisfied by her vocation, she eventually separated from her husband and hovered on the Left without a clear purpose.

The catalytic events that embroiled them both in overt political conflict—with Baader at first caught up along the fringes, and Ensslin almost immediately at the heart—were the June 2, 1967, demonstrations mounted against the Shah of Iran during his visit to Berlin. Protests in Berlin against the American bombing in Vietnam in 1965 (during which the U.S. Embassy was attacked by an angry splinter group) and in 1967 against vice president Hubert H. Humphrey—during which Humphrey was hit by a custard pie hurled by representatives of Kommune 1 (K 1), a flamboyant Berlin collective—caused government embarrassment and alarm but were, given the times, comparatively peaceful. Overall, however, there had been a steady change in the tenor of dissent. In 1958, when 5,000 students—the twenty-four-year-old Meinhof among them—demonstrated against the bomb, they wore skirts and ties; nine years later, this disciplined show of discontent spun into absurdity by K 1's slapstick assault on an American dignitary. Even so, June 2, 1967, marked an abrupt and irrevocable escalation of street violence. Under the eyes of the Berlin police, the Shah's own security guards attacked the protesters with sticks, and turned the march into a melee, at the end of which, Benno Ohnesorg, a pacifist student who had never before taken part in a demonstration, was shot dead by a careless, or simply trigger-happy, police detective. The naked display of vigilantism by the Shah's men and the acquiescence by German authorities to the "accidental" killing of Ohnesorg both chilled and inflamed the protestors, who saw in the conduct of officials the specter of state terror. Ensslin was especially quick to make the connection. Speaking at a rally shortly after the news of Ohnesorg's death had broken, she voiced sentiments widely shared by her comrades, although acted upon by only a small number of them. "This fascist state means to kill us all. We must organize resistance. Violence is the only way to answer violence. This is the Auschwitz generation, and there's no arguing with them!"[10]

Shortly after making this speech, Ensslin met Baader, and her righteous passion matched with his delinquent impetuosity set the tone of their disastrous joint foray into revolutionary politics. Their first venture together was inspired by another K 1 prank. Following a catastrophic fire in a Brussels department store on May 22, 1967, in which about three hundred people perished, K 1 published a broadside that linked the fiery deaths of the shoppers to the ongoing bombing of North Vietnam by American planes, and the stationing of American troops in Germany. "When will the department stores of Berlin burn?" the text read. "The Yanks have been dying for Vietnam in Berlin. We were sorry to see the poor souls obliged to shed their Coca-Cola blood in the Vietnamese jungle. So we started by marching, and throwing the occasional egg at the America House and we would have liked

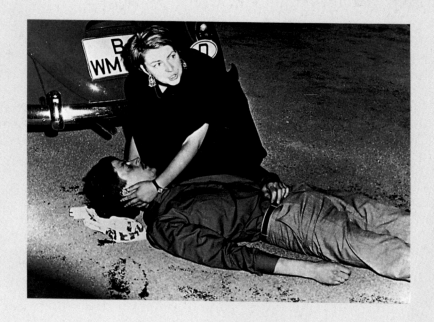

to finish seeing HHH [Hubert H. Humphrey] die smothered in custard. Now our Belgian friends have at last found the knack of really involving the whole population in all the fun of Vietnam. Brussels has given us the only answer: BURN DEPARTMENT STORE, BURN."[11] The gruesome humor of this Swiftian proposal makes no sense unless one takes into account the horrifying reports issuing daily from Southeast Asia, and the strenuous efforts made by hawkish spin doctors to keep the war at a distance while emphasizing the concurrent "guns and butter" prosperity of the Western democracies.

Baader's and Ensslin's decision to literally carry out K 1's mock call to action is a measure of how easily satirical exaggeration can become an imperative to fervent but otherwise directionless individuals. Thus on April 2, 1968, a year after the Brussels calamity, and less than a year after the Berlin riots, Baader, Ensslin, and two friends, Thorwald Proll and Horst Söhnlein, planted firebombs set to explode after business hours in two Frankfurt department stores, causing considerable damage but, because of the bombs' predetermined timing, no injuries. Although approved by K 1, whose leaders (no doubt surprised that someone had actually taken them up on the idea) were then charged with incitement, the action was strongly condemned by the SDS, opening a split between the organized Left and its impatient veterans and fevered new recruits, which gradually undermined the authority and effectiveness of more programmatic radicalism for a decade and more.

Almost immediately apprehended, the foursome was charged with arson, and their case became a cause célèbre, attracting the talents of politically committed lawyers Horst Mahler and Otto Schily. The divergent trajectories subsequently taken by these defenders throw into stark relief the choices that sympathizers then confronted. Mahler, eager to put an end to his complicity in a legal system he contested, quickly succumbed to the heat of the moment and became a front line ally of his clients. Before the case was settled, the formerly buttoned-down attorney was arrested for rioting and soon thereafter fled to Italy, where he unsuccessfully competed with Baader for leadership of the fledgling RAF. Following an excursion to the Middle East to make contacts with revolutionaries, and a series of mishaps on his return to

Benno Ohnesorg in the arms of passerby Friederike Hausmann after being shot and killed by police, West Berlin, June 2, 1967

49

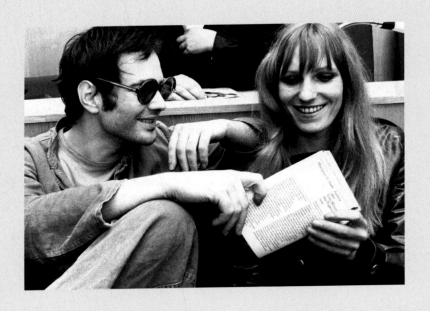

Germany, Mahler was captured, tried for a variety of crimes, and sentenced to a prison term of twelve years. (Among the sourest ironies of this period is the fact that since his release, Mahler has moved from the far Left to the hard Right, and become a featured speaker at meetings of the neo-fascist Nazionalsozialistische Partei Deutschland, claiming that this is consistent with his original beliefs.) Schily, who remained the Baader-Meinhof group's counsel throughout most of their long legal battles, is currently Minister of the Interior in a government composed of former student protestor and SPD Chancellor, Gerhard Schroeder, whose Foreign Minister, Joschka Fischer, an even more prominent figure in radical politics, had once tried to divert the trend toward armed struggle with the unsuccessful plea, "Comrades, lay down your guns and pick up paving stones."[12] One is reminded by such details that the differences in personal experience and ideological perspectives separating extremists from reformers in the 1960s and 1970s were sometimes comparatively small. The fact that the harsh choices made and the pain suffered in those difficult days have not faded from memory is not surprising, and neither is the fact that the political conclusions people on all sides of the issues rushed to at the time remain in question. We are dealing with living history. Openly or under cover, those touched by these events bear the scars, and many must still harbor doubts.

The sense of urgency that prompted public support for Baader, Ensslin, Proll, and Söhnlein in many quarters was heightened by the April 11, 1968, attempt on the life of Rudi Dutschke, a leader of SDS, and the most charismatic of the young radicals in the burgeoning APO. When he was arrested, his would-be assassin, a twenty-four-year-old housepainter named Josef Bachmann, was carrying clippings about Dutschke from the sensationalist, Springer-owned *Bild-Zeitung*. Also in his pocket was an article from the far right-wing *Deutsche Nationalzeitung* that read "Stop Dutschke Now! Otherwise there will be civil war. The order is to stop the radical left revolution now! If we don't, Germany will become a place of pilgrimage for malcontents from all over the world."[13] Superficially, there might seem to be parallels between K 1's provocation and that of the neo-Nazi writer who penned the article that appeared to have given Bachmann his marching orders, but K 1's idea was, by design, far-fetched, and the two members of the commune

Andreas Baader and Gudrun Ensslin, during a break in their trial for arson of a department store, Frankfurt, October 31, 1968

brought to trial for inciting the arson were acquitted of any responsibility. In the context of Germany's past, the bloody repression of the Revolution of 1918–19 by the proto-Nazi Freikorps, the gang-land style "anti-Bolshevism" of Hitler's Brown Shirts, and so much else, the hysterical xenophobic command to "Stop Dutschke Now!" was almost bound to produce the result that it did. Although Dutschke survived the attack, the lasting neurological damage he suffered contributed to his death eleven years later. Moreover, the reverberations of Bachmann's act included setting the stage for the RAF's terror campaign, while driving moderates more fearful of neo-Nazi violence than of anarchist attacks on property into their camp. The immediate response to the shooting were riots in Berlin at the site of Springer's corporate offices. For the first time, Molotov cocktails were used by the radicals—Mahler was among those who threw them—but unknown to the rioters and to the public at large, these had been supplied by a police agent who would later offer Baader and his comrades access to guns. Whether it was in an effort to polarize public opinion or to entrap hard-core protestors, someone in a position of authority was tempting fate.

Ulrike Meinhof was present at the Springer-building battle, which she wrote up for *Konkret*, the widely circulated left-wing journal of which she had been editor since 1960. After attending university in Münster, where she assumed a high-profile role in the antinuclear-weapons movement and SDS, Meinhof, still in her twenties, became a nationally known political speaker and columnist, and by her early thirties was appearing regularly on television as a resolute intellectual and moral voice of the new Left. In the meantime, she had married Klaus Rainer Röhl, a *Konkret* founder. Together they settled into a comfortable house in Hamburg with their two children, and were much in demand in liberal as well as radical social circles. Then things came unstuck. Like her foster mother Renate Riemeck, Meinhof had been sharply disappointed by the SPD's conciliatory swing toward the center in the mid-1950s, leading to the party's demand that SDS sever its affiliation with *Konkret* because of its Marxist leanings and continued contacts with the communists in the East. This led to a final break between the SPD and the still-dynamic SDS in 1959.[14] At each turning point, Meinhof took the more radical path. In keeping with that tendency, her editorial on the shooting of Dutschke, "From Protest to Resistance," announced a new militancy on her part, echoing Ensslin's declaration after the killing of Ohnesorg, but advancing the argument and ratcheting up the stakes several notches by exhorting her readers to emulate nationalist movements such as those of the Vietcong and the Palestine Liberation Organization, and urban guerillas such as the Uruguayan Tupamaros—primary role models for German urban guerrillas after 1967—and the American Black Panthers.[15]

Shortly afterwards, Meinhof interviewed Ensslin in jail, and was greatly impressed by her explicitly revolutionary aims; for that very reason, her potentially self-incriminating text was never published. Ensslin's fervor galvanized Meinhof, and their encounter effectively punctuated her own incremental ideological conversion to violence. A year after that first meeting and the Springer riots, Meinhof divorced Röhl, quit *Konkret*, and made her way to Berlin with her two daughters, where, among other projects, she worked on a television drama about reform-school girls called *Bambule*, a slang word meaning "riot" or "resistance."[16] In the meantime, Baader, Ensslin, and Proll

Ulrike Meinhof and her friend Irene Goergens, West Berlin, 1969

had been sentenced to three years in prison and released under a special amnesty for political prisoners. During their five months of freedom, they worked in a program for teenage runaways from state-supervised homes. It was called the Frankfurt Apprentices Collective, and once more put them in touch with Meinhof; in that context, Baader's knack for enlisting the energies of young renegades came out, encouraging him in the belief that they might soon be marshaled into some kind of irregular revolutionary army. When, in November 1969, Ensslin, Baader, and Proll were ordered back to jail, they decided to go underground. Their first stop was Paris, where they stayed at the apartment of the French writer and activist Regis Debray, then serving a thirty-year term in Bolivia, where he had accompanied the late Cuban fire-brand Che Guevara into the jungle.[17] For a group of freelance insurgents on the run, the legitimizing symbolism of this association was potent. After several months abroad, however, they decided to go back to Germany and plan further actions. Not long after returning, Baader was stopped for driving without a license, identified, and re-imprisoned. While serving his time in Berlin's Tegel jail, he managed to obtain permission to work with Meinhof in the library of the Institute for Social Studies, ostensibly on a project growing out of their involvement with troubled youth. But on May 14, 1970, Baader used this setup to make a daylight escape, assisted by Ensslin, Meinhof, and several other comrades, during which an elderly guard was shot, but not killed.[18]

The jailbreak sealed the bond between Baader and Meinhof, and its much-publicized audacity fused their names in the popular imagination, though Ensslin was, in this instance, the driving force behind the deed. Seeking refuge from police pursuit and instruction in the techniques of armed struggle, Baader, Ensslin, and Meinhof made their way to East Germany, and from there traveled to Jordan, where for a month they trained at a PLO camp. Baader's arrogance, the group's lack of discipline, and the men's and women's displays of sexual liberation in an Islamic enclave, earned them an earlier-than-planned departure, and only the most skeptical support from their Third World role models, who had come to regard them as revolutionary tourists, and later took to thinking of them as counters in the larger game of post-colonial power politics.[19] Back in Germany, however, the Baader-Meinhof group promptly applied the lessons they had learned, securing apartments as safe houses under false or borrowed names, renting get-away cars and changing the license plates, and in September of 1970, pulling off three almost simultaneous bank robberies in West Berlin, the proceeds of which were intended to finance future operations.

The two years between Baader's flight in May 1970 and his capture after a shoot-out in a Frankfurt garage in June 1972 (along with two RAF comrades, Jan-Carl Raspe, and Holger Meins) followed an almost Bonnie-and-Clyde-like progression from bravado to desperation—relatively benign acts of lawlessness to increasing destructiveness and confusion of motives. It is unnecessary, here, to narrate the Baader-Meinhof group's many movements, narrow escapes, aborted schemes, thefts, and bombings, in the same detail that the process of their banding together has thus far been described. As in many stories that end badly, the seeds of destruction are sown in the earliest chapters, and the outlines of the denouement are readily foreseeable from the outset. In such situations, accidental encounters acquire the aspect of inevitability, while common misunderstanding or weaknesses of character

assume specific tragic dimensions. Recognizing the importance of what happened to Baader, Ensslin, Meins, Meinhof, Raspe, and the other members of the RAF, and rendering a balanced account of what they did and why, hinge in large measure on the realization that these things could have happened to, or been done or thought by, any number of their contemporaries under comparable circumstances, though, as has been mentioned before, each of the actual participants was predisposed to dissent by particulars of personal or family history. The exemplary quality of the Baader-Meinhof group explains the attraction they held for so many disenchanted, but otherwise nonviolent, people. Meinhof's stern analytic conviction, Ensslin's fierce outrage, Baader's angry bravado, Meins's utter devotion to the cause, and Raspe's hapless earnestness, were the faces that German youth, pushed to its limits, showed

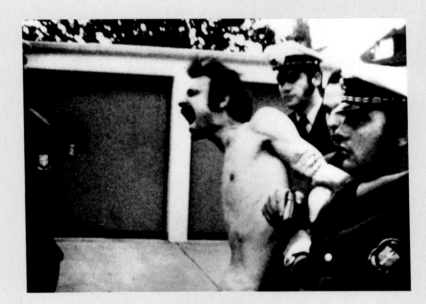

to elders determined to contain substantive change, and intent on deflecting attention from their own past failures and excesses. At the crux, this was not just an ordinary clash of generations, but the collision of contrary and, as far as actual power at their disposal was concerned, grossly unequal manifestations of ideological rigidity and self-deception.

If, until now, there has been no discussion of the subtleties of the RAF's political rationale, that is for good reason. There weren't many. Of all its members, only Meinhof had a developed grasp of practical or theoretical politics, and after allying herself with Baader and Ensslin, she tended to doubt herself and to yield to their more reductive zealotry.[20] Roughly speaking, the coordinates of the RAF's fundamentalist worldview were American hegemony and German authoritarianism, exemplified by American bases and the bastions of the Auschwitz generation's renewed strength. Within this negative matrix, the RAF's points of positive alignment included, to a greater or lesser extent, virtually anyone who shared their anticapitalist and anti-imperialist rhetoric—from the rough-and-ready "Bommi" Baumann or members of the Socialist Patients' Collective (SPK) (an erratic psychiatry-based political tendency), to shadowy representatives of Al Fatah, the Japanese Red Army, and the East German regime and its secret service, the Stasi. Notably lacking was sustained dialogue with other sectors of the APO—much less with the labor

The arrest of Holger Meins, Frankfurt, June 1, 1972

movement or other grass-roots organizations—though, for awhile, some in the above-ground Left secretly aided them. Frequently on the move, and usually cut off from all but essential local contacts, the Baader-Meinhof group was soon operating in a near-vacuum. As the crisis they had triggered worsened, it tended to occlude any social reality beyond the internal dynamics of their secret clusters, and inhibited the articulation of any vision of what their "revolution" would accomplish, beyond the rescuing of captured comrades and the disruption of the smooth-running machinery of the modern state.[21] Their fatal gamble—based on the widely read manifesto of the Brazilian insurrectionist Carlos Marighella, and on the Maoist notion that the triumph of the revolutionary Third World over the reactionary First World depended on bringing the battle from the margins to the center of empire—was that by relentlessly exposing the vulnerabilities of the establishment while goading

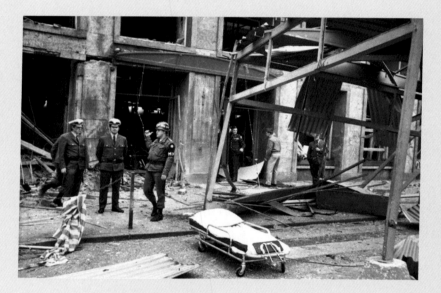

them into overreaction, radical saboteurs could gradually expose the true, uncompromising nature of institutional power, and draw others into the fight with them as that power expressed itself in ever more punitive and provocative ways. Or, as Hans-Joachim Klein characterized their strategy in the 1970s: "From the beginning the RAF has always said: the important thing is to exacerbate contradictions in such a way that the situation becomes more and more openly fascist. The important thing is to make the latent fascism that's predominant in West Germany clearly visible. After that the masses will rally round. And also the Left, including those who are opposed to them today."[22]

The consequences of this adventurist doctrine was an increasingly heavy-handed response from the police, the courts, and lawmakers. However, the RAF's apocalyptic obsession, compounded by their isolation, was such that they could not see that instead of hastening the downfall of all that they held repressive or corrupt, they had cast themselves and their supporters into a whirlpool that would shatter the Left's fragile cohesion, and pulverize its hopes. Once the RAF moved from isolated gestures of defiance to a systematic campaign of violence, the maelstrom's pull was inexorable. And so what may at the outset have seemed quixotic and innocent to some rapidly revealed itself to be a death-dealing naiveté. Or, as another RAF member, Klaus Junschke, recalled: "It was like going down hill out of control, if

An RAF bomb attack on United States headquarters at the IG-Farben highrise building in Frankfurt, May 11, 1972, which killed one person and injured thirteen.

you jump out you're done for, if you carry on you're done for just the same."[23]

Less than a week after Baader, Meins, and Raspe were captured in Frankfurt, Ensslin was arrested when a saleswoman in Hamburg spotted a gun in her purse and tipped off the police. A week later, Meinhof was seized in Langenhagen, near Hannover, when a teacher belonging to the RAF's network of protectors had second thoughts about hiding her, and turned informant. Sympathizers, frightened by the rising dangers of associating with outlaws whose faces appeared on wanted posters throughout the country were deserting them, along with dedicated leftists put off by the RAF's often imperious demands for shelter, as well as by their increasing incoherent politics. Although Meinhof, like Ensslin, surrendered without incident, she was beaten in a struggle that took place afterward, and a photograph of her badly bruised face was widely published. As of mid-June 1972, all the principal figures of the Baader-Meinhof group and their closest collaborators were in custody. The crimes for which Baader, Ensslin, Meins, Meinhof, and Raspe were charged included seven counts of murder and twenty-seven counts of attempted murder in connection with bombings, as well as additional counts of murder, or attempted murder, for separate individuals. The indictment also cited a bank robbery, involvement in the raid that resulted in Baader's escape, forming a criminal organization with Horst Mahler, and other related offenses.

The most intense period of bombing was from early to mid-1972. On May 19, 1972, explosives were set off at Springer headquarters in Hamburg, at German police stations in Augsburg and Munich, at American military sites in Heidelberg and Frankfurt (timed to the escalation of American air raids over North and South Vietnam), and in various other locales, such as Karlsruhe. Although the exact identity of the perpetrators of these attacks remains in many cases unknown, several of them were claimed by Commandos bearing the names of radicals killed in the increasingly frequent and lethal shoot-outs with authorities. In addition to the RAF, terrorist cells associated with the June 2nd Movement (commemorating the date of Benno Ohnesorg's death), the Revolutionary Cells (RZ), and the SPK were pursuing the same tactics, and while casualties mounted among the RAF and affiliated organizations, the toll of policemen, U.S. soldiers, and those unlucky enough to be in the wrong place when bombs went off, also soared.[24] Although only a tiny percentage of the population had raised its hand in violence, it was in a very real sense a civil war. Lamenting the futility of the Baader-Meinhof group's crusade, the novelist Heinrich Böll called it, the war of "six against sixty million."

The most wrenching phase of that war began with the detention of those who had triggered its outbreak. By that time, Germany was a country under siege—and counter-siege. Presided over by Dr. Herold, the BKA effectively became a national police and surveillance unit on the order of the American FBI. For the first time since World War II, Germany collected massive quantities of information on its citizens—by 1979, the BKA's computer center in Wiesbaden had files on 3,100 organizations and 4,700,000 individuals, along with 2,100,000 sets of prints, 6,000 writing samples and 1,900,000 photographs. In the meantime, police searches became routine, and highways were periodically cordoned off all across the Federal Republic. At one roadblock in July 1972, Petra Schelm, an RAF member, was killed when she drew a gun and tried to flee. She was the first person to die in the expanding crisis. In March of the following year, however, a seventeen-year-

old who attempted to run a barricade simply because he was driving without a license, was also shot dead, and incidents such as this one, plus a growing unease about pervasive police presence, turned many people against the government, even though the police suffered its own fatalities at the hands of gun-wielding radicals.[25]

The conditions in which the RAF prisoners were held and under which they were tried were similarly extreme and politically double-edged. For the first year of her confinement, Meinhof was kept in almost total physical and acoustic isolation in the so-called "Dead Section" of a Cologne jail. After more than a decade of activism, and two years as a fugitive (which had worn down her health and nerves), Meinhof suddenly found herself quite literally boxed in. She described the experience as "the feeling that your head is exploding . . . the feeling of your spinal column being pressed into your

brain . . . furious aggression for which there is no outlet. That's the worst thing. A clear awareness that your chance of survival is nil."[26] The others were held in less draconian circumstances, but they, too, were cut off from the world and from each other for long intervals, and more importantly, they were periodically cut off from their lawyers, some of whom were summarily dismissed from the case on the grounds that they were in league with their clients. After a long build-up to the trial, involving the construction of a special high-security courthouse on the grounds of Stammheim prison, the majority of the RAF prisoners were eventually gathered in a block of cells separate from the rest of the prison population, further restrictions were put on their attorneys, and surreptitious measures were taken to eavesdrop on discussions among them, and between them and their legal representatives. When the case finally came before the judge, his consistent rejection of motions made by the defense—in particular, motions seeking relaxation of the harsh regimen under which the prisoners lived—made it clear that whatever the courtroom provocations of the accused—and they were many—fair and open proceedings were impossible. Revelation late in the trial that listening devices had been placed in the defendants' cells and the rooms where they met with their lawyers came as no surprise, and neither did the discovery that the judge had been leaking information to a conservative newspaper,

Police search for RAF terrorists throughout the Federal Republic of Germany: a roadblock at a Bonn autobahn exit, May 31, 1972

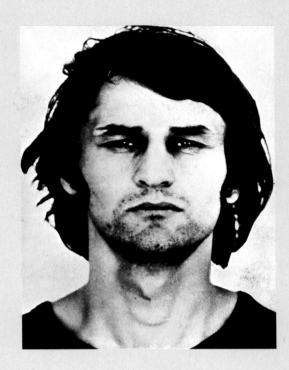

Die Welt, so as to counter stories in the more liberal news magazine *Der Spiegel*, for which, finally, he was obliged to step down.

The judge's actions alone, however, do not account for all the trial's flaws and inequities. Frustrated by Baader's, Ensslin's, and Meinhof's frequent outbursts in court, and especially by their request that daily sessions be limited to three hours due to their poor physical and mental stamina after years of incarceration, prosecutors asked for, and in late 1974 the Bundestag enacted, special laws, which in addition to imposing broad limits on the writing, publication, and dissemination of politically controversial materials, and laying down narrow guidelines for who could represent the accused on political cases (one lawyer was dismissed merely for calling himself a socialist), gave judges the right to carry on with a trial in the absence of those being tried. Thus, on the grounds that a state of national emergency existed, Germany overtly and covertly curtailed its civil liberties, summoning the ghosts of law-and-order past.[27]

The grim backdrop against which these maneuvers played themselves out was marked by death on all sides. Inside the prison, members of the RAF mounted a series of hunger strikes to protest their treatment. Torturous force-feeding of the strikers was the prison warden's response. The effects of these debilitating battles over the control of their own bodies further sapped the strength and attention of the defendants in court, and made a martyr of Holger Meins, who died in the Wittlich jail on the fifty-third day of the third strike, after proper medical attention was withheld. His last recorded words mix political slogans with genuine stoicism: "Either pig or man, either survival at any price or fight to the death, either problem or solution. There's nothing in between. Of course, I don't know what it's like when you die or when they kill you. Ah well, so that was it. I was on the right side anyway—everybody has to die anyway. Only one question is how one lived, and that's clear enough: fighting pigs as a man for the liberation of mankind: a revolutionary battle with all one's love for life, despising death."[28]

Holger Meins, early 1970s

57

Widespread rioting followed Meins's death, and a post-autopsy photograph of his horribly emaciated corpse became an icon of radicalism. Klein said: "I have kept this picture in my wallet to keep my hatred sharp."[29] Much of the general public was also shocked by the sight of this image, and by the cruel reality to which it testified. In the battle of symbols, the RAF had gained a heightened moral credibility even as direct support for its actions continued to wither. The keenness of public ambivalence was made manifest by the call paid on Baader by the existentialist philosopher Jean-Paul Sartre, whom Baader, like much of his generation, had read in the early stages of radicalization. A former fellow traveler of the conservative Soviet-controlled French Communist Party turned ally of the upstart, go-for-broke Maoist factions that played a crucial role in the general upheaval that shook France in May 1968 and its aftermath, Sartre was persuaded to visit Stammheim out of

concern for the well-being of the prisoners, but not at all out of solidarity with their political stance. This brief cross-generational summit, which garnered much publicity, was a blunt non-meeting of minds. "This group is a danger to the Left. It does the Left no good. One must distinguish between the Left and the RAF," Sartre declared after it was over.[30] Of Sartre, Baader said: "As for him, what I got was the impression of *age*."[31] The fact remained, however, that much of the old Left which had remained militant was deeply distressed by the perilous detour taken by frenzied elements of the new Left. (This included Meinhof's foster mother Renate Riemeck who had done much to inspire her radicalism, but who, during the manhunt for the Baader-Meinhof group in 1971, had published a letter in *Konkret* headlined, "Give Up, Ulrike," arguing that terrorism would be blamed on the Left as a whole and used as a propaganda weapon to block progress of their common social aims.)

By December 4, 1974, when Sartre went to Stammheim, forces were in motion that resulted in actions and reactions far outstripping his or Riemeck's worst fears. After Meins's death, the second generation of terrorists went into high gear, immediately demonstrating an unpredictability and a willingness to spill blood that exceeded anything for which the original

Press conference at Stammheim prison, December 4, 1974: left to right, Klaus Croissant, lawyer for Gudrun Ensslin; Jean-Paul Sartre, existentialist philosopher and writer; and Daniel Cohn-Bendit, radical politician

Baader-Meinhof group could be held responsible. Their first action, made by the June 2nd Movement, was the killing of a judge (during an attempted kidnapping) who was unconnected with any of the pending cases against the RAF. The second, also by the same group, was to kidnap the Christian Democratic politician and candidate for mayor of Berlin, Peter Lorenz, and demand a cease-fire with the police and the release of all radical prisoners not charged with murder. It is some indication, perhaps, of the divisions and mistrust within the movement that Mahler, one of those named by the hostage-takers, refused to accept the invitation. In any event, after tense negotiations, other prisoners were flown to exile in Aden, and Lorenz was let go unharmed. The next incident did not end peacefully. A month after the Lorenz case, six heavily armed terrorists invaded the German embassy in Stockholm, demanding freedom for twenty-six prisoners, including those in Stammheim. When the governments of the Socialist prime minister of Sweden, Olaf Palme, and the German socialist chancellor Helmut Schmidt refused to negotiate, the invaders shot two diplomats in full view of the surrounding police, and then, mishandling the bombs they had brought in to mine the building, set off a huge explosion that gutted the premises, killing one guerilla and one hostage, and wounding several others. The siege, engineered by the SPK, ended in chaos.

Similar incidents arising out of the Middle East stand-off between Israel and the Palestinians had occurred earlier, and had provided the background for the Lorenz kidnapping and the attack in Stockholm. In September 1972, Arab commandos seized members of the Israeli Olympic team in Munich, and by the end of the confrontation, all eleven of the Israeli hostages, as well as five terrorists and one policeman, were dead. (Germany's decision not to arm police guarding the Olympic Village in order to avoid projecting a militaristic image, and its fatal bungling of the final showdown with the hostage-takers, added to political pressures to strengthen its security forces overall.) The brutal slaying of Jews on German soil raised the specter of anti-Semitism in ways few imagined possible. For example, by openly siding with the perpetrators of the attack on the grounds that they were Third World revolutionaries, Meinhof and some, but by no means all, of her anti-imperialist colleagues tacitly aligned themselves with Judaism's perennial enemies, in a context in which the assertion that their anti-Zionism was purely political rather than ethnically based, simply ceased to be a meaningful distinction. The December 1975 raid on the Vienna meetings of eleven OPEC ministers in which Hans-Joachim Klein participated was the next episode binding together the offensives of Arab and German terrorists. Although three people were killed and Klein was gravely wounded at the beginning of the siege, there were no further deaths after the ministers were ransomed by their governments, and Algeria agreed to be a refuge for the commandos who had been led by the cold-blooded sociopath, Ilyich Ramirez Sanchez, popularly known as Carlos the Jackal. Six months later, on June 27, 1976, an Air France plane flying from Tel Aviv to Paris was hijacked in Athens by a group that included members of the Revolutionary Cells (RZ). The stand-off at Uganda's Entebbe airport came to an abrupt conclusion when German and Israeli special forces stormed the airport's control tower and the former terminal where the passengers were being held. Seven terrorists were killed and all the hostages were rescued, except for three who died in the fire-fight,

and one other, an elderly woman named Dora Bloch, who died of suffocation after having been forcibly removed from a Kampala hospital by security guards of the Ugandan dictator Idi Amin, whose protection Bloch had been guaranteed.

The convergence of once disparate terrorist groups inside Germany and out, the entanglement of their still differing motives and aims, and the increasing savagery of their strikes, created the national and international setting for the last act of the Baader-Meinhof story. The isolation of Baader, Ensslin, Meinhof, Raspe, and the rest of the RAF prisoners from the world beyond their walls, their intensifying pessimism, and the gradual disintegration of relations among them, complete the demoralizing picture.

Gathered in adjacent cells on the seventh floor of Stammheim jail, the prisoners lived in what amounted to a bizarre collective, watched over by a squad of guards. For long periods, the special Baader-Meinhof laws enacted in 1974 effectively denied them contact with anyone except their lawyers, and even that was limited. Contact with each other was in principle allowed during certain hours and in certain common areas, but it was frequently interrupted; otherwise, they communicated by semi-coded messages sent back and forth through their attorneys or, near the end, with the aid of a walkie-talkie system improvised out of old transistor radios. Permitted record players and books—Baader, for example, had a library of some 974 volumes, most of it revolutionary literature, while Ensslin's collection also included *Measure for Measure* and *Moby Dick*, both of which she interpreted as revolutionary allegories—they passed their time listening to music, reading, writing, and arguing. At night, courtesy of their warders, several of them were routinely given strong sleeping drugs.

From the time of her year-long solitary confinement in Cologne, Meinhof experienced a gradual nervous breakdown. Political as well as personal tensions between her and Ensslin were at the core. Particular sore spots included Ensslin's criticisms of Meinhof's support for Black September, and their disagreements over whether or not the hunger strike should be maintained after Meins's death; Meinhof wanted to stop it, but Ensslin insisted that it go on, until finally it was called off after 146 grueling days. Self-criticism sessions conducted by letter or face-to-face dredged up Meinhof's abiding self-doubt and turned it into self-loathing. However, her slide into melancholy merely made Ensslin suspicious that she was trying to crack up so as to shirk responsibility. Meinhof's previously rebuffed attempts at composing manifestos acceptable to the others, and the never-completed history of the RAF she embarked on late in the trial, were further demonstrations of her need to make sense of their mission, and her inability to do so. By late 1975, Meinhof began withdrawing from her comrades into a numbing depression—she had long since severed ties with Riemeck and then, in late 1973, stopped writing to her daughters—a depression relieved, if that is the word, only by periodic eruptions in court, in which her old vehemence was momentarily restored. In the end, she became a victim of her own totalizing beliefs; revolution had consumed the whole of Meinhof's identity, but, ultimately, there seemed to be no place in the revolution for her.

On May 4, 1976, Meinhof briefly appeared for the last time at her own trial, and left before hearing her lawyer call Willy Brandt, Richard Nixon, and Helmut Schmidt as witnesses, the kind of political gesture she ordinarily

would have savored. On May 9, she was discovered hanging by a strip of towel in her cell. While doubts were raised about the circumstances of her death—including the accusation that she had been raped before being murdered by a person or persons unknown—no substantial evidence was found to support these suspicions—though many believed it may have been destroyed—and the case was ruled a suicide. As was true after Meins's death by starvation, demonstrations occurred throughout West Germany, and a week after she died, thousands attended her funeral, at which twenty-six people were arrested.

Although Ensslin seems never to have lost her ardor, and Baader seems never to have lost his combativeness, desperation stalked them even as efforts to spring them from jail reached a climax. The final bid for their freedom started September 4, 1977, with the kidnapping of Hanns-Martin Schleyer in an ambush during which his chauffeur and three of his bodyguards were machine-gunned down. Release of the RAF prisoners in Stammheim, was the kidnappers' main demand. As soon as the news broke, Baader, Ensslin, Raspe, and the others, were placed in total quarantine, with all contact among themselves or with anyone on the outside—including their lawyers—banned. They were only allowed to speak to prison or government officials, and clergy members. Within the pressure-cooker atmosphere of their cellblock, tensions with guards, which had already led to brawls, reached fever pitch.

The German government's policy, as it had been in Stockholm, was to resist acceding to terrorist threats. Seeking to secure a clear mandate for that policy, Chancellor Schmidt called a special meeting of senior political figures and opposition leaders, including Helmut Kohl of the CDU, and Franz-Josef Strauss of the CSU, in which all parties agreed to a strategy of public negotiations and secret intransigence while police hunted for Schleyer and his captors. [32] The ins-and-outs of those pro-forma negotiations are too complicated to summarize, except to say that they involved bad faith toward Schleyer's family as well as toward the neutral human-rights activist who served as intermediary, and all the others with a vital stake in the outcome. After a delay of a month and a half, the ante was raised with the October 13 hijacking of a Lufthansa jetliner by a combined team of RAF gunmen and Palestinian guerillas, who, after several interim landings, brought the plane down on an airstrip in Mogadishu, Somalia.

Although Baader, Ensslin, and Raspe may intermittently have hoped that their self-appointed saviors would be successful, instinctive certainty that they would not, plus a widening gap between their sense of the politically appropriate tactics and those of their more fanatical allies, appear to have convinced them that the whole effort was one of remorseless futility. Throughout the weeks leading up to their mysterious deaths following the liberation of the captives on the Lufthansa plane by an elite unit of the German army, Baader, Ensslin, and Raspe sent mixed messages. On the one hand, the prisoners laid full responsibility for their fate at the feet of the officials; on the other, they intimated that one way out was to do away with themselves.[33] Thus Baader warned the prison doctor, Dr. Henck, of incipient attacks by guards: "A few more days and there'll be people dead. There's sadism bursting out everywhere now," he said."[34] Putting together all the measures adopted over the last six weeks, one can conclude that the

administration is hoping to incite one or more of us to commit suicide, or at least make suicide look plausible. I state here that none of us intend to kill ourselves. Supposing, again, in a prison officer's words, we should be 'found dead' then we will have been killed in the fine tradition of all the judicial and political measures taken during these proceedings."[35] Yet, in another recorded comment, Baader threatened that the prisoners might take the matter out of the negotiator's hands by coming to "an irreversible decision" on their own.[36] Moreover, it appears that Raspe had reached the point of despair, and Ensslin one of resignation, prompting her to summon a Catholic priest, as well as a Protestant minister to whom she entrusted the care of certain papers still in her cell, papers that vanished after her death and before the pastor could recover them, and have never since been located.

Meanwhile, as he watched events spin out of control, Baader offered a revisionist, partly exculpatory, but still pointed critique of the mercilessness of the second-generation terrorists and errors of the authorities facing them: "There are two lines to take in the fight against the state, and through its attitude, the federal government has helped the extreme form to break through. . . . International terrorism isn't the RAF scene. . . . I can see two possible ways ahead. One's further brutalization; the other's regulated struggle as opposed to total war. . . . Terrorism is not the policy of the RAF."[37] And, in a last-minute conversation with a high-ranking aide to the Federal State Secretary, Baader affirmed that the prisoners had had no direct or indirect part in masterminding the Schleyer kidnapping or the Lufthansa hijacking, and no leverage over those ostensibly acting on their behalf. Furthermore, Baader claimed, the original RAF would never have engaged in an operation that deliberately endangered innocent civilians, and, he promised, if they were sent into exile, they would never come back to renew their fight in Germany, given the new situation. In conclusion, Baader reasserted that the RAF's response to the Vietnam War had been necessary and just and the origin of all that ensued, but he admitted having made mistakes, and stated that whatever the outcome of the immediate crisis, he and the other prisoners would not survive.

The next morning, Baader, Ensslin, and Raspe were dead. Guards making their usual rounds at 7:40 a.m. found Baader on the floor of his cell clutching a pistol. A bullet had entered the back of his head. In her cell, Ensslin was hanging by an electric cord that had been attached to a metal grate. She too was dead. In his cell, Raspe, shot in the temple, was dying. A fourth prisoner, Irmgard Möller, had been stabbed four times in the chest, but was not mortally wounded.

The party or parties responsible for this carnage remains a matter of bitter speculation. Möller claimed that on the night of October 17, 1977, she had read until 4:00 a.m.—roughly two and a half hours after Raspe was thought to have heard over the radio that the hijacking of the Lufthansa plane had ended in the total defeat of the hijackers, and reported the news to Baader and Ensslin—and that when she turned off her light, she had called out to Raspe in his adjacent room as was her custom, and that he had responded in the usual way. Sometime around 5:00 a.m., she was briefly awoken by thudding and squealing sounds through the walls and floor. The next thing she remembered was waking up covered in blood on a stretcher. Although Möller insisted that there was no suicide pact in place, it does

appear that guns had been smuggled into Stammheim by lawyers involved in the case, and hidden in the molding of Raspe's cell, and the record player in Baader's, and their comrades had intimated that decisive action of some kind was in the offing. Whether or not Baader and Raspe fired the shots, Ensslin tied the noose, or Möller wielded the knife, can neither be proven nor disproven, nor do the incomplete facts in the case (mislaid evidence, important lapses in the investigation, and anomalies in the official explanation that raise numerous unanswered questions about official involvement or cover-up) provide sufficient grounds for calling their deaths murder. And if it was murder, there is no way of ascertaining if prison guards, some secret police or military unit, or others higher up in the governmental chain of command, were to blame. Chancellor Schmidt, for one, professed shock when he heard what had happened at Stammheim. He could not have wanted his clear victory in

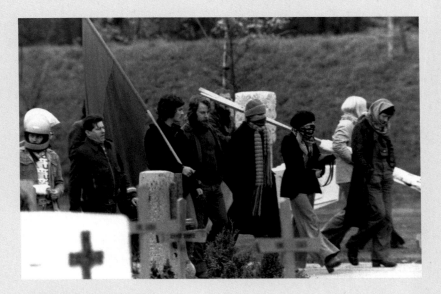

Masked guests at the funeral of Gudrun Ensslin, Andreas Baader, and Jan-Carl Raspe, Stuttgart, October 27, 1977

Mogadishu tainted in such a manner, though by the very same token, Baader, Ensslin, and Raspe surely understood that their untimely and inexplicable deaths would constitute a last weapon against the success of Schmidt's policy. A day after they occurred, a message was sent to the French daily, *Libération,* announcing the execution of Hanns-Martin Schleyer and the location of his body. The communiqué ended with the words: "The fight has only just begun. Freedom through armed anti-imperialist struggle."[38] Such freedom was a phantom, and more than a decade of skirmishes lay ahead.[39]

The funeral of Baader, Ensslin, and Raspe was the coda to their drama. Attended by thousands of mourners, most young, some bearing placards pointing the finger at the government and promising to avenge the martyrs, and many wearing Bedouin head-cloths as an expression of revolutionary solidarity and to conceal their faces from prying cameras, the common burial was also watched over by a thousand heavily armed police officers prepared for trouble, who busied themselves gathering intelligence. When it became public that out of respect for the dead prisoners' wishes, their families had made arrangements to inter them together in a cemetery on the outskirts of Stuttgart, conservatives seeking to obstruct the plans and have their common grave relocated, protested that the site would become a shrine. In one of the few genuinely noble moments of this otherwise dismal saga, the mayor of

Stuttgart ruled against the ban. It is more than poetic irony that the city's mayor was Manfred Rommel, son of the German war hero General Erwin Rommel, who in order to save his family, had, in the manner of a Roman soldier, been forced to commit suicide by the Gestapo after being implicated in the plot to assassinate Hitler. Mayor Rommel's reasons were simple and dignified: "I will not accept that there should be first class and second class cemeteries. All enmity should cease after death."[40] One would like to be able to say that he had the last word, but the unrelenting recriminations and debates that continue to revolve around the Baader-Meinhof group suggest that no last word will ever be spoken.

NOTES

The narrative of this chapter has been based on facts gleaned from several sources, but one in particular deserves to be acknowledged, Stefan Aust's *The Baader-Meinhof Group: The Inside Story of a Phenomenon*, trans. Anthea Bell (London: The Bodley Head, 1985), which is as close to being a definitive journalistic account of the Baader-Meinhof group's origins and activities as we can expect to have. A friend of many of the principals, and a protagonist in part of the story, he was instrumental in preventing Meinhof's daughters from being spirited away to a PLO camp in Jordan, where they would most likely have been killed in the war between the PLO and King Hussein that broke out there in September 1971. Aust is a convincing participant-observer and a scrupulous researcher. I have relied heavily on the facts he provides, and trust his judgments regarding matters of speculation. Aust's book is also significant in that Gerhard Richter was in part spurred on to paint *October 18, 1977* after reading it.

The insights provided by Michael "Bommi" Baumann and Hans-Joachim Klein in their books—*Wie Alles Anfing/How It all Began*, with statements by Heinrich Böll and Daniel Cohn-Bendit, trans. Helene Ellenbogen and Wayne Parker (Vancouver, Canada: Pulp Press, 1977), and Jean-Michel Bougereau's "Interview with Hans-Joachim Klein" in *The German Guerilla: Terror, Reaction and Resistance* (Sandey, Orkney: Cienfuegos Press; Minneapolis: Soil of Liberty, 1981)—were also indispensable. Tom Vague's *Televisionaries: The Red Army Faction Story 1963–1993* (Edinburgh and San Francisco: AK Press, 1994) provided a running chronology and additional information of great value. Last, there is Jillian Becker's *Hitler's Children: The Story of the Baader-Meinhof Terrorist Gang* (Philadelphia and New York: J. P. Lippincott, 1977). A sloppy and blatantly biased version of the story, published in haste after the Stammheim deaths, Becker's book hinges on the crude analogy suggested by the title that the Baader-Meinhof group was made up of direct descendants of the Nazis rather than young adults belonging to a generation struggling to overcome Hitler's legacy. Its biases and analytic faults aside, the book does contain some facts and sources that I have used.

In addition to these sources, and others cited directly below, I have reviewed newspaper coverage of the Baader-Meinhof group in the English and German press, read various other journalistic accounts of the situation, as well as consulting general histories, such as J. A. S. Grenville's *A History of the World in the Twentieth Century* (Cambridge, Mass.: Harvard University Press, 1980), and specialized studies such as Sabine von Dirke's *"All Power to the Imagination!": The West German Counterculture from the Student Movement to the Greens* (University of Nebraska Press, 1997).

1. Baumann, *Wie Alles Anfing*, p. 119.

2. Aust, *Baader-Meinhof*, p. 58.

3. Anton Kaes, *From Hitler to Heimat: The Return of History as Film* (Cambridge, Mass.: Harvard University Press, 1989), p. 83.

4. In 1960 Adolf Eichmann was kidnapped by Israeli agents and brought to Jerusalem to stand trial. Eichmann's case spurred a series of arrests of his accomplices still living in Germany as well as renewed inquiries into the war records of judges and other civil servants, some of whom were forced to resign when the full truth of their past was acknowledged. One of them was among Adenauer's closest advisers, Dr. Hans Globke, who, it was revealed, had helped draft the notorious anti-Semitic Nuremberg laws promulgated by the Nazis in 1935, as well as other racist commentaries. Much press coverage accompanied these events: it was the first time since the war that the exposure and trial of war criminals made regular headlines. See Hannah Arendt's *Eichmann in Jerusalem: A Report on the Banality of Evil* (New York: Viking Press, 1963).

5. Aust, *Baader-Meinhof*, p. 25.

6. Ibid., p. 10.

7. Ibid., p. 418.

8. Baumann, *Wie Alles Anfing,* p. 66.

9. Published in 1975, banned in 1976, and then republished in 1977, Michael "Bommi" Baumann's account of his progression from "a perfectly normal person, a competent, well-adjusted apprentice" to a bomb-throwing agitator—hence his nickname—who claimed that "violence in the political realm has never been a problem for me," is the testament of a candid, subtle man, and one of the key documents of the period. Hans-Joachim Klein was another influential working-class radical. A victim of regular beatings at home, whose Jewish mother had died at Ravensbrück concentration camp, he was drawn into dissident circles after witnessing women protesters being cudgeled by the police during a demonstration. After being wounded in the 1975 attack on the OPEC ministers' Vienna Summit—an action, he says, in which he was coerced into taking part—Klein backed away from his former colleagues, and in May 1977 wrote a public letter to the liberal German news magazine *Der Spiegel*, dissociating himself from the militant Left. The letter was followed by a 1978 interview published in the Parisian daily *Libération,* in which he detailed his harrowing experiences and the reasons for his having bolted the terrorist movement. Like Baumann's memoir, Klein's insider's analysis of the inherent contradictions of urban-guerrilla strategy in the 1960s and 1970s was often denounced, but also much debated, in the radical community. It too is an essential text for understanding the pull of fanaticism, and the motives and doubts of the perfectly ordinary people who succumbed to its logic. See Bougereau, "Interview with Hans-Joachim Klein," pp. 7–61.

10. Aust, *Baader-Meinhof,* p. 44. Röhl also emphasizes the shock of Ohnesorg's death, and, like Hans-Joachim Klein, sees the attempted assassination of Rudi Dutschke as the turning point for the Left. "Whatever one may say about the later escalation of violence . . . however one may condemn the regression into a wild west epoch as senseless . . . no one who seriously aims at understanding this time and the people of this time, such as Ulrike Meinhof, can ignore that the majority of this 'robber' gang, which declared a war against the entire society, still acted out of the feeling that developed at that time [when Ohnesorg was killed] and which became more pronounced after the attack on Rudi Dutschke: the feeling one had to shoot back." Klaus Rainer Röhl, *Fünf Finger sind keine Faust: Eine Abrechnung* (Munich: Universitas Verlag, 1998), pp. 203–04.

11. Vague, *Televisionaries,* pp. 8-9. A quite different version of this text appears in *Hitler's Children,* and the variants in translation—for example, "marched" in *Televisionaries* is rendered as "shambled" *in Hitler's Children*—is indicative of the slant of the latter book.

12. Klein, *Interview,* p. 45. Klein went on to say that the urban guerillas to whom Fischer appealed "killed themselves laughing. They don't pay any attention to what the left is doing."

13. Aust, *Baader-Meinhof,* pp. 52–53.

14. According to Klaus Rainer Röhl, who helped found the student journal in 1957, *Konkret* was subsidized by the East German government and the Communist Party, despite the critical articles it sometimes published attacking the communists' reactionary cultural positions and other policies. Income from newsstand sales was enhanced when the journal began to include increasing doses of erotica, but Röhl credits Meinhof in her capacity as editor-in-chief with turning *Konkret* into a serious journal, in part by securing the participation of writers like Hans-Magnus Enzensberger. See Röhl, *Fünf Finger sind keine Faust,* pp. 119–20.

15. It is worth noting that numerous former radicals, including those who took up arms, have become integral parts of government in several countries thirty years after the crises of the 1960s. This includes not only Otto Schily and Joschka Fischer in Germany, but also Daniel Cohn-Bendit, "Danny the Red," who was one of the leaders of the national student strikes in France in 1968, and who has since distinguished himself as the representative of the Greens in the European Parliament. It also includes anti-war organizer and Chicago 7 defendant Tom Hayden, and former Black Panther Bobby Seale in the United States, and recently members of the Tupamaros, who were among the first urban guerilla groups to emerge in the 1960s. They entered the Uruguayan government in the spring of 2000. It is also important to point out that the past involvements of some of these figures have been used against them; also, in the spring of 2000, a call was made to remove parliamentary immunity from Daniel Cohn-Bendit for having allegedly concealed the whereabouts of Hans-Joachim Klein while he lived incognito in France, after breaking with the terrorist underground. The 1960s and 1970s are still very much with us.

16. Gritty and compelling cinéma verité, *Bambule* was completed before Meinhof went underground, but its planned broadcast was set aside after her part in the escape of Baader was made public.

17. Guevara was killed by Bolivian troops in 1967.

18. Although she was a member of the RAF underground for only nine months in 1970–71, Astrid Proll is an important eye-witness to the origins and internal dynamics of the Baader-Meinhof group. Like that of Michael "Bommi" Baumann and Hans-Joachim Klein, her testimony captures both the initial idealism and eventual disenchantment of an insider. "Our group was formed from a network of friendships and love relationships: everything was based on trust," she wrote. But she was also critical of the consequences of this bonding: "After Baader was arrested while trying

to procure arms, I had no doubts whatsoever that I would be part of the action to free him. This action, on May 14, 1970, was the birth of the RAF. It is strange that, as in the autumn of 1977 with the abduction of Hanns-Martin Schleyer, which was intended to obtain his release, Andreas was always the center of attraction. From that point of view the RAF was the RBF, a Free Baader Faction." Although the RAF attacked many military and civilian targets, from the outset their focus tended to be on trying to rescue each other as much or more than to pursue other political objectives. Astrid Proll, ed., *Baader-Meinhof/Pictures on the Run 67–77* (Zurich, Berlin, New York: Scalo, 1998), pp. 9–10.

19. In Aust's account, the response to the nude sunbathing of women members of the RAF drew the comment from the military commander of the camp where they trained: "This is not the tourists' beach in Beirut." Further details about tensions between the RAF and their Palestinian hosts can be found in Aust, *Baader-Meinhof,* pp. 92–99.

20. In assessing the personal and political dynamics among Baader, Ensslin, and Meinhof, I have relied primarily on the documentation in Aust's account, but Klein also provides some insider's insight into the tensions between Ensslin and Meinhof, and the latter's demoralization prior to her death. See Klein, *Interview,* pp. 52–53.

21. Both Baumann and Klein speak about the intellectually stultifying and emotionally draining effects of living clandestinely, as well as the political consequences of such isolation. See Baumann, *Wie Alles Anfing,* pp. 105–06, 108–110, and Klein, *Interview,* pp. 47, 50.

22. Klein, *Interview,* p. 49.

23. Vague, *Televisionaries,* p. 47.

24. The number of deaths and injuries suffered by all parties involved in the civil conflict in Germany in the 1960s through the late 1980s, is truly appalling. As noted, in July 1971, Petra Schelm was the first RAF member to die at the hands of police. In October 1972, Norbert Schmid was the first law officer killed by the RAF; although a security guard, Georg Linke, was badly wounded by a gunshot during Baader's escape in 1970. In February of 1972, a sixty-six-year-old boat builder was killed when a bomb planted by "Bommi" Baumann (then a leader of the June 2nd Movement) went off at the British Yacht Club in West Berlin, on February 2, 1972. The death of this innocent bystander led to Baumann's decision to cease his terrorist activities, but other actions by the J2M, and the RAF quickly added to the body count; in May of 1972, bombs killed an American Army colonel, and maimed thirteen others in Frankfurt. The attack was claimed as an act of retribution by the Petra Schelm Commando. Days later, bombs in various locations crippled the wife of a German

judge, wounded fifteen workers at a Springer publishing plant, and killed three more GIs and injured five others. RAF bombings and shootings crescendoed through the late 1970s, and continued sporadically through 1989. Meanwhile, the toll of terrorists killed or wounded in shoot-outs mounted apace, the most recent having occurred in September of 1999. The overall number of casualties cannot easily be calculated, but Hans-Peter Feldmann's book *Die Toten (The Dead) 1967–1993* contains portraits and short biographies of eighty-nine people, although some, such as the Italian publisher and terrorist Giangiacomo Feltrinelli, did not die as a direct result of events in Germany.

25. During the mid-1970s political instability in Germany grew after the resignation in 1974 of Chancellor Willy Brandt, whose close aide Gunther Guillaume had been exposed as an East German spy. SPD leader Helmut Schmidt, an able but less charismatic figure within the SPD, became chancellor upon Brandt's departure. In the meantime, economic instability increased with the onset of a deep recession bringing with it serious labor unrest, and making many people feel that the virtually uninterrupted prosperity of the postwar "economic miracle" had come to an end. The middle and latter phases of the Baader-Meinhof drama played themselves out against this doubly unsettling background.

26. Aust, *Baader-Meinhof,* p. 232.

27. The "Baader-Meinhof" laws passed in 1974 were only a part of the larger umbrella of antiterrorist legislation enacted by the government that compromised previously exercised liberties. Another such law was the Professional Ban that made it a crime for government employees to advocate antigovernment activity. Insofar as broad latitude for interpreting this law's application rested with the courts, and most teachers and professors were paid by the state, the law amounted to a loyalty oath inhibiting free speech. Under auspices of the Professional Ban, some 1,300,000 security checks were made between 1973 and 1975. Open-ended restriction on the press, a law permitting the use of German Army troops on German soil, and many police search-and-surveillance practices instituted during the 1970s created a new climate in Germany. Most of these laws and practices remain on the books or in use, despite calls for their repeal and court challenges as to their abuse.

28. Aust, *Baader-Meinhof,* pp. 262–63.

29. Klein, *Interview,* title page.

30. Aust, *Baader-Meinhof,* p. 278.

31. Ibid.

32. Aust, *Baader-Meinhof,* pp. 489; Vague, *Televisionaries,* p. 78.

33. One indication of the lynching mentality that spread in official circles as well as in some parts

of the population during the Schleyer crisis was the suggestion made by the CSU leader Franz Josef Strauss that a special court-martial should be created, and that for every hostage killed by terrorists, one of the RAF prisoners would be shot in retaliation.

34. For documentation of conflicting statements regarding suicide made by the Stammheim prisoners during the Schleyer crisis, see Aust, *Baader-Meinhof,* pp. 489–95, passim, and with regard to Ensslin's earlier suggestion of a suicide pact, see ibid., p. 277.

35. Ibid., p. 489.

36. Ibid., p. 491.

37. Ibid., pp. 525–26.

38. Ibid., p. 541.

39. The story of the RAF and allied underground groups did not come to an end with the deaths in Stammheim prison. Less than a month after the events of October 18, 1977, Ingrid Schubert, an RAF prisoner whose release had also been demanded by the Mogadishu hijackers was found hanged in her cell in Munich. Meanwhile Birgitte Mohnhaupt, an RAF prisoner set free in February 1977, assumed leadership of the organization, and for the next decade a string of arrests, jail-breaks, shoot-outs with police, robberies, bombings, kidnapping, assassinations, and attempted assassinations made news in Germany and kept the nation in a state of tension. Occasionally, former RAF members would be discovered living quietly in hiding. Thus, Astrid Proll took refuge in England after having dropped out of the group in 1971, only to be captured and extradited back to Germany in 1978. She was released from prison in 1988 after having served her term. In 1989 the Berlin Wall came down and the East German government collapsed, whereupon it was revealed that a number of RAF members were holed up in the GDR as guests of the Stasi. Several of them were arrested and brought back to West Germany for trial. In 1991, during the Gulf War, surviving members of the RAF shot up the United States Embassy in Bonn and killed a West German government official in charge of overseeing economic privatization in East Germany. It was the RAF's last major action. In April of the following year a letter arrived at the Bonn office of a French news agency announcing that the RAF was prepared to renounce violence in exchange for the release of seriously ill and long-term prisoners, and explained that with the fall of communism their raison d'être had ceased to exist. Even so, armed RAF members remained underground, and as late as September 1999, the fugitive Horst-Ludwig Meier was shot dead when he was stopped by the Vienna police.

40. Aust, *Baader-Meinhof,* p. 542.

II: THIRTY YEARS AGO TODAY

Joseph Beuys. *Dürer, I'll guide Baader + Meinhof through Dokumenta V personally (Dürer, ich führe persönlich Baader + Meinhof durch die Dokumenta V).* 1972. Two wood-fiber boards, two wood planks, paint, two carpet slippers, fat, and rose stems, 6' 8 5/16" × 6' 6¾" × 15¾" (204 × 200 × 40 cm). The Speck Collection, Cologne

I n 1968 a generation erupted. Before that there had been restlessness and angry optimism. Afterward there was retrenchment and stifled rage. It is nearly impossible to convey such a generation-defining experience to those who were not there or to others who may be indifferent to, or scornful of, the things in which so many of their contemporaries believed, or to evoke the expectancy that hung over everyone present and engaged. Likewise, it is hard to describe the letdown that followed when stagnation set in and idealism soured. The whole truth cannot be reconstructed from documents or statements made at the time. Indeed, words uttered in the flush of impro-vised history may sound absurd when lifted out of their once-urgent context. An essential element of this larger truth is preserved only in the consciousness of participants and witnesses—and occasionally in art. It is almost a sensory memory of ambient excitations, confusions, fear, anguish, and decisiveness, of compound reasons and liberating illogic, of unparalleled alertness and pent-up energy, and, finally, of an always lingering sense of imminence.

One did not have to be at the center of the power struggle to feel its spasms. Nor, wherever one happened to be, was it necessary to occupy a frontline position in an actual confrontation to be caught up in the exhilara-tion of the possibility that from one moment to the next the calcified old way might give way to the imagined new one. However, many who arrived late on the scene or stood on the sidelines assumed a premature cynicism, having

been robbed of hope before it could take root. Those who endured the greatest disillusionment and later on sometimes caused the most suffering during the drawn-out aftermath of the crisis of 1968 were the young who instinctively sensed their defeat as they first entered the fray, and, staring down the odds against them, lashed out. The Baader-Meinhof group epitomizes that response, and though for a while it may have appeared to sympathizers that they had rekindled the passions of their generation, in fact, their actions were like a flame exploding with a last combustible infusion before it went out.

The example is not unique in history. In 1848 revolutionary pressures came to a head in Austria, France, Germany, and Italy, and their repercussions were felt throughout the rest of continental Europe as well as in Scandinavia, the British Isles, and across the Atlantic in the Americas. And so too, depending on the country, was the partial or full-fledged counterrevolution that came after. The spread of socialism and the birth of communism issue from that incomplete process of fundamental social transformation, as does the rise of anarchism. From 1848 on, through the end of the nineteenth century and into the first third of the twentieth, anarchism evolved—under the influence and stresses of industrial expansion, the disfranchisement of the peasantry, sectarian infighting, and police persecution—from a pamphleteer's doctrine to episodic outbreaks of terror, from Pierre-Joseph Proudhon's and Prince Peter Alexeivich Kropotkin's theories of unalienated association to Mikhail Bakunin's defense of the Russian fanatic Sergei Nachaev and the Italian anarchist Errico Malatesta's reliance upon "the propaganda of the deed." Bakunin's apology, like Malatesta's practice, was premised on the idea that exemplary acts of violence could revive the fervor of the masses in retreat. The appeal of this solution to the veterans of the revolutions of 1848, of 1871 in France, and of 1905 in Russia, as well as of numerous other interludes of liberal reform and periodic success at radical grass-roots organizing in various countries, was that all it required was a handful of men and women with an agreed-upon aim and absolute resolve. Thus Bakunin and Nachaev wrote: "The revolutionary despises and hates present-day social morality in all its forms . . . he regards everything as moral which helps the triumph of revolution. . . . All soft and enervating feelings of friendship, relationship, love, gratitude, even honor, must be stifled in him by a cold passion for the revolutionary cause. . . . Day and night he must have one thought, one aim, merciless destruction."[1]

Terrorism of this kind differs from traditional forms of political violence such as regicide or tyrannicide in that it envisages not just the removal of a hated figurehead but the undoing of an entire system. If it picks its targets from among the elite the point is not so much to settle accounts with an individual as to disrupt the machinery of power of which that individual is a component so that a tiny minority can impress upon the majority that those who rule over them are not, after all, omnipotent.[2] Terrorist incidents inspired by this conviction are hardly exceptional in modern history. The indignation and fury they provoke is owing not only to the terrible losses they may inflict but to the way in which they destabilize ordinary life for ordinary citizens. The willingness to believe that terrorism is a total aberration is a mixture of voluntary forgetfulness in the hope of restoring a sense of security and of a simple ignorance of history. In the last century and a half terrorism has in fact been frequent and nearly universal.

70

Thus, for example, France was torn by bombs during the 1890s at the height of La Belle Epoque—it has been argued that the art critic Félix Fénéon was the author of one of the most infamous of these outrages—and again during the Algerian war (1954–62) when right-wing French officers of the Secret Army Organization (OAS) and members of the Algerian National Liberation Front (FLN) engaged in a clandestine war in Paris and Algiers. One of the most moving and chilling descriptions of the daily lives of a band of terrorists and their adversaries is to be found in the 1966 film *Battle of Algiers*. Anticolonial or irredentist causes have often compensated for their underdog status by terrorist tactics. The Irish uprising of the 1910s and 1920s, and its seemingly endless reprise since the 1970s, is another example, as is the struggle for Israel's independence from Great Britain in which the Stern gang and the Irgun—to which future Israeli prime minister Menachem Begin belonged—resorted to a strategy of surprise attacks that claimed the lives of numerous civilians and non-combatants as well as enemy soldiers.

Despite their common techniques, nation-building terrorists are of a different breed from system-destroying ones. The former sometimes opt for parliamentary government once the fight is over, the latter seldom do, in part because they are rarely victorious, but also because it is the basic forms of conventional politics against which they are pitted. In this regard, terrorism has never been an exclusive prerogative of the Left. Though it promises ideologically different remedies, the far Right has often chosen the same objectives and methods. Historically, terrorism has, thus, been pursued by the full spectrum of insurrectional movements from anarchism to fascism, from the unknown Chicago Haymarket bombers of 1886 to the 1995 Oklahoma federal building bomber Timothy McVeigh, from Malatesta to the anonymous right-wing terrorists who, in 1980, set off an explosion in the railroad station in Bologna, causing eighty-five deaths. If, as Karl von Clausewitz maintained, war is nothing but the continuation of politics by other means, then terror is the pursuit of revolutionary war by still other, unpredictable means—by any means necessary.

The purpose of these examples is not to relativize, and thereby dissolve, the crucial political distinctions that engender terrorism under different circumstances, but simply to underscore terrorism's prevalence and its ineradicable roots in the utopian or dystopian eschatologies of convulsive and definitive social transformation. Revolutionary communists and neofascists do not share the same goals, but they are prepared to do, and have done, the same things to achieve their opposing purposes. To the extent that terror is a constant of developed as well as underdeveloped societies, it is not primarily because there is such a thing as a born terrorist—an inscrutable "lone assassin" often blamed for the deaths of statesmen—but because there are so many conditions in which terrorists are made, almost all of which arise out of, or are worsened by, reigning authority's refusal to countenance reasonable reform.

Encompassing "national liberation struggles" in the Austro-Hungarian Empire and national consolidation in Germany as well as democratic reforms coupled with demands for social and economic leveling, the turmoil of 1848 seeded Europe and the Americas with revolutionaries. The crises leading up to 1968 did the same. Two conservative forces were at risk: Soviet communism and Western-style capitalism. In Poland and Czechoslovakia, 1968 marked the beginning of the end of the former, though in both places the

uprisings of that year were crushed by the Communist Party and Warsaw Pact apparatus, as the Hungarian revolt had been in 1956. In the West—which by ideological extension included Mexico and Japan—the rebellion challenged both the powers-in-place and the old Left opposition to them, especially in Italy and France, where established communist parties that had made accommodations with both the ruling elites of their own countries and with Russia—which feared a dramatic shift in Europe's Cold War equilibrium—tried to put the breaks on emerging radicalism. In France, the autocratic government of president Charles de Gaulle came within a hair's-breadth of being toppled when students, workers, cultural figures, and a significant proportion of the middle class took to the streets in May and June, bringing the country to a halt. In the end, though, the exhaustion of the strikers, the reluctance of the communists to join with socialists in forming a provisional government, adroit maneuvering by de Gaulle, and the threat of French tanks rolling into Paris from NATO bases in Germany saved the Fifth Republic.

Italy's always precarious, but somehow always flexible, parliamentary system absorbed the initial shock of mass demonstrations and riots much more readily than the rigid French system, but the split between the new Italian Left and the old deepened, and several new factions came into existence whose above-ground polemics posed a growing challenge to old-line communists and socialists, and whose underground activities would lead in

Wolf Vostell. *Benno Ohnesorg.* 1967. Synthetic polymer paint on photosensitized canvas, 39⅜ × 39⅜" (100 x 100 cm). Private collection, Kempen

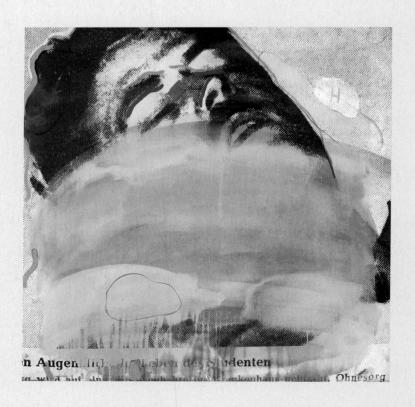

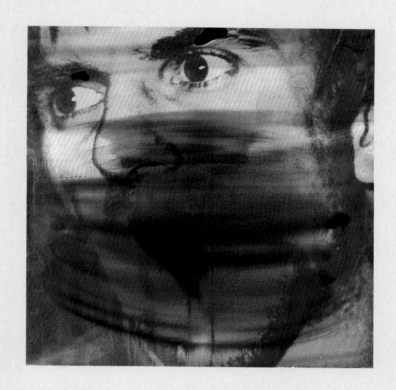

Wolf Vostell. *Dutschke.* 1968. Synthetic polymer paint on photosensitized canvas, 39¾ × 39½" (101 x 100.3 cm). Haus der Geschichte der Bundesrepublik Deutschland, Bonn

the 1970s and 1980s to a sustained campaign of knee-cappings, bombings, hostage-takings, and murders that culminated in the 1978 kidnapping of Christian Democratic prime minister Aldo Moro by members of the Red Brigade, the RAF's Italian counterparts. Suspicions that the far Right, the Mafia, and members of Moro's own party—who wished to prevent his planned and unprecedented coalition with the communists—were involved rendered the already confusing situation even murkier. After protracted negotiations for his release similar to the talks that decided the fate of Hanns-Martin Schleyer in 1977, Moro was found dead in the trunk of a car in central Rome. What students had failed to do in 1968—overthrow an administration in power—terrorists almost accomplished ten years later, but the Moro case was the last major event in the profoundly destabilizing conflicts that dominated Italian public life during the intervening decade.[3]

In 1968 Japan was shaken by demonstrations at American bases and civilian airports used by American planes in transit to the war in Vietnam, as well as by protests against Japanese institutions, and in 1969 Tokyo University was occupied by protestors, who were driven out by riot police backed up by water cannons. Out of these confrontations—in which students often marched in paramilitary formations—Japan too saw the birth of a terrorist network, the Japanese Red Army, which collaborated with some European terrorists, though not directly with the Baader-Meinhof group, and participated

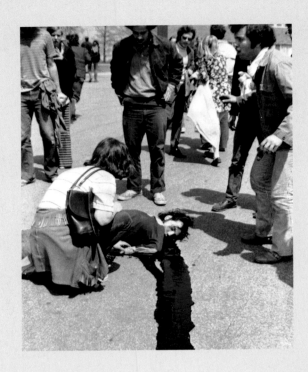

A student shot and killed by national guardsmen at an anti-war demonstration at Kent State University, Kent, Ohio, May 4, 1970

in jointly executed raids with Palestinian terrorists that were some of the bloodiest incidents of the 1970s.

And all this happened in the United States, too. 1968 was the fourth year since the Gulf of Tonkin Resolution gave president Lyndon B. Johnson the power to take "all necessary steps" to "prevent further aggression" by the North Vietnamese as well as the year that Johnson, sensing there was no way out of the fight and no way to win the upcoming election as long as the war continued, turned down the Democratic nomination for a second term. Meanwhile, the over 525,000 American troops in South Vietnam were caught off guard by the Viet Cong's offensive during the lunar New Year Tet, as some tens of thousands young men burned their drafts cards, and people of all ages flocked to antiwar rallies.

1968. This was the year the black-white coalition that had made the Civil Rights Movement possible fell to pieces, and attempts to repair it by liberal Democrats and others foundered as racial violence—particularly clashes between the police spoiling for a fight and militant black groups such as the Black Panthers—blazed out of control. Then, dooming future black-white/liberal-leftist alliances of any substantial political coherence or power, there were the assassinations of Robert F. Kennedy and Martin Luther King, Jr., whose deaths ignited fires in ghettos across the nation, which in turn brought down the heavy hand of the police and the national guard.

All the tensions of 1968 reached a climax at the Democratic National Convention in Chicago, when an army of law-enforcement officers staged a "police riot" against thousands of antiwar demonstrators who had converged on the city so that their voices would be heard by politicians inside the hotels and meeting halls. The morning after the Democratic Party regulars and the demonstrators left town, posters with the smiling face of the soon-to-be-victorious Republican candidate Richard M. Nixon appeared on the unbroken windows of downtown Chicago businesses.

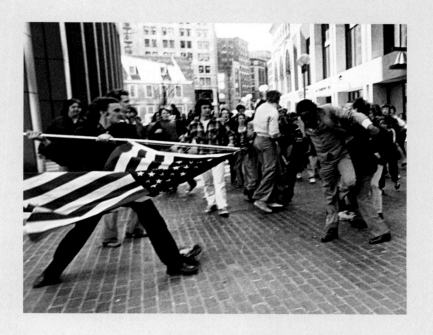

Then, in 1969, after months of internal dissension, Students for a Democratic Society (SDS), the big tent under which moderates and radicals active in the Civil Rights movement and opposed to the Vietnam War had gathered, was torn apart by bitter fights between old-line organizers hopeful of expanding the SDS base into the working class by traditional means, neo-Marxists of various types anxious to align the group with differing interpretations of revolutionary dogma, and the so-called "action faction" that coalesced around a group that gave itself the name The Weathermen, and later, The Weather Underground. Among its first acts were blowing up the statue commemorating the Haymarket bombing in Chicago, and the October Days of Rage, when militants went on a rampage through Chicago's streets looking for—and finding—a showdown with police. The Weather Underground's aim was to repay the cops for the beatings protesters had endured the year before at the Democratic convention and to show them that henceforth radicals were ready to fight back.[4]

The constitution of The Weather Underground (overwhelmingly middle and upper middle class), its reductive program ("Bring the War Home"), its romantic idea of revolution and general lack of practical or theoretical political experience, its unquestioning commitment, and its calamity-begging impatience have everything in common with the RAF, and for a period its story closely paralleled theirs. The years 1969–70 saw the massacre of innocent Vietnamese men, women, and children by American troops at My Lai; the deaths (at the hands of Chicago policemen who shot them in their beds) of Black Panthers Mark Clark and Fred Hampton, who had criticized The Weather Underground for its adventurism; the gunning down of four students by national guardsmen at Kent State University in Ohio; and the killing of two students by police at Jackson State University in Mississippi. Following the United States decision to invade Cambodia, The Weather Underground stepped up its campaign against the military's presence on college campuses,

Ted Landsmark, executive director of the Boston Contractors Association, restrained en route to a City Hall meeting by students and their parents during an antibusing demonstration, April 5, 1976

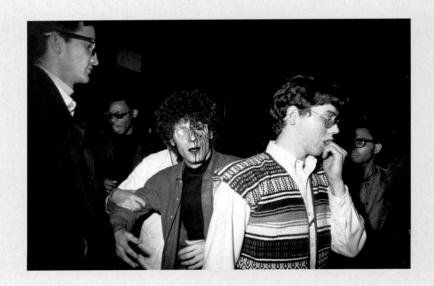

and against the judiciary responsible for cases involving radicals. This escalation of the conflict was further indicated by bombings in Long Island, New York; Madison, Wisconsin; Marin County, California; Chicago, New York City, San Francisco, Seattle, and Washington, D.C. The most dramatic explosion, however, was the one that gutted a townhouse in Manhattan, killing three "Weather people" who had been making bombs there and sending two survivors into the street. One, Katharine Boudin, was the daughter of a famous liberal lawyer; the other Cathy Wilkerson, had been raised a Quaker—that is to say a pacifist—and as a young woman had taken part in a sit-in at a segregated lunch counter in Cambridge, Maryland, at a time when nonviolent actions of that type took real courage. Like the RAF, the dominant personalities in The Weather Underground were educated, intensely committed women like Boudin, Wilkerson, and the group's Meinhof, Bernadine Dohrn.

Armed confrontations between the American government and leftwing groups—The Weather Underground, Black Panthers, American Indian Movement, Puerto Rican Liberation Front, and strangest of all, the Symbionese Liberation Army (with its hostage-turned-urban-guerilla Patty Hearst)—did not last as long as their European equivalents. But while they lasted they were intense and the cost in lives, political freedoms, and broken spirits was as high as it was on the Continent. Moreover, as in Germany, armed civil strife provoked lawmakers and law enforcers to bend, conveniently amend, or evade their own laws and step up legal and illegal surveillance of citizens.[5] By 1977, the mid-point in the RAF's history, The Weather Underground had begun to split up but the symbolic havoc they created and the conservative backlash they hastened were similar to the RAF's legacy.

The purpose of recapping and comparing the American situation to that of Germany, and the 1968 generation everywhere, is to underscore a basic fact: what the Baader-Meinhof group did and what they represented

Garry Winogrand. *Demonstration Outside Madison Square Garden, New York.* 1968. Gelatin silver print, 10¾ x 15¹⁵⁄₁₆" (27.2 x 40.4 cm). The Museum of Modern Art, New York. Purchase and gift of Barbara Schwartz in memory of Eugene M. Schwartz

Left: Accidental explosion by members of The Weather Underground at the townhouse at 18 West 11 Street, New York, March 7, 1970

Top right: The Days of Rage, Chicago, October 8–12, 1969

Bottom right: Patty Hearst, San Francisco, April 1974, surveillance-camera image

was not unique to Germany—far from it. Similarly motivated and similarly constituted clusters of young radicals emerged internationally out of the shaky, heterodox amalgam of the student Left of the 1960s, guided by the notion that the prologue of peaceful protest necessarily led to the main event of actual violent revolution. Time after time and place after place, that hypnotic, desperately simple assumption compelled dedicated and often outstandingly decent people to commit acts they previously could not have imagined for the sake of ideals they could not possibly achieve, and too often could scarcely articulate.

In recent years there has been much debate about whether or not Germany's history is in some basic way exceptional in modern times or

whether equivalents exist. Insofar as this controversy has focused on the Nazi period and the Holocaust, it seems indisputable that regardless of the absolute numbers killed by Stalin as opposed to Hitler, or any other averaging comparisons that might be made between communist atrocities and fascist ones, Hitler's version of totalitarianism and his execution of the "final solution" are unique.[6] And, to the extent that they are, that heritage necessarily and significantly qualifies anything that one might say about the similarities between what the children of "the Auschwitz generation" did and what their contemporaries in other countries may have done. But the curse of the parents is not automatically passed along to their progeny, as some commentators on the Baader-Meinhof group would have it, nor do such cultural and historical specifics overshadow the larger correspondences where they exist.[7] After all, Vietnam, which mobilized German youth, was the nightmare and shame of Americans, as was the entrenched racism that also polarized radicals, liberals, and conservatives in the United States and tarnished the nation's image abroad.

The revolt in the 1960s of the postwar generations was a worldwide phenomenon, and its paradoxes reached into every society touched by it. This was the generation that was supposed to be content with its lot and to quietly ignore the falsehood, injustice, and contradictions of the system that produced material wealth for so many in its upper and middle levels. This was the generation that grew up after the struggle between the left-wing and right-wing revolutionary movements of the 1910s, 1920s, and 1930s had burned themselves out in war, or had supposedly lost their appeal in comparison to Western-style pragmatism and democracy—the generation, so the American sociologist Daniel Bell claimed, "after ideology." But no matter how privileged they were, no matter how cut off from the historical passions and mistakes of their elders, the men and women who came of age in the late 1950s through the late 1970s were not ready to accept what was offered on the condition of thankful obedience and silence; they could not shut out the glaring truth that poverty, prejudice, war, social conformity, and intellectual taboos were integrally connected to their presumed well-being. The more authority denied these discrepancies and insisted upon the "reasonableness" of their version of reality, the more resistant young people became, and the more critically "unreasonable." Furthermore, in the face of the official pretense that the modern democratic state has no ideology but only humanist principles and practical means and solutions, ideological tendencies resurged with a vengeance. Challenging the enforced "common sense" of business-as-usual governance and the ostensible objectivity of the social sciences, while reaffirming ideology's potential for explaining the deeper complexities of economics, politics, and human consciousness, these discourses also demonstrated their capacity for distracting undisciplined minds, perverting argument, and providing true believers and demagogues with rhetorical ammunition. The cultural and historical factors influencing how this process occurred, how discontent spread, how it devolved into violence and sometimes into terror, and how order was reimposed by the superior strength of a hard new conservatism vary from country to country, but the essential dynamic was the same in Germany as it was in France, Great Britain, Italy, Japan, Latin America, Mexico, the United States, and elsewhere.

Just as revolutionary terrorism has its history and etiology, so too it has

its cultural myths. The most common expressions are stereotypes created by the media and codified in popular entertainment: the snarling sadists of the sort played by Alan Rickman in *Die Hard* and the shadowy ciphers like those in John Le Carré's thriller *The Little Drummer Girl*. *Die Hard* is reactionary pulp in the end-of-the-world mode, with its update of the nineteenth-century melodramatic villain, the black-clad dynamiter. *The Little Drummer Girl*, a morally ambiguous chase story partially based on the situation in Germany in the 1970s, takes off from the conventions established by Joseph Conrad's *The Secret Agent* and *Under Western Eyes*. Yet, whereas the Polish-born Conrad emphasized the incomprehensible foreignness of the revolutionaries he scrutinized with the attitudes of his adoptive England, Le Carré renders the Palestinian mastermind at the center of his tale with some appreciation of his motives and predicament. For both writers, however, exoticism, intrigue, and the final "poetic justice" of defeat are the essential tropes.

Conspiracy also defines the ambiance of Dostoyevsky's polemical classic *The Possessed*, in which a group of Russian terrorists—the most evil of whom is a dead ringer for Nachaev—are portrayed as corrupt, cowardly, deluded, or half-mad. All are demonic or enthralled by demons. Since the mid-nineteenth century the number of novels and stories in which bomb-throwers or assassins have appeared is vast—Henry James's *The Princess Casamassima* and Andrei Bely's *Petersburg* are two others. Other than the Le Carré, contemporary examples in English include Doris Lessing's *The Good Terrorist*, in which political extremism is reduced to the conflict between mother and daughter; Andre Brink's *An Act of Terror*, an examination of the backgrounds, motives, and evolution of multiracial activists who launch attacks on Apartheid; and Marge Piercy's *Vida*, an earnest but believable attempt at describing the life of a woman in The Weather Underground as her world shrinks and times change. Heinrich Böll's *The Lost Honor of Katharina Blum* chronicles the case of an innocent apolitical woman who, after a one-night stand with a political fugitive she meets at a party, is mercilessly harassed by the police and the press and finally murders one of her tormentors. A parable of Germany under "emergency laws" and during the tabloid frenzy that accompanied the pursuit of the RAF, Böll's novel is less about the ideological conversion to violence than the way in which ordinary people may be goaded into it by the abuse of power. But whether evil incarnate from central casting, or a carefully rendered invention by a serious writer, by and large the fictional terrorist is an aberration, the extreme political "other" made so by psychological predilection rather than an imaginable version of anyone we might know, anyone who by incremental steps or genuine trauma evolved into the mortal enemy of the things we may take for granted, much less anyone who, despite his or her actions or obsessions, retains a basic humanity.[8]

Experimental or independent film and video have responded more subtly to political realities than fiction. There is neither time nor space to review the recent history of even the major contributions in these media, but it is important to note that a growing number of works have been devoted to the Baader-Meinhof group, some while events were still unfolding, some long after them. Of the latter, two by Americans stand out, Dara Birnbaum's video installation *Hostage* (1994), in which six monitors—separated by six firing-range targets of a head and torso and connected by a red laser targetting

light that traverses them—show a montage of images of Schleyer's kidnapping, police training exercises, TV news footage of the RAF, and coverage of the Stammheim prisoners. The other, *Outtake* (1998) by Dennis Adams, is the slow-motion recreation of a scene from Meinhof's film *Bambule*, in which a young woman flees the nuns who persecute her in a home for wayward girls, but after a series of twists and turns is trapped in a cul-de-sac. Adams rephotographed this helpless bid for freedom as a suite of individual frames from the film that he blew up into palm-sized prints and doled out to passersby on the streets of Berlin as if he were distributing leaflets. Each of these prints passes before his video camera lens in an agonizingly protracted replay of the scene before being handed over to a recipient who, by accepting it, is unsuspectingly drawn into the piecemeal reenactment of the drama and into the historical problematics of the Baader-Meinhof story.

Besides television reportage and docudramas like *Das Todesspiel (Death Play)* (1997), several German filmmakers have also tackled the subject of the RAF in a serious fashion. Margarethe von Trotta's *Marianne & Juliane* (1981) tells the story of two sisters, one a leftist journalist, the other a revolutionary who dies mysteriously in prison, and of the surviving sister's struggle to come to terms with the latter's death and to reach out to her nephew for whom she cares and who has been traumatized by his mother's choices and her fate. Like the movie version of Böll's *The Lost Honor of Katharina Blum* (1975), which von Trotta also wrote and directed (the former in collaboration with Volker Schlöndorff), *Marianne & Juliane*, which fuses the characters of Meinhof and Ensslin in the part played by the activist sister, is a reserved naturalistic treatment of the subject, which poses the unanswered question of how the rebellious children of the children of the "Auschwitz generation" will be able to make sense of their past. Rainer Werner Fassbinder—who belonged to the

Yvonne Rainer. *Journeys from Berlin/1971.* 1980. 16mm film, color and black and white, sound, 125 minutes. The Museum of Modern Art, New York. Circulating Film and Video Library

80

same milieu from which the RAF arose and who knew Baader as a figure on the Berlin scene of the late 1960s—dealt with the RAF twice, first in his segment of *Germany in Autumn* (1977–78), a collaborative project also involving Böll, Alexander Kluge, Edgard Reitz, and Volker Schlöndorff, among others, and second, in *The Third Generation* (1979). Fassbinder spares no one in either film: not the "third generation" of terrorists, by which he means the RAF members and others who came after Baader and Meinhof, and who, he felt, lacking even their confused political motives, had transformed the urban guerilla ethos into an excuse for thrill crime; not his mother, who in *Germany in Autumn*, portrays a woman who, having lived through National Socialism, counsels her son to accept the benign dictatorship of the state rather than side with those who make war on it; and not himself playing the son, argues for liberty yet bullies his male working-class lover. Even more so than the moving but prosaic films of von Trotta, the richness of Fassbinder's ironies brings home the private dilemmas and self-betrayals Germans faced in the midst of this very public crisis.

The most intellectually and psychologically complex film to center on the Baader-Meinhof group, Yvonne Rainer's *Journeys from Berlin/1971* (1980) also concentrates on the interpenetration of private and public realities. Mixing elliptical dialogues and monologues that speak of nostalgia for a pre-1933 Berlin that has disappeared forever, of suicidal depression, and of the misuses of psychiatry to deflect social criticism, the script, also punctuated by news bulletins detailing the RAF's actions and the government's reactions, is a meditation on terrorism as a quest for individual self-determination. Studded with excerpts from the memoirs of early twentieth-century anarchists Vera Zasulich, Angela Balabanoff, and Alexander Berkman, the would-be assassin of robber baron Henry Clay Frick, as well as statements by and about Meinhof, Rainer's scenario draws the connection between these two historical moments, and focuses on the promise of existential freedom held out by the categorical rejection of all external authority. Weaving strands that subtly bind elusive personal motivations to irrevocable political choices, Rainer's film is among the only works we have that renders palpable the moral and emotional pain out of which terrorism is born.

As with film and video, it is impossible to summarize all the visual art—painting, sculpture, drawing, photography, photomontage, prints, and multimedium works—made in response to the events of the 1960s and 1970s, but it is worthwhile making certain observations.[9] The first concerns the fact that for many if not most of the leading American painters of the 1960s and 1970s, political concerns were largely incidental to their principal aesthetic interests. This, of course is not true of Leon Golub, Philip Guston, Nancy Spero, and a number of others, but it is generally true of the major Pop artists, Minimalists, Process artists, and even most of the Conceptualists who made "things." James Rosenquist's *F-111* (1965) is undeniably a Cold War picture, but unrest in America was rarely the theme of "mainstream" art during the country's moments of greatest dissension in the 1960s and 1970s. Exceptions are the agitprop posters conceived by the Art Workers' Coalition, whose members included the painters Irving Petlin and Rudolf Baranik along with Conceptualists Mel Bochner and Carl Andre; posters made by Jasper Johns and Frank Stella for the anti-Vietnam War mobilization; and one-off protest works such as Barnett Newman's *Lace Curtain for Mayor Daley*,

named for the Chicago machine boss who oversaw the mayhem at the 1968 Democratic convention.

Besides Rosenquist's magnum opus and the fragmentary social content of his other paintings and graphics, partial exceptions also include Robert Rauschenberg's references to the war and domestic turmoil, especially in prints and drawings based on direct newsprint transfers, for example the phalanx of riot police in *Canto XXI: Circle Eight, Bolgia 5, The Grafters: Illustration for Dante's Inferno* (1959–60). Indeed, just as in Rosenquist's work, political symbols and subjects are scattered throughout Rauschenberg's—symbols like the Bald Eagle, portraits of Eisenhower and Kennedy, military vehicles, Huey-helicopters, GIs, and so on—but it is this scattering that counts as much or more than the particular images. With a Cageian randomness, each of them is experienced on roughly equal terms with its incommensurable neighbors, a postcard landscape, printed text, or the hazy reproduction of an old master painting. The suave contrast and elision of shapes, textures, and colors, and the dizzying glide through shifting mental gears, is greater than any clash of social realities.

Using similar silkscreen and transfer techniques, Andy Warhol also incorporated news photography into his art but to jarring as well as distancing effect. In all of their permutations Warhol's Race Riot paintings and prints freeze the violence in a form that highlights the naked hostilities behind it. These are not paintings about the morality of hatred or remedies for it; they are

Robert Rauschenberg. *Canto XXI: Circle Eight, Bolgia 5, The Grafters: Illustration for Dante's Inferno.* 1959–60. Transfer drawing, gouache, cut-and-pasted paper, pencil, color pencil, and wash on paper, 14⅜ × 11½" (36.5 × 29.2 cm). The Museum of Modern Art, New York. Given anonymously

Andy Warhol. *Mustard Race Riot.* 1963. Silkscreen ink on synthetic polymer paint on canvas, two panels (one shown), each 9' 6" × 6' 10" (289.6 × 208.3 cm). Collection Barbara and Richard S. Lane

paintings about the fact of it, but a fact seen at one remove as if one were watching a disaster happen from inside a bubble, now rose-colored, now jaundiced yellow. In that respect, they are akin to Warhol's other disaster paintings which say no more or less than that disasters *do* happen and death invariably eclipses life, just as the kodalithed darks eclipse the glaring lights that composed Warhol's wafer-thin shapes. Meanwhile, if death is the great leveler, striking electric-chair-bound thugs, joy-riding teenagers, unhappy debutantes, unlucky housewives, and all the anonymous people that haunt his pictures, death also burnishes the glamour of the famous: Marilyn, of course, and Jackie too. Their emblematic faces created the template for others whose status varies from the notorious but long forgotten to the notable and unforgettable. Thus Warhol enshrined The Thirteen Most Wanted Men on the exterior of a pavilion at the 1964 World's Fair, and, at the other extreme, he turned China's Chairman Mao into a Pop icon.[10]

Warhol's direct appropriations from the police blotter and media sources set in train paradigm shifts in aesthetic discourse and studio practice

of which Richter's October cycle is, unmistakably, an extension. But there are differences to be taken into consideration that pertain not only to painterly process and intent, but to context as well. When Warhol first made Mao a superstar in 1973, following Nixon's decision to play the "China card" and smiled on America's bogeyman, the Cultural Revolution that had created Mao's cult of personality was over. The mania for Mao's little red book that swept China between 1966 and 1968, and touched down in Europe on its way around the world, passed lightly over America, making only a superficial impression in the political and cultural domains.[11] In France, however, the Cultural Revolution left a definite mark in both arenas— the role of Maoist "groupuscules" and Sartre's support of the banned Maoist paper *La Cause du peuple* represent the first; Jean-Luc Godard's ambivalent film *La Chinoise*, in which apartment-bound Parisians dream of peasant revolution and shoot a member of the bourgeoisie whom they mistake for a Soviet diplomat, after which they assassinate the originally targetted representative of "revisionist" Russian communism, represents the second.

In Germany Maoism also had an impact on both the political and artistic avant-gardes that reached into the 1970s. Thus Eugen Schönebeck, who had begun painting in an expressionist style influenced by the Northern Renaissance masters and Francis Bacon that was close in form and feel to the contemporaneous allegorical work of Georg Baselitz, ended up painting the likenesses of paragons of Marxist virtue—from the Russian poet Vladimir Mayakovsky and the Mexican muralist David Alfaro Siqueiros to Lenin and Mao—before giving up painting altogether in 1966 at the onset of the troubles in Germany.[12] Jörg Immendorff, once the impish protégé of his Düsseldorf Art Academy professor Joseph Beuys, responded to the abrupt politicization of art in the late 1960s by joining a Marxist collective in the early 1970s (to which he tried to subordinate his art), and painting his own placardlike images of workers, students, the pantheon of Communist leaders, Marx, Engels, Lenin, Stalin, Mao, and a rainbow coalition of cartoony Mao-inspired babies. In short, there were accomplished artists for whom the prospect of adopting a hero-worshipping or party-line aesthetic was not a laughing matter.

Of the artists who raised the red banner in their work, Immendorff was not only the liveliest painter but the most critical, and his later 1985 canvas, *Worshipping Content*, of a middle-aged artist on his knees in front of his portrait of the ever-radiant Mao, is retrospectively skeptical and self-mocking. Sigmar Polke's *Mao* (1972) is also satirical, but the joke is closer to Warhol's whimsical but acidic burlesque than to Immendorff's broad but still politically focused caricature. Significantly, Polke, like Richter, had left communist East Germany for the West not long before the Wall went up, and neither was tempted by new Left versions of the old Left tenets of faith, whereas Immendorff, who came from the West, tried, like Dada artists George Grosz and John Heartfield before him, to adapt his anarchic sensibility to the strictures of social realism as the necessary next step in his avant-garde rejection of bourgeois art-for-art's-sake. Nevertheless, Polke's rendition of Mao, like Richter's, arose from a context where Mao's myth held genuine sway. Richter's out-of-focus print of Mao occupies a special place at arm's length both from the paintings of his German counterparts and from Warhol. Conceived as a large unsigned edition, the slightly off-key gray 1968 lithograph has a ghostly quality to it, as if the Great Helmsman were watching

Gerhard Richter. *Mao.* 1968. Collotype, printed in gray, 33 × 23⅜" (83.9 × 59.4 cm). The Museum of Modern Art, New York. Jeanne C. Thayer Fund

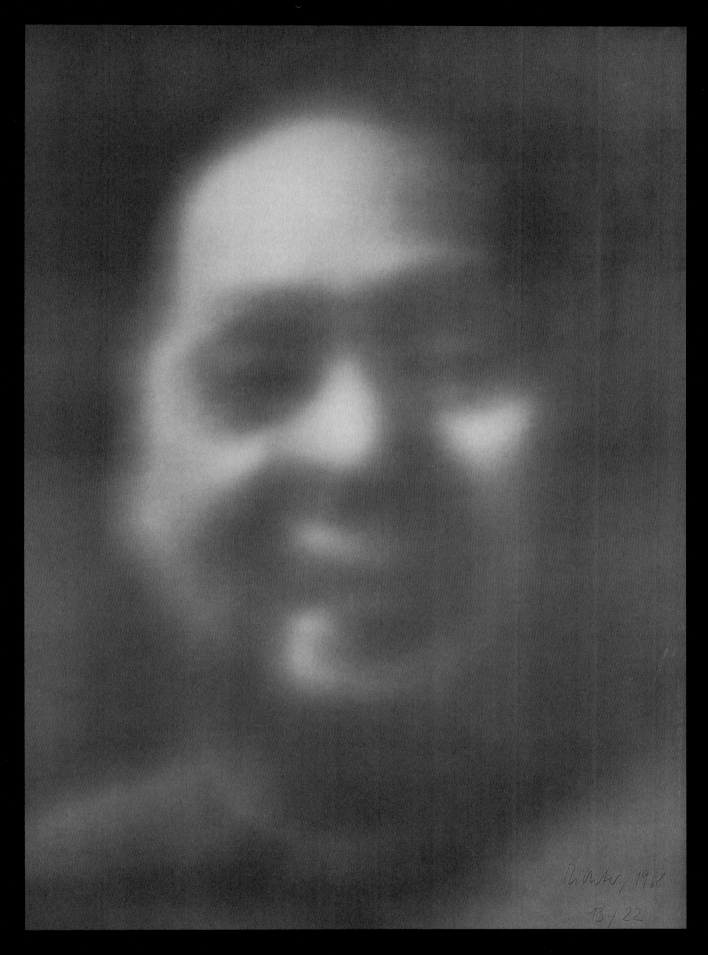

from the shadows or behind a screen, or hovering over all like an intangible but threatening nimbus. Having grown up under two dictatorships, Richter had no illusions about what it takes to be a maximum leader, and this picture correspondingly assumes that Mao is more than a figure of fun, but instead is what Mao saw himself to be, the incarnation of a revolutionary idea.

Numerous other German artists have touched on the political crisis of the late 1960s in their work. In addition to making multimedium tableaus with apocalyptic overtones, Wolf Vostell dedicated one work each to Benno Ohnesorg and Rudi Dutschke; the Conceptual artist and publisher Klaus Staeck created a series of text- and photo-based posters and postcards that recall the agitprop montages of Heartfield. Of those who preceded Richter in addressing the Baader-Meinhof group, two in particular stand out. Beuys, the German vanguard's man-for-all-seasons was the first. During the course of his one hundred days of dialogue for "direct democracy" at Documenta 5 in 1972, Beuys announced to his principal interlocutor Thomas Peiter—who rechristened himself Albrecht Dürer for the occasion—"Dürer, I will guide Baader and Meinhof through Documenta 5, and thus they will be resocial-ized." Peiter/Dürer then lettered the statement—minus its didactic second half—onto two pieces of poster board with Beuys's signature, and Beuys later planted them in two felt slippers filled with fat and rose stems, thus trans-forming the signs into totems.

The felt, fat, and rose stems were Beuys's talismen of healing and spiri-tual flowering, and the whole gesture was in keeping with his efforts to sym-bolically repair a damaged postwar German society. At the time the peace

Andy Warhol. *Mao.* 1972. Serigraph, printed in color, comp.: 35¹⁵⁄₁₆ × 35¹⁵⁄₁₆" (91.4 × 91.4 cm). The Museum of Modern Art, New York. Gift of Peter M. Brant

Opposite: **Sigmar Polke.** *Mao.* 1972. Synthetic polymer paint on cloth on cotton fabric, suspended from wood pole, 12' 3¹⁄₁₆" × 10' 3⅝" (373.5 × 314 cm). The Museum of Modern Art, New York. Kay Sage Tanguy Fund

statement was made, Baader and Meinhof were both still at large, and Beuys's invitation, in addition to calling for them to come back in from the cold, was an appeal to their followers and supporters to return to the fold rather than pursue revolution outside of the broad counterculture front in which Beuys saw himself as one of the father figures. It was thus not out of sympathy with the RAF that Beuys issued his plea, but, rather, out of a desire to recuperate the most alienated elements of the Left and redirect their energies toward his vision of a new society dedicated to the imagination and miraculously poised between communism and capitalism. Improbably, Beuys hoped to dissolve the antagonisms of Cold War era Germany and the violent tendencies they had nurtured in the amniotic fluid of his own poetic and philosophical transcendentalism, offering an ideology of unfettered creativity as the alternative to the ideology of destruction.

Polke, Richter's comrade in the creation of the short-lived German Pop art movement, Capitalist Realism, was the second of the two artists to address the theme; his painting, made in 1978, a year after the Stammheim deaths, featured the cartoon image of a desk-jockey shooting himself in the head with a slingshot under the wanted-poster portraits of Baader and Raspe. The subtitle of the picture and presumably the name of the bureaucrat

Eugen Schönebeck. *Mao Tse-Tung.* 1965. Oil on canvas, 7' 2⅝ × 70⅞" (220 × 180 cm). Collection Frieder Burda

Opposite, top: **Jörg Immendorff.** Untitled (*Träume führen nicht zum Ziel*). 1972. Synthetic polymer paint on canvas, 35⅞₁₆ × 31½" (90 × 80 cm). Courtesy Michael Werner Gallery, New York and Cologne

Opposite, bottom: **Jörg Immendorff.** *Worshipping Content (Anbetung des Inhalts).* 1985. Oil on canvas, 9' 4³⁄₁₆" × 10' 9¹⁵⁄₁₆" (285 × 330 cm). Collection John and Mary Pappajohn, Des Moines, Iowa

Träume führen nicht zum Ziel

Aktiv die Kräfte unterstützen, die die Beseitigung der Ausbeutung und Unterdrückung und den Aufbau des Sozialismus zum Ziel haben — auf Grundlage der totalen Entlarvung des kapitalistischen Systems! Soll die künstlerische Arbeit dem Fortschritt dienen, muß sie dies zum Inhalt haben.

is "Dr. Bonn," after the capital of the Federal Republic. Characteristically irreverent, Polke's painting ridicules the faceless policy-makers who "managed" the Baader-Meinhof affair, suggesting that whatever may have happened to the Stammheim prisoners, it was the government that committed suicide in the crisis.

Richter was to wait another decade before approaching the subject himself. When he finally did, its immediate topicality had already begun to fade; there was no longer hope of saving the extreme Left from itself and its implacable adversaries, as Beuys had proposed by his gesture, nor was there any further point in attacking the authorities, as Polke had done so effectively. Radicalism had run its course, and the conservatism of Helmut Kohl, Ronald Reagan, and Margaret Thatcher was still ascendant. Lost or won, the battles of the 1960s and 1970s were over. The world had changed; and a different understanding was now needed.

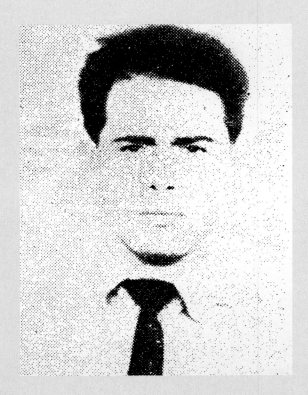

Opposite: **Andy Warhol.** *Most Wanted Men No. 13,*
Joseph F. 1963. Silkscreen ink on canvas, two panels, each
48 × 40" (122 × 101.5 cm). The Sonnabend Collection,
New York

Sigmar Polke. Untitled (*Dr. Bonn*). 1978. Synthetic
polymer paint on fabric, 51³⁄₁₆ × 51³⁄₈" (130 x 130.5 cm).
Groninger Museum, Groningen

NOTES

1. Quoted in James Joll, *The Anarchists* (London: Eyre & Spottiswoode, 1964), p. 95.

2. The 1966 assassination of Dr. Hendrik Voerster, the prime minister of South Africa and one of the principal architects of Apartheid, by Demetrios Tsafendas, a man of mixed racial heritage who stabbed Voerster to death on the floor of the Parliament, is one of the surprisingly rare examples of modern tyrannicide.

3. The activities of the Italian Red Brigades had many parallels and some overlaps with those of the Red Army Faction in Germany, but the reactions of the Italian and German governments were quite different, in particular, as regards the trials, which in the case of those charged with the kidnapping and murder in Italy lasted even longer than that of the Baader-Meinhof group. But this did not involve extreme prison conditions, emergency abridgement of the rights of lawyers or defendants, or the widespread suspension of civil liberties. Furthermore, in keeping with Italian legal traditions, defendants who "repented" of their actions or otherwise testified in ways that helped the courts solve the crime were shown considerable leniency, and even those who adamantly refused to concede the charges or recant their political beliefs were treated with a measure of respect. The result was that while the Italian Red Brigades came far closer to overthrowing the government in Rome than the RAF came to destabilizing the one in Bonn, those directly involved with or generally sympathetic with the Red Brigades have been in many instances reintegrated into the fabric of Italian political life to a much greater degree than have the survivors of the RAF and their sympathizers. This said, the Italian system of justice was in a number of respects prejudiced against defendants when insufficient evidence of their guilt was presented. For a detailed account of the principal trials of the Red Brigades, see Richard Drake, *The Aldo Moro Murder Case* (Cambridge, Mass.: Harvard University Press, 1995). A view similar to the author's is taken by Arnulf Baring, a German historian quoted in Benjamin H. D. Buchloh, "A Note on Gerhard Richter's *October 18, 1977*," *October* 48 (spring 1989), p. 105. See also Carlo Ginzburg, *The Judge and the Historian: Marginal Notes on a Late Twentieth Century Miscarriage of Justice* (New York: Verso, 1999), p. 192.

4. For detailed discussions of the formation and activities of The Weather Underground, see Kirkpatrick Sale, *SDS* (New York: Vintage Books, 1974); Todd Gitlin, *The Sixties: Years of Hope, Days of Rage* (New York: Bantam Books, 1987); and *The Way the Wind Blew: A History of the Weather Underground* (London and New York: Verso, 1997).

5. In the United States, infringement of the constitutional rights of dissenters in regional courts, unlawful police searches and surveillance by police "Red Squads," as well as the use of agent provocateurs were not at all uncommon during the 1960s and 1970s, but for much of that period such abuses were the work of local or state authorities. At the Federal level the FBI campaign against "subversives" was of long-standing, but in 1968 the institution of the Nixon administration's COINTELPRO (Counter Intelligence Program), under the auspices of the FBI with linkages to the CIA and other intelligence services, carried government surveillance of and secret interference with dissenters to a new level and was the rough equivalent of the sort of tactics employed in Germany at the same point in time.

6. At the center of the recent debates over the uniqueness of the Nazi period, or over its similarity to other totalitarian episodes in history, have stood two scholars: the historian Ernst Nolte, who has taken the view that fascism has multiple faces and fascist terror many essentially comparable perpetrators; and the philosopher Jürgen Habermas, who has rejected this revisionist thesis as a form of politically motivated exculpation by specious analogy.

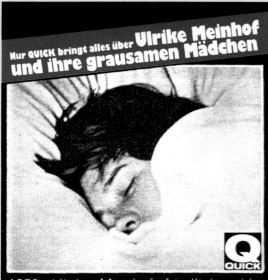

Klaus Staeck. *Quick.* 1972. Photolithograph, offset, 23¼ × 33¹⁄₁₆" (59 × 84 cm). Poster, edition of 1,000. Edition Klaus Staeck

7. Jillian Becker, *Hitler's Children: The Story of the Baader-Meinhof Terrorist Gang* (New York: Lippincott, 1977) is the most egregious example of this simplistic correlation of the Nazi past and present.

8. In addition to these fictional works, a raft of books on terrorism appeared from the mid-1970s onward, and their tone and frequency map the political mood in the countries where they were published like a fever chart. Some, such as Benjamin Netanyahu, ed., *Terrorism: How the West Can Win* (New York: Farrar/Straus/Giroux, 1986), review policy choices from a fixed political perspective rather than question those political assumptions in the light of terrorism, while others, like Claire Sterling, *The Terrorist Network: The Secret War of International Terrorism* (New York: Holt Reinhart & Winston, 1981), are blatantly sensationalist and factually unreliable. Both are documents of the Cold War in that they take every opportunity to emphasize the involvement of Soviet and Eastern European communists—which was real enough in some situations but virtually irrelevant in others—at the expense of inquiring into local or regional factors that were far more important, as do many of the academic works published in the United States during the period.

9. Over the years the Baader-Meinhof group has gradually entered into the popular culture. A recently published compendium of interviews from the trend-setting British magazine *Dazed and Confused* not only featured an interview with Astrid Proll about her involvement but a photo spread juxtaposing an image of Meinhof under arrest and the filmmaker Harmony Korine. See Mark Sanders and Jefferson Hack, *Star Cultures* (London: Phaidon Press, 2000), pp. 232–33, 283–87. Already in 1979 the singer and ex-addict Marianne Faithful had written a song, "Broken English," with Ulrike Meinhof in mind. "I indentified with [Meinhof]. The same blocked emotions that turn people into junkies turn other people into terrorists. It's the same rage." (Marianne Faithful with David Dalton, *Faithful: An Autobiography*, New York: Cooper Square Press, 1994, p. 234). For discussion of "Broken English" see Greil Marcus, *Double Trouble* (New York: Henry Holt and Co., 2000), pp. 87–90.

10. Jim Dine and Roy Lichtenstein also made Pop versions of Mao—both in print mediums—but Mao was never the icon for them that he was for Warhol.

11. In the United States there were several groups with strong Maoist leanings, most notably the Progressive Labor Party, a faction of SDS which played an instrumental role in the splits within that organization that in 1969 produced The Weather Underground. But outside of the organized student Left these groups had no impact, nor did they benefit from or create anything like the vogue for Maoist slogans and Red Army style and mystique that was prevalent in Europe outside the committed left.

12. Like Richter, Schönebeck came from Dresden and his turn to a Pop-influenced Socialist Realism is interesting precisely because it would seem to have been motivated by a desire to resuscitate the themes and formats of conservative East German painting within a more sophisticated painterly manner; however, the artist has kept silent about his intentions as well as about his reasons for abandoning his art after 1966. In the same context, it is also noteworthy that A. R. Penck (born Ralf Winkler) returned to East Germany from the West after the Wall went up, convinced, it appears, that his future and the future of socialism to which he was committed lay there. Although his artistic ambitions and accomplishments were largely ignored by the East German cultural establishment, it was nineteen years before he crossed back over to the West.

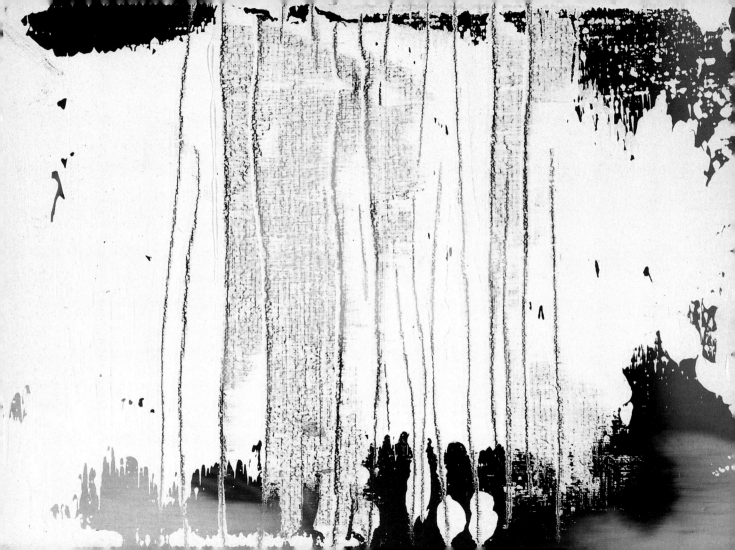

III: THE PAINTINGS

I don't mistrust reality, of which I know next to nothing. I mistrust the picture of reality conveyed to us by our senses, which is imperfect and circumscribed.

Gerhard Richter[1]

Gerhard Richter embarked on the paintings that would eventually constitute the series *October 18, 1977* in March 1988, and completed work on them in November of the same year. Looking back on his nine-month labor in notes for a press conference at Haus Esters where the series was to be shown, Richter took stock: "December 7, 1988. What have I painted? Three times Baader shot. Three times Ensslin hanged. Three times the head of the dead Meinhof after they cut her down. Once the dead Meins. Three times Ensslin, neutral (almost like pop stars). Then a big, unspecific burial—a cell dominated by a bookcase—a silent, gray record player—a youthful portrait of Meinhof, sentimental in a bourgeois way— twice the arrest of Meins, forced to surrender to the clenched power of the State. All the pictures are dull, gray, mostly very blurred, diffuse. Their presence is the horror of the hard-to-bear refusal to answer, to explain, to give an opinion. I am not so sure whether the pictures ask anything: they provoke contradictions through their hopelessness and desolation; their lack of partisanship. Ever since I have been able to think, I have known that every rule and opinion—insofar as either is ideologically motivated—is false, a hindrance, a menace, or a crime."[2]

Richter's comments are revealing on several counts. Most obvious is the mention of canvases that were not included in the cycle when it was exhibited. Of the three versions of Baader shot, only two remained in the final

Gerhard Richter. *Abstract Painting (Abstraktes Bild).* 1988. Oil on canvas, $10^5/_8 \times 13^3/_4$" (27 × 35 cm). Private collection

grouping; of the three versions of Ensslin hanged, only one was used. The painting of the starved Meins on his deathbed was left out altogether, and eventually overpainted, as were at least one and probably both of the excluded paintings of the dead Ensslin.[3] One of the two Ensslin paintings can be partially seen in a photograph of the artist's studio; the composition of the Meins painting can be deduced from a photograph in the album of images the artist kept for reference, and bits of the composition can be glimpsed in the margins of the gestural painting that replaced it. Thus, beneath the surface of three abstractions lie layers that are not "underpainting" in the traditional sense but the intact archaeological sediment of deliberately obscured pictures. Their cancellation is a part of the meaning of the finished abstract work insofar as finding new ways to make images visible—or invisible—is at the heart of Richter's enterprise. In that respect these painterly outtakes constitute an appendix to *October 18,1977*, in a way similar to the frames of a movie that fall to the floor of a film editor's cutting room, frames that may in themselves be of great interest or beauty but that detract rather than add to the integrity of the realized whole.

Also revealing are Richter's descriptions of key paintings in the final selection. The three canvases of Ensslin that it seems had yet to be titled *Confrontation 1, Confrontation 2*, and *Confrontation 3* strike him as "neutral (almost like pop stars)," as if, cleansed by the camera's detachment and the painter's apparent dispassion, almost nothing of the tension that must have filled the air clung to the unguarded, then smiling face of Ensslin as she looked into the flashbulbs that made her famous. Richter emphasizes this neutrality elsewhere by speaking of the pictures as "dull, gray, mostly blurred, diffuse" and underscores "their hopelessness and desolation; their lack of partisanship." Two remarks break this muted tone. First is his characterization of Meins being "forced to surrender to the clenched power of the state." Second is his concluding paragraph condemning "every rule and opinion" that is "ideologically motivated" as "false, a hindrance, a menace, or a crime." Embedded in the paintings' "refusal to answer, to explain, to give an opinion," and underlying the despair that seems evenly spread across them, there is anger.

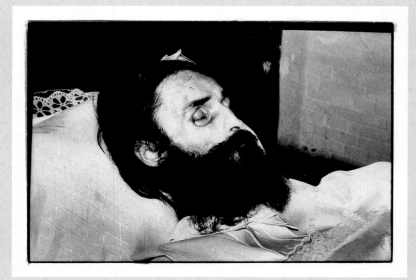

Holger Meins, dead, after a hunger strike, November 1974, from the artist's notebook

What prompted Richter to paint this particular subject at this particular time? Preparing for his press conference the artist left that question aside, and it is one he has never fully answered when it has been posed to him. But what do we know? Published journals tell us that in the years leading up to the creation of *October 18, 1977,* Richter was wracked by aesthetic and moral doubts exacerbated by his mounting distaste for the hyped-up art world of the 1980s. A January 13, 1988, diary entry written on the eve of Richter's beginning the cycle voices his bitter discontent: "Art is wretched, cynical, stupid, helpless, confusing—a mirror-image of our own spiritual impoverishment, our state of forsakenness and loss. We have lost the great ideas, the Utopias, we have lost all faith, everything that creates meaning. Incapable of faith, hopeless to the utmost degree, we roam across a toxic waste dump in extreme peril: every one of those incomprehensible shards, these odds and ends of junk and detritus, menaces us, constantly hurts and maims us and sooner or later, inevitably kills us. Worse than insanity."[4]

Sitting alone at the center of an art world sharply divided between neo-Expressionist painting and neo-Conceptualist work in various mediums, and impatient with art of both varieties that exploited cleverness, stylistic novelty, or provocative subject matter for easy effect, Richter replayed the classic arguments of the relation between form and content in his head. On March 18, 1986, he had addressed the deficiencies of pure formalism, but affirmed that form could engender meaning rather than merely being instrumental in the presentation of preconceived ideas: "Formalism stands for something negative: contrived stuff, games played with color, form, empty aesthetics. When I say that I take form as my starting point, and that I would like content to arise out of form (and not the reverse, whereby a form is found to fit a literary idea), then this reflects my conviction that form, the cohesion of formal elements . . . generates a content—and that I can manipulate the outward appearances as it comes, in such a way as to yield this or that content. . . . The issue of content is thus nonsense: i.e., there is nothing *but* form." [5]

On October 12, 1986, Richter seemed to reverse his position in favor of the primacy of subject matter, but then took a half-turn back in disparaging journeymen painters who rely on signature "concerns" to validate their work: "What shall I paint? How shall I paint? 'What' is the hardest thing because it is the essence. 'How' is easy by comparison. To start off with the 'how' is frivolous, but legitimate. . . . The intention: to invent nothing—no idea, no composition, no object, no form—and to receive everything: composition, object, form, idea, picture. . . . Even in my youth, when I somewhat naively had 'themes' (landscapes, self-portraits), I very soon became aware of this problem of having no subject. . . . The question 'What shall I paint?' showed me my own helplessness, and I envied (still do envy) the most mediocre painters those 'concerns' of theirs, which they so tenaciously and mediocrely depict (I fundamentally despise them for it.)."[6]

The ambivalence of these remarks recalls the fact that as a young man Richter had studied at the Dresden Art Academy in East Germany, where officially sanctioned content overruled formal invention, and, while there had executed two public commissions with allegorical programs in a modified but still conventionally heroic Socialist Realist style.[7] One is also reminded that as a relatively recent arrival in West Germany, Richter, who had previously worked

for awhile as a photographer's assistant, chose "found" photography as a source for images because it allowed him to downplay modernist formal innovation while exploring many different subjects with an apparently Dada arbitrariness consonant with the avant-garde spirit of Düsseldorf and Cologne, the new centers of his artistic life. Remembering this later he said: "Do you know what was great? Finding out that a stupid ridiculous thing like copying a postcard could lead to a picture. And then the freedom to paint whatever you felt like. Stags, aircraft, kings, secretaries. Not having to invent anything any more, forgetting everything you meant by painting—color, composition, space—all the things you previously knew and thought. Suddenly none of this was a prior necessity for art."[8]

However, Richter was not a neo-Dada artist. As far back as 1964 he was clear in his mind that "for me there really exists a hierarchy of pictorial themes. A *mangel-wurzel* and a Madonna are not of equal value, even as art objects."[9] Explicitly contradicting a basic tenet of post-Duchampian art for which an at least polemical equivalency exists between ironing boards and Mona Lisas—turnips and Madonnas—Richter was already staking out a conservative territory within the aesthetically radical community of the Rhineland. This leads us to the third dialectical term in his debates with himself prior to painting *October 18, 1977*: ideology.

Richter's hostility toward ideology is the leitmotif of his interviews, statements, and studio jottings, particularly in the mid to late 1980s, just as it is the coda of his press-conference notes of 1988. Some of his vehemence derives from his experience of National Socialism and Soviet-style communism, and some is a reaction to varieties of extremism he encountered in the West. There are, of course, those who, never having subscribed to any consistent religious, philosophical, or political system of beliefs, uncomprehendingly look askance at anyone who does or has done so. And there are others who having once willingly submitted to orthodoxy and then lost faith, dedicate themselves to renouncing "the God that failed," thereby extending their dependence on their former beliefs.[10] Richter fits neither category. Thirteen years of living under Nazi rule and sixteen years living under Communist Party discipline had inoculated him against totalizing ideology. But, having been exposed to the virus, he was intimately familiar with its sometimes all-but-irresistible contagion. It is not, therefore, that Richter deems ideological commitment unimaginable, but rather that he judges it unacceptable precisely because it is, in its overcompensation for uncertainty, all too human. For Richter, absolute conviction precedes irrevocable error and, perhaps, moral or physical violence.

In the 1970s and 1980s, the rhetoric of artistic and political avant-gardes frequently overlapped, and so did the circles in which advocates of both moved, especially in the student milieu surrounding the Düsseldorf Art Academy, where Richter began teaching in 1971. Inevitably, Richter came in contact with people who were more or less actively engaged in promoting social revolution and the revolutionary transformation of art. While he was sometimes deeply impressed by their seriousness, he remained unsympathetic to their reasoning, and insofar as their arguments recapitulated the utopian dogma he had fled or dogma that called into question the legitimacy of art, he recognized the threat they represented to him and, to a degree, he internalized it.[11] Squeezed between the ideology-

saturated art world of the 1970s and the market-driven art world of the 1980s, Richter confronted a dilemma: how to imbue painting with meaning whose complexity could resist co-option by a sensation-hungry public while at the same time fend off the pressures to reduce painting to one or another of its dialectical components—form or content. On the one hand, having felt the hot breath of political extremism with its call to action and, on the other, the chilling effects of aesthetic radicalism with its long list of prohibitions— including a prohibition against or at least theoretical objection to painting— Richter was confronted on all sides by unhappy choices. Notes dated February 1986, a month before he began *October 18, 1977*, show the separate strands of his thoughts—idea, theme, ideology, action, reflection— tied into a knot: "The idea as a point of departure for the picture: that's illustration. Conversely, acting and reacting in the absence of an idea leads to forms that can be named and explained, and thus generates the idea. ('In the beginning was the deed.') To put it another way, Marx 's teachings didn't cause historical change: new facts gave rise to interpretations, and thus to ideology. Action in pursuit of ideology creates lifeless stuff, at best, and can easily become criminal."[12]

A knot that can't be untied must be cut. The first step toward doing that is recognizing the knot for what it is. That recognition came with the realization that the Baader-Meinhof group was not only a subject matter of profound historical import and moral resonance in its own right but that the contradictions enmeshing it—in particular those issuing from the RAF's apocalyptic absolutism—were a metaphor for those that ensnared him as an artist.

Well before his thinking zeroed in on the events leading up to the deaths at Stammheim, Richter had been reading about and collecting documentary images of the Baader-Meinhof group. Pictures of the RAF were ubiquitous in Germany throughout the 1970s and 1980s, on posters, in magazines, and on television. By various means, Richter managed to amass a large trove of pictures—some of them taken by the police, some by the media, and some by members of the underground, such as Astrid Proll— which he filed in an album kept in his studio. The indexing of photographs had been fundamental to Richter's practice since 1962 when he started to compile *Atlas*, a still-evolving compendium of thousands of found, reproduced, and original photo-materials chronicling his career and containing most of the sources he has drawn upon for his paintings, and many he has passed over. Sharing space on the early pages of *Atlas* with publicity stills, advertising spreads, pornography, and family snapshots, are newspaper clippings of crime victims (a murdered prostitute, Helga Matura, the eight student nurses killed by Richard Speck), of perpetrators (Lee Harvey Oswald) as well as a memento of Richter's Uncle Rudi in a Nazi uniform, and photographs of concentration-camp victims presumably taken by their persecutors. Some have ended up on canvas—Helga Matura, the nurses, Oswald, Uncle Rudi—and some did not. The concentration-camp photographs are among the latter. These Richter has termed "unpaintable," and having decided this was so, he pasted them together with the pornography pictures as if one obscenity deserved another, except that the two groupings of images remain wholly incommensurable. Richter thus shockingly juxtaposed romping nudes and corpses—a juxtaposition he himself called "weird and

seemingly cynical"—in a manner so disorienting that the viewer is forced to look at the "familiar" atrocities of the Holocaust with fresh eyes.[13]

All of this raises the question of why other atrocities, almost as horrific, were "paintable." When asked about this with regard to the Baader-Meinhof photos, Richter claimed, with a glancing blow at intellectually overdetermined art, that the decision resulted from "more or less an unconscious process. That sounds terribly old-fashioned. These days, pictures are not painted but thought out."[14] Pressed by the interviewer Jan Thorn-Prikker as to whether he had been sure from the start that the subject of terrorism could be dealt with, Richter replied that "the wish was there that it might be—had to be—paintable."[15] In short, Richter felt compelled to tackle the theme of the RAF, but the process of deciding which images to paint, and, later, which paintings to keep was initially an intuitive and then an empirical one. The product of trial, error, and elimination, *October 18, 1977* is, by this measure, the very opposite of programmatic political art.

Atlas contains a hundred photographs pertaining to the Baader-Meinhof group that have been reprocessed and rendered more than usually fuzzy; they are works of art in their own right, or parts of a larger archival work of art rather than the artist's working models.[16] Richter's studio album

Gerhard Richter. *Atlas: Panel 19.* 1967. Five black-and-white photographs, 26¼ × 20⅜" (66.7 × 51.7 cm). Städtische Galerie im Lenbachhaus, Munich

contains 102 photographs of varying quality; not all of them are the same as those in *Atlas,* and none of them is significantly out of focus. At the outset, Richter had intended to paint a large selection of these pictures, covering the whole RAF story, which he had recently read about in the exhaustively detailed account published by Stefan Aust in 1985. In the end, he drastically narrowed his choices by excluding everything documenting the actions, life on the run, or trial of the RAF, and, with the exception of *Funeral*, set aside pictures in which the RAF members appeared together or with others. What remained, in addition to one image of Baader's empty cell and one of his record player, were pictures in which each of them—even Meins facing a mini-tank—appears in isolation, such that the viewer faces them as they confronted their fate. Playing on the question already raised by Thorn-Prikker, Richter explained the paradoxes of his winnowing down the images in this way: "The ones that weren't paintable were the ones I did paint. The dead. To start with, I wanted more to paint the whole business, the world as it then was, the living reality—I was thinking in terms of something big and comprehensive. But then it all evolved quite differently, in the direction of death. And that's really not all that unpaintable. Far from it, in fact. Death

Top left: **Gerhard Richter.** *Atlas: Panel 472*. 1989. Eight black-and-white photographs, 20 3/8 × 26 1/4" (51.7 × 66.7 cm). Städtische Galerie im Lenbachhaus, Munich

Top right: **Gerhard Richter.**. *Atlas: Panel 474*. 1989. Eight black-and-white photographs, 20 3/8 × 26 1/4" (51.7 × 66.7 cm). Städtische Galerie im Lenbachhaus, Munich

Bottom left: **Gerhard Richter.** *Atlas: Panel 473*. 1989. Eight black-and-white photographs, 20 3/8 × 26 1/4" (51.7 × 66.7 cm). Städtische Galerie im Lenbachhaus, Munich

Bottom right: **Gerhard Richter.** *Atlas: Panel 475*. 1989. Twelve black-and-white photographs, 20 3/8 × 26 1/4" (51.7 × 66.7 cm). Städtische Galerie im Lenbachhaus, Munich

and suffering always have been an artistic theme. Basically it is *the* theme. We've eventually managed to wean ourselves away from it, with our nice, tidy, lifestyle."[17]

Death is the *eidos*—the essential form—of photography, the French critic Roland Barthes has written.[18] What we witness in a picture taken of a particular person or thing at a precise instant is what Barthes calls "the that-has-been," the unrepeatable moment that in reproduction can be infinitely multiplied. While a painting may seem lifelike, a photograph never does and never can. Unlike painting, which is a synthetic fiction even when it is based on observation, the fact of the photograph's static quality is always at odds with the fact—actual or potential—of movement. Indeed, the more vitality recorded in a photograph, the more uncanny such signs of life appear. Dramatic action in a painting is action at or approaching its climax; gesture or motion in a photograph is action interrupted and forever suspended. And inaction? A figure standing stock-still for a photo-portrait is a figure waiting to ease the set of the body and face, a figure waiting to breathe. And if the person is dead? But for decay that will in reality waste the body, the picture before us is what that person will look like henceforth: this is their final

Top left: **Gerhard Richter.** *Atlas: Panel 476*. 1989. Twelve black-and-white photographs, 20 3/8 × 26 1/4" (51.7 × 66.7 cm). Städtische Galerie im Lenbachhaus, Munich

Top right: **Gerhard Richter.** *Atlas: Panel 478*. 1989. Twelve black-and-white photographs, 20 3/8 × 26 1/4" (51.7 × 66.7 cm). Städtische Galerie im Lenbachhaus, Munich

Bottom left: **Gerhard Richter.** *Atlas: Panel 477*. 1989. Twelve black-and-white photographs, 20 3/8 × 26 1/4" (51.7 × 66.7 cm). Städtische Galerie im Lenbachhaus, Munich

Bottom right: **Gerhard Richter.** *Atlas: Panel 479*. 1989. Twelve black-and-white photographs, 20 3/8 × 26 1/4" (51.7 × 66.7 cm). Städtische Galerie im Lenbachhaus, Munich

aspect. And yet the expectation we have of such a picture is the same we have of pictures of the living. We anticipate a shiver, twitch, or abrupt realignment while we ourselves inhale and exhale. Suddenly the duration of our gaze is thrown out of sync with the permanent "momentariness" of the image. We cannot match it up again by thinking that in the next photographically unrecorded instant he will turn away, she will turn toward us. Time has stopped twice, in the click of the shutter and in the extinction of a life. Camera-time equals an increment of unchanging eternity. More than the thought of this is unbearable. Our body rebels, our eyes cannot stay fixed on this already redoubled inertia. Physically restless as much as troubled by the confrontation with mortality we move on. In photographs we can see death with a nakedness no other medium affords. But photography does not allow us to contemplate death. In order to do that, duration must reenter the equation, for without a measure of time's passage the depiction of time arrested becomes tautological, senseless.

Painting, which takes time to make—time indelibly marked in its skin—restores duration to images of death. *October 18, 1977* introduces an existential contradiction between painting's slowness and photography's

speed, between the viewer's condition, which allows one to spend time, and that of the subject for whom time has ceased to exist. Because of this, one might say, *painting* chose the images of the dead over those of the living when Richter went to work on the Baader-Meinhof cycle because painting could open up the experiential space that photography reduces to zero, a space defined not by our identification with the dead subject but by our differences and distance from him or her, differences and distances which we can ponder but never diminish or obliterate. Like all that preceded their deaths, this, the paintings of the dead RAF members insist, happened to them alone. Death claims us all, but it is an individual not universal phenomenon, and though it operates as a leveler it does not bind us to each other but instead separates us categorically and definitively. Based on the evidence provided, we can reflect on what Baader, Ensslin, and Meinhof did and speculate on what was done to them, but we cannot imagine them in their final hour or even in the death-haunted hours and years that led up to it, and we cannot bridge the divide that the camera points to and that painting widens.

"Death and suffering always have been an artistic theme. Basically it is *the* theme. We've eventually managed to wean ourselves away from it, with our nice, tidy, lifestyle," wrote Richter. Well-ensconced in armchairs, we may look at magazines and watch television programs in which images of death abound but they do not intrude very far on "our nice, tidy, lifestyle." On the contrary, they generally reassure us that we are among the lucky. Or, they may give us a vicarious thrill. Richter has said, "people can't wait to see corpses. They crave sensations."[19] However, encountering such images in public—even in the safe precincts of a museum—lowers our defenses. The history of art (and, for that matter, the history of film) prepares the way for

Gerhard Richter's Studio, Cologne, 1988, from the artist's notebook

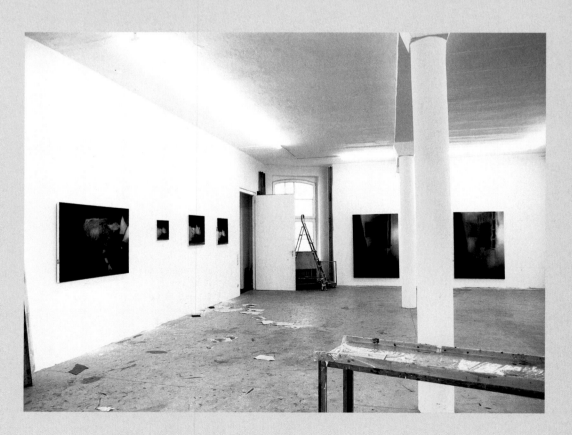

this. The presence of paintings and sculpture (or the expanse of the big screen) makes the specter of death stronger than on the tube or glossy page, and the proximity of strangers leaves our suppressed discomfort and fear more exposed to scrutiny than they would be in the company of familiars whom we can count on to excuse our nervous responses. Multiplying this effect fifteen times, *October 18, 1977* bombards us with death from every side. Altogether the series is a relentless assault on denial and decorum and the false security they foster. In harrowing contrast to their well-appointed environs, the paintings are suffused with the air of annihilation. No crucifixion or deposition was ever more morbid, or more enhanced in that quality by the grandeur or solidity of its church or gallery setting. In these paintings, however, there is no hope, no resurrection, only numbing finality.

Of course, some of the canvases give us glimpses of Ensslin, Meins, and Meinhof alive, but all of the paintings tend toward oblivion. The manner in which they do, the particular images selected, and the types of photography used as sources phrase the series as a whole. The primary images from which Richter worked are of several distinct kinds. The *Youth Portrait* of Meinhof, which begins the cycle, is based on a picture posed in a movie-star manner and derived from old-master painting, a manner that is "sentimental in a bourgeois way," as Richter was quick to point out. The two *Arrest* paintings were based on magazine photographs of Meins being taken prisoner at gunpoint by police in an armored car; these had first been taken from television coverage of the event. As mentioned, the three *Confrontation* paintings were based on pictures taken in June or July of 1972 by a photographer present when Ensslin was being escorted to a police lineup. Except for *Funeral,* which is also a news shot, all the rest—*Man Shot Down 1* and *Man Shot Down 2; Dead 1, Dead 2,* and *Dead 3; Hanged; Cell;* and

Gerhard Richter's Studio, Cologne, 1988, from the artist's notebook

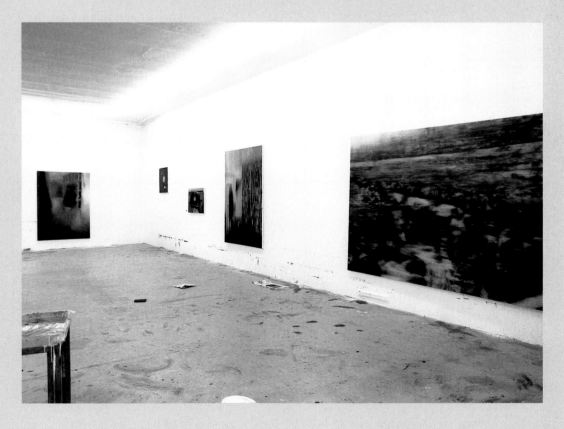

Portrait of Ulrike Meinhof, c. May 1970. Photographic model for *Youth Portrait*, from the artist's notebook

Record Player—are, as is plain from their routine framing, harsh exposures that concentrate on gruesome or evidentiary detail, photographs made by the prison authorities or police after the discovery of the bodies.[20] The ordering and repetition of some images in the cycle evoke cinematic techniques as well; action or stop-action sequences in *Arrest 1* and *Arrest 2*, and *Confrontation 1, Confrontation 2,* and *Confrontation 3,* the close-up and fade-out in *Man Shot Down 1* and *Man Shot Down 2* , and *Dead 1, Dead 2,* and *Dead 3*. Overtly dramatized narrative is thus introduced or implied by reference to film effects to which the viewer will almost involuntarily respond. We have left the realm of "straight" photography, and even within the range of pictures that might lend themselves to such a reading Richter subtly insists on telltale differences in genres—studio portrait, photo-journalism, forensic shots—that belie such homogenizing assumptions. Meanwhile, for those familiar with Richter's source-images from their heavy as well as heavy-handed use in news coverage of the time—or familiar with the way comparable images have been packaged when other such stories have been fed through the machinery of attention-grabbing journalism—the artist's subtle manipulations downplay all the sensational qualities the mass media exploited, effectively short-circuiting the viewer's reflex reaction to seeing them again.[21] In sum, we are not dealing with documentary photography and we are not dealing with documentary painting either. Instead, we are confronted with a continuum of representations stretched taut between the abstract concepts of photography and painting, each of which by asserting its own conventional reality implicitly questions the conventions and the truth of the other.

Richter's other interventions are both more and less obvious. As it turns out, the photograph that is the model for *Youth Portrait* was probably taken in 1970 for publicity purposes around the time Meinhof's film *Bambule* was to have been released and shortly before she participated in Baader's escape from jail.[22] Comparison with the painting shows that Richter has considerably softened not only the look of the photograph itself, but the severe unflinching look Meinhof directs at the lens. The woman in the photograph has been an activist and writer for over a decade, has married and divorced, has given birth to twin daughters, has undergone a life-threatening operation, and is on the verge of breaking with everything such a "bourgeois" likeness represents. The woman in the painting, which resembles a high-school yearbook picture, is on the eve of maturity. As the German critic Kai-Uwe Hemken has pointed out, she is the only RAF member whom Richter has given a past, but in altering that past and making her younger, Richter has not idealized her in any hagiographic sense; the sentimentality he has injected into the picture is an antidote-in-kind to the true poison of tabloid kitsch, and he has created a hypothetical innocent against which to gauge the ravages of *Dead 1, Dead 2,* and *Dead 3*.[23]

Richter's treatment of Ensslin in *Confrontation 1, Confrontation 2,* and *Confrontation 3* is similar. In this case, the original photographs are denuded of atmosphere. Dressed in a rough shirt, skirt, sandals, and high socks, with bare knees and straggly hair, Ensslin is seen standing full-length against a barren institutional context. She smiles at the photographer as if enjoying the attention; only a fourth image, which Richter rejected, betrays any wariness. In the paintings, though, Richter crops out all but Ensslin's upper torso and

106

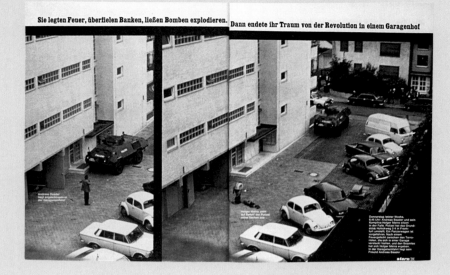

11.

12.

Arrest of Holger Meins, Andreas Baader, and Jan-Carl Raspe, Frankfurt, June 1, 1972. Photographic models for *Arrest 1* and *Arrest 2*, from the artist's notebook

Top right: Arrest of Holger Meins, Andreas Baader, and Jan-Carl Raspe, Frankfurt, June 1, 1972, as published in *Stern*, June 8, 1972

head, eliminating her body's awkwardness, and places her in front of a uniform gray backdrop, narrows the tonal span, and diminishes the contrast of lights and darks—making the confrontation oddly less confrontational—smoothes out the angularities of her face, removing the strain from her expression (along with some of the sparkle in her eyes), and in the end presents a disconcertingly intimate three-stage encounter during which Ensslin catches our eye out of the side of hers, turns to us, lips parted, brightening face open and expectant, and then turns away, drops her head, squares her jaw and the line of her mouth, and seemingly steps toward the outer edge of the frame as if she were about to disappear behind a door. Initially, the three canvases suggest a first meeting with someone we have heard about but never seen close up before, but what Richter has really staged is her parting.

In *Arrest 1* and *Arrest 2* Richter transforms two sharply focused images of Meins's capture to a hazy smear in which Meins is reduced to a faint shadow and all one can see of "the clenched power of the state" is the amorphous mass of the armored car. *Cell* and the smaller *Record Player*—in effect a detail of the larger picture though the source image was a separate photograph—are "portraits" of Baader's prison reality. The turntable that sits silently and does not turn is a memento mori, analogous to the skulls Richter painted in 1983, but without their explicit art-historical associations. *Record Player* is a vanitas for our time. One must conjure up the real mechanical, noise-making thing to appreciate the painting's leaden objectivity, and in so doing consider not only the suicide gun which was said to have been hidden there but also the resonance of music in a locked room cut off from the world.[24] The black coat hanging off the screen to the left in the photograph, which Richter used as his point of departure for *Cell*, becomes in the painting the husk of the man whose intellectual universe is contained on the book-lined shelves to the right.[25] However, as the floor drops out it is the vertiginous mass of those books that dominates the canvas, which represents a cul-de-sac of the revolutionary mind, and a queasy, claustrophobic icon of ideology.

Man Shot Down 1 and *Man Shot Down 2* complete the Baader paintings. The first painting most nearly approximates the photograph—

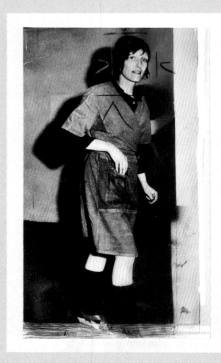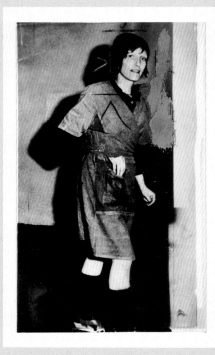

Richter chose not to use a closeup of Baader's head but instead opted for the three-quarter-length image, with its almost Pieta-like disposition of arms and body—but the painter has obscured Baader's dead stare and the pool of blood under his head, and lent his torso a brittle, insubstantial aspect accentuated in the second painting in which everything floats in a ghostly void. The progression from muted realism to the near-total dematerialization of the images in *Dead 1, Dead 2,* and *Dead 3,* follows the same pattern. In the first canvas, Richter surrounds Meinhof's head in rich blacks, adding space not found in the photograph to the top and bottom edge of the horizontal canvas, but otherwise faithfully rendering Meinhof's features. In the second painting, Richter deepens the blacks, squares off his format, gives her a less-distinct, more-somnolent expression, and then cocks Meinhof's chin backwards, straightens her neck and darkens the ligature around it, thus emphasizing the horrible manner of her death in contrast to the peace that has settled on her face. In the third version, Richter shrinks the size of the canvas, slightly elongating it again, and lets the image dissolve into the engulfing but no longer quite so deep gray-black background. With each iteration Meinhof withdraws from us.

More disturbing even than the paintings of Baader and Meinhof is that of Ensslin. The source photograph, in which a slender woman, head tucked, legs dangling, is suspended from a grate in her cell window, is ghastly. Once again Richter's handling of a cut-and-dried documentary image softens the forms but intensifies the effect. In *Hanged,* the curtain to the left of the figure

Gudrun Ensslin, 1972. Photographic models for
Confrontation 1, Confrontation 2, and *Confrontation 3,*
with hand notations by Richter, from the artist's notebook

and the floor beneath fuse to create a framing device that focuses attention on Ensslin's body, whose torso is the same black as the curtain and floor, but Richter has tilted her shoulder, arms, and torso away from the vertical window, making her swing against gravity as her legs fade into the pale gray below, and the floor falls away. Read one way these almost unnoticeable adjustments make it seem as if Ensslin had been dropped from a gallows; read another way she seems almost to be levitating above the abyss at her feet.

Funeral, the largest and last painting in the cycle, centers on the three coffins of Baader, Ensslin, and Raspe as they were escorted through the cemetery by a crowd of mourners and journalists. In the daylight-filled photograph these attendants—many wearing the period dress of the Left—can be clearly made out. In the penumbral painting they are homogenized into a somber, virtually undifferentiated mass that optically pushes and shifts around the barely distinguishable rolling carts bearing the three RAF members to their graves. Lowering the horizon, much as he flattens the background in other paintings in the series to close out the space beyond the primary image, Richter gives the trees in the distance only the vaguest definition, which is why one tree in particular—a simple vertical with lateral branches—draws attention to itself. Nothing exactly like it appears in the original photograph, though such an addition could easily be extrapolated from trees that do appear. Perhaps, however, it is not a tree after all, but a cross positioned at the top and near the middle of the composition. A dozen years ago this suggestion would have seemed implausible and it might still

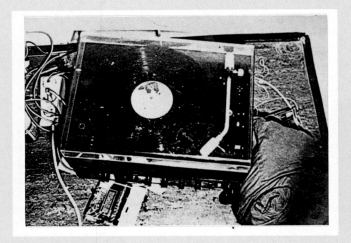

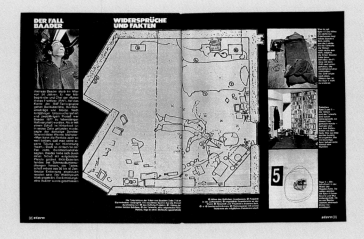

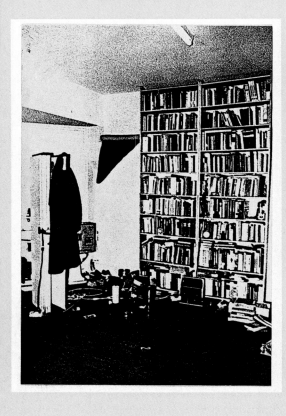

Left: Andreas Baader's Stammheim cell, October 18–19, 1977. Photographic model for *Cell,* from the artist's notebook

Top right: Andreas Baader's record player, October 18–19, 1977. Photographic model for *Record Player,* from the artist's notebook

Bottom right: Andreas Baader's Stammheim cell and record player, October 18–19, 1977, as published in *Stern,* October 30, 1980

strike secularists of the Left as a kind of blasphemy. However, Richter has since made a sculptural multiple of a similarly proportioned cross and he has painted his wife Sabina with their son as a kind of Madonna and child. In light of this, it is hard not to acknowledge the deliberateness of what Richter has done and recognize his addition to *Funeral* as a discrete benediction at the end of a modern-day passion play which, in his scrupulous and agonizing rendition, offers no other consolation. [26]

Richter is vague about the specifics of how such differences between the photographic and the painted image come about, just as he is about why certain images were chosen over others. The techniques employed to achieve these nuances and to give the paintings their muffled feel—feathering the edges of the shapes, dragging brushes or squeegees across the still-wet surface of the canvas—are a kind of erasure or, as some critics have called it, a *de*painting or *un*painting. There is, of course, a long history of aesthetic substraction reaching down in the modern era to Alberto Giacometti's tonal paintings and Willem de Kooning's mottled ones, but Richter's removal of information, which varies in quality from a *sfumato* pall hovering over the canvas to the rich disorienting impastos that slide vertically in *Cell* and sweep horizontally in *Funeral,* is at odds with Photorealism generally, where a

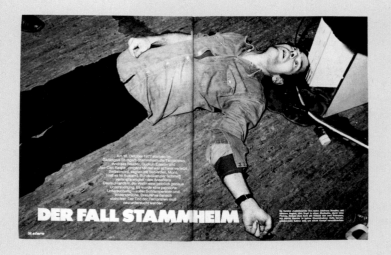

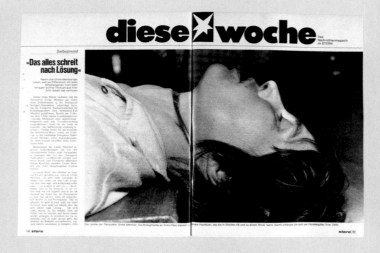

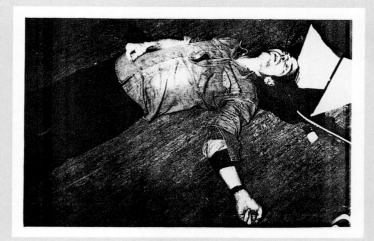

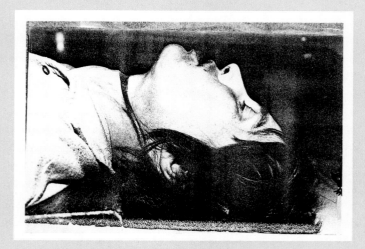

Top left: Andreas Baader, dead, October 18, 1977, as published in *Stern*, October 30, 1980

Top right: Ulrike Meinhof, dead, May 9, 1976, as published in *Stern*, June 16, 1976

Bottom left: Andreas Baader, dead, October 18, 1977. Photographic model for *Man Shot Down 1* and *Man Shot Down 2*, from the artist's notebook

Bottom right: Ulrike Meinhof, dead, May 9, 1976. Photographic model for *Dead 1, Dead 2,* and *Dead 3,* from the artist's notebook

premium is usually placed on hyper-verisimilitude. It is also different in character from the photomechanical depletions of Warhol's silkscreen pictures, just as Richter's solemn meditation on death is different from the macabre voyeurism of Warhol's Disasters paintings. In *October 18, 1977* we are not looking at average, redundant death but an exemplary suffering. Responding to a question about voyeurism with Warhol perhaps in the back of his mind, Richter said of his paintings: "I hope it's not the same as seeing an accident on the motorway and driving slowly simply because one is fascinated by it. I hope that there's a difference and that people get a sense that there is a purpose in looking at those deaths, because there is something about them that should be understood."[27]

But what Richter wants us to understand is directly connected to the difficulties of visual access he puts in our way. The contradictory impression resulting from Richter's *un*painting is to push the physical reality of the painting forward while pushing the image back, so that it seems to retreat as the viewer advances to have a better view of the painterly manipulations that body it forth. To paint an artificially crisp version of a photograph can call into question the artifice of the source, but to blur a photograph as Richter does accomplishes the same thing but adds this: whereas the super-real picture

allows us to distill a more "natural" image of the surfeit of visual data, the blurred picture prevents us from doing the reverse—we cannot supply the missing details or correct the incomplete resolution of part-to-part relations.

Richter's use of gray is of a piece with these obfuscations, all of which open gaps among the painter, the viewer, and the subject. In part, his motives were contextual. "When students at the academy heard I was doing these works," Richter recalled, "most of them said I wasn't allowed to paint this, that I was too bourgeois, too much a part of the establishment. This seemed very stupid to me. But many young artists are going to say this is bullshit, polit-kitsch, and maybe it is possible to see the works this way."[28] In qualified recognition of the contention that he was not capable of rendering the situation with the urgency and immediacy of those close to it, he added, "It is impossible to paint the misery of life, except maybe in gray, to cover it."[29] Gray was also a way of showing that he was painting the past, and a signal that he had opted for a style belonging to *his* past. Other than the two versions of *Tourist (with a Lion)* of 1975, Richter had not painted purely tonal realist pictures since completing *48 Portraits* in 1971–72. "I never really make contemporary works," he told a London critic. "When it's painted gray like this it's partly a way of establishing distance. I knew it was an anachronism to return to my old technique, but I couldn't really do anything else."[30] In the earlier paintings Richter had used gray as a buffer or demurrer: "Gray. It makes no statement whatever; it evokes neither feelings nor associations: it is really neither visible nor invisible. Its inconspicuousness gives it the capacity to mediate, to make visible, in a positively illusionistic way, like a photograph. It has the capacity that no other color has, to make 'nothing' visible. To me, gray is the welcome and only possible equivalent for indifference, non-commitment, absence of opinion, absence of shape."[31]

Richter's recourse to gray, in a series of works that were bound to be lightening rods for repressed anxieties and animosities, carried with it an element of resistance and of discipline. After years in which he painted color-saturated abstractions, his decision constitutes a refusal to be carried away by painterly pyrotechnics, even as the work itself threw conceptual and emotional sparks by pitting aesthetic non-commitment against political commitment, the artist's apparent indifference against his inner need to finally come to grips with what had impressed him about the Stammheim prisoners despite their false ideology and destructive acts, namely "their energy" and their "absolute bravery."[32]

At one level, then, gray is a symbolic middle term in a context where many are prone to seeing things black and white. The keynote of an anti-rhetorical style, moreover, it not only distinguishes his work from the neo-Expressionist painting prevalent at that time, it fundamentally alters our appreciation of the tradition of chiaroscuro painting, which *October 18, 1977* updates in unanticipated ways. Whereas chiaroscuro painters have usually employed extremes of light and dark to give forms muscular volume and to highlight significant details, Richter has lopped off the top of his gray scale and sometimes the bottom as well, leaving himself a *grisaille* range of ashen, slate, or anthracite tones that in their variously warm shades, cool bluish tints, and occasionally white-streaked accents deflate rounded shapes, slow the darting eyes on the lookout for surprises, and dampen the pictorial ambiance like a low, hushed cello drone. Above all, Richter does the opposite

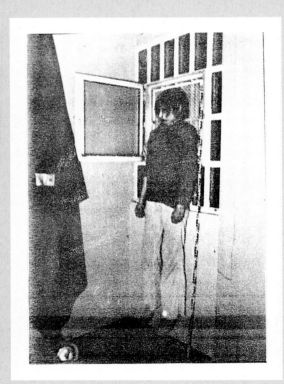

Gudrun Ensslin, hanged in her Stammheim cell, October 18, 1977. Photographic model for *Hanged,* from the artist's notebook

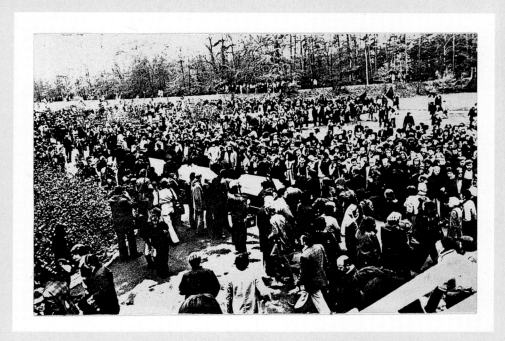

Funeral of Andreas Baader, Gudrun Ensslin, and Jan-Carl Raspe, Stuttgart, October 27, 1977. Photographic model for *Funeral*, from the artist's notebook

of what we expect from chiaroscuro painting; rather than reveal the essence of the image, his dour palette further conceals it. Playing against our desire to trust our own eyes, he has given us reason to mistrust them.

Combined with various *un*painting procedures, gray thus operates as the agency and emblem of doubt, in a situation where doubt is intolerable to many if not most of those with the deepest involvement. The conventional wisdom is that radical doubt defines the postmodern condition in a world in which traditional notions of cause and effect, and the assumed connection between representation and the thing represented, have lost their authority. Nothing in contemporary reality, it is said, retains a "necessary" meaning or remains subject to the reliable methods of verification. Consequently, we have been cast adrift in the flotsam and jetsam of disconnected signs whose plural use-value overshadows the importance of whatever they originally signified.

With roots in linguistic theory, the collapse of old political and social antinomies, and the vogue for the "end of history," this relativizing postmodernist tendency of thought has its stylish apogee in the work of the French gadfly Jean Baudrillard. In an influential essay, Baudrillard has written that the semiotic breakdown of links between the image and what has been pictured leaves the viewer with four possibilities: the image can be the reflection of a basic reality; the image may mask and pervert a basic reality; it may mask the absence of a reality; or it may bear no relation to any reality.[33] Increasingly, he argues, we are at a loss as to which of these cases applies to what we see, and this uncertainty produces a phantasmagoria of possibilities that annul objective truth.

Baudrillard's examples include one that is particularly apropos the Baader-Meinhof episode and Richter's *October 18, 1977*. He asks: "Is any given bombing in Italy the work of leftist extremists, or of extreme right-wing provocation, or staged by centrists to bring every terrorist extreme into disrepute . . . or again is it a police-inspired scenario in order to appeal to public security. All this is equally true, and the search for proof, indeed the objectivity of the fact does not check this vertigo of interpretation."[34]

113

The contingencies Baudrillard cites are hardly frivolous. One has only to think back to the police agent provocateur who supplied Horst Mahler with Molotov cocktails and promised Baader guns in order to establish an exact parallel with this kaleidoscopic scenario. The various conspiracy theories that lay the blame for the deaths of the Stammheim prisoners at their own doors or at the feet of the police, prison officials, or some secret government agency fall into the same multiple-choice miasma.

What is lacking in Baudrillard's elegant intellectual gambit is the abiding compulsion to understand the terrible things that happen, the imperative to investigate and judge incomplete and inconclusive evidence, and above all an appreciation of the price of never knowing and the emotional and spiritual weight of ineradicable doubt. It is not enough to shrug and say that history is inscrutable or fictional or that only the victors write it. Not all interpretations are equally plausible or equally flawed. But all interpretations *do* have consequences for the present and the future. Richter's reticence and the ambiguity of his work are not evasive in this fashionably postmodern sense. They are, instead, the probity of his art. He does not answer the question "How and why Baader, Ensslin, Meinhof, and Raspe died," but he has asked it publicly at a time when others have made up their minds once and for all or have fallen silent. More importantly, Richter has suggested—and his paintings confirm—that the lasting significance of their lives and deaths rests on the contradictions within society and within the individuals their ideas and actions so violently exposed. Those unresolved contradictions are RAF's unwelcome but unavoidable bequest and the crux of *October 18, 1977*.

NOTES

1. "Interview with Rolf Schön, 1972" in Hans-Ulrich Obrist, ed., *Gerhard Richter: The Daily Practice of Painting. Writings and Interviews, 1962–1993* (London: Thames & Hudson and Anthony d'Offay Gallery, 1995), p. 73.

2. "Notes for a Press Conference, November–December 1989," in Richter, *Daily Practice,* p. 175.

3. The corner of the window frame and dark shadow on the left hand side of the image of Ensslin hanging are readily discernible around the margins of a 1988 painting, *Blanket,* that was shown in the 1989 exhibition *Richter 1988/1989* at the Museum Boijmans Van Beuningen in Rotterdam, which also included *October 18, 1977.* The title plainly suggests that the veil of white pigment the artist has dragged over the image is equivalent to covering a corpse with a sheet or blanket. A similar reading of the white painting spread over the small painting of the dead Meins, *Abstract Painting* (1988) is also reasonable. There is no painting of the same dimensions in the works from this year, which leads one to believe that the third version of *Hanged* Richter painted was destroyed and not painted over, but two vertical canvases measuring 140 x 100 cm are of the same size as *Man Shot Down 1* and *Man Shot Down 2,* and it is possible that under one of these the third version of this subject Richter cited in his notes can be found. If that is the case, it is perhaps significant that unlike *Blanket,* these two paintings have agitated surfaces and harsh colors—charred blacks and fiery reds, yellows and oranges—that are singularly violent.

4. Richter, *Daily Practice,* p. 171.

5. Ibid., p. 127.

6. Ibid., p. 129.

7. See Peter Guth, *Wände der Verheissung: Zur Geschichte der architekturbezogenen Kunst in der DDR* (Leipzig: Thom Verlag, 1995).

8. "Notes, 1964-65," in Richter, *Daily Practice,* pp. 33–34.

9. "Notes, 1964," in ibid., p. 23.

10. The phrase comes from the title of a famous collection of anticommunist essays written by former communists and fellow-travelers, such as Richard Wright, Stephen Spender, and Ignazio Silone that was published in 1950 at the height of the Cold War.

11. Two personal factors may also help explain why Richter felt compelled to paint incidents out of the recent history of the German Left, a Left with which he had no direct involvement and scant sympathy. The first, suggested by the German writer Ulf Erdmann Ziegler, was Richter's marriage to the sculptor Isa Genzken, who, according to a 1972 article published in *Der Spiegel,* was reported to have traveled in circles close to the RAF. Ulf Erdmann Ziegler, "How the Soul Leaves the Body: Gerhard Richter's Cycle *October 18, 1977,* The Last Chapter in West German Postwar Painting," in Eckhart Gillen, ed., *German Art from Beckmann to Richter: Images of a Divided Country* (Cologne: DuMont Buchverlag; Berlin: Berliner Festspiele GmbH, 1997), pp. 374–80. Furthermore, Richter explained that he first met Genzken around 1972 but did not get to know her until she was introduced to him again by the Marxist-oriented critic Benjamin H. D. Buchloh, who had recommended that she study with the painter. Richter recalled that the first real conversation they had together was about the recent killing of Hanns-Martin Schleyer, which, contrary to some opinion on the left at that time, Richter thought was a bad end to a bad affair. (Conversation with the author.) The second personal factor was Richter's ongoing dialogue with Buchloh, whose interview with the painter in the catalogue of his 1988 North American retrospective, organized by Roald Nasgaard (see Benjamin H. D. Buchloh, "Interview with Gerhard Richter," in Roald Nasgaard, *Gerhard Richter: Paintings* (London: Thames & Hudson, 1988)—conducted while Richter was at work on the Baader-Meinhof pictures—shows the two friends taking diametrically opposite positions not only on

fundamental questions regarding Richter's work and motivation but on the nature and role of art itself. At almost every turn, the painter rejects the critic's sweeping generalization about the obsolescence of painting as a medium, the impossibility of conveying true emotion in works of art and other postmodernist assumptions arising out of the then current mix of Duchampian or Warholian tropes and ideas transposed from the writings of Walter Benjamin and the Frankfurt School. It is a testament to Buchloh's respect for Richter that he permitted such a thoroughgoing rebuttal of his interpretations to be published, and, reciprocally, it is an indication of Richter's regard for Buchloh that he responded forthrightly to the critic's challenges and incredulity when affirming his faith in ideas that Buchloh treats as anathema. In his private writings, Richter argued with himself; in public he argued with Buchloh, who represented political and aesthetic ideas antithetical to his own with a seriousness Richter could honor. Ideology had, in effect, become Richter's antimuse. Meinhof and Ensslin were its fullest embodiments, Buchloh its spokesman in the present.

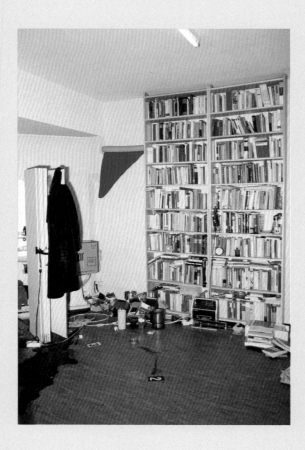

12. "Notes, 1986," in Richter, *Daily Practice,* p. 125.

13. "Conversation with Jan Thorn-Prikker Concerning the Cycle *October 18 1977*, 1989," in ibid., p. 185.

14. Ibid., p. 183.

15. Ibid.

16. More so even than the cancelled paintings of Meins and Ensslin, the photographs in *Atlas* are an appendix to *October 18, 1977,* as is the cycle of twenty-three pages of a book by Pieter H. Bakker Schut on the Stammheim trial, which Richter painted on and the Anthony d'Offay Gallery published in facsimile in 1995 as *Stammheim.* When asked in 1995 by a reporter for the left-wing newspaper *DieTageszeitung* how this work came about, Richter answered, "I do not know. The book [by Bakker Schut] was lying around, the situation similar to the one before [Aust's book]. I did not know what to do with the book. Then I began to paint the pages, the way I sometimes paint photographs. Maybe I wanted to finish the topic for myself entirely. One, two years later I showed the painted pages to a friend who thought they were very good and advised me to keep these pages as one piece." In 1991 Richter made a series of performance-based photographs titled *Six Photos 2.5.89–7.5.89* in which one sees the artist—usually in shadowy gray, at times a nearly phantasmagorical double-exposure—moving uneasily around a dark, otherwise vacant room. Akin in certain respects to some of Bruce Nauman's early black-and-white videos, these images also suggest solitary confinement and in that way seem to refer back to Richter's

preoccupations in *October 18, 1977,* painted three years earlier.

17. In another statement, Richter even more emphatically says of the Baader Meinhof cycle that: "It was meant to be far more comprehensive, far more concerned with the subjects' lives. But then I ended up with a tiny selection: nine motifs and a strong concentration on death—almost in spite of my intentions." "Interview with Sabine Schütz, 1990," in Richter, *Daily Practice,* p. 209.

18. Roland Barthes, *Camera Lucida: Reflections on Photography* (New York: Hill and Wang, 1981), p. 15.

19. "Conversation with Jan Thorn Prikker," in Richter, *Daily Practice,* p. 185.

20. In "Notes on Gerhard Richter's *October 18, 1977,* Buchloh speaks of Richter's refusal to accept the socially prejudicial instrumentalization of the photographic gaze, particularly with regard to the police photographs used by Richter insofar as they seemed to Buchloh to be designed to "ritualistically" assure "the final liquidation of the enemies of the state." There is some truth to Buchloh's argument. Certainly the Bolivian government's "trophy" picture of the dead Che Guevara fits this description, but when asked by Jan Thorn-Prikker whether he intended his paintings as a criticism of the "cruel gaze" of the police photographs, as Buchloh had asserted, Richter demurred: "No that's not what I meant at all. Perhaps I can describe the difference [between the photograph and the painting] like this: in this particular case, I'd say the photograph provokes horror, and the painting—with the same motif—something more like grief." "Conversation with Jan Thorn-Prikker," in Richter, *Daily Practice*, p. 189.

21. This implicit "critique" of the media's treatment of the Baader-Meinhof story is central to the interpretation of many German writers, including Kai-Uwe Hemken who deals with the subject in detail in his book *Gerhard Richter: 18 Oktober 1977* (Frankfurt and Leipzig: Insel Verlag, 1998). It is also worth pointing out that among Michael "Bommi" Baumann's criticisms of the underground was its preoccupation with the media. This he felt both distracted radicals from attention to their own base of support but also caused them to play into the hands of powers they could not control, creating a vicious circle in which the underground's own hunger for media attention made it prey for media consumption: "There was a great interest in the press. We figured out particularly how the press in Berlin would react to an action, how they would interpret the thing, and our strategy was planned with that in mind. There's a mistake in that, because the position of the bourgeoisie toward revolutionary action is clear in the final analysis: one should not measure one's actions against it.

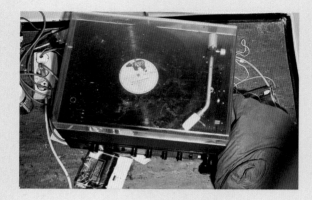

Opposite: Andreas Baader's cell, Stammheim, October 18–19, 1977, from the public prosecutor's office, Stuttgart

Top: Andreas Baader's record player, Stammheim, October 18–19, 1977, from the public prosecutor's office, Stuttgart

Bottom: Detail from photograph of Andreas Baader's record player, showing the label on the record found there

There is far too much attention paid to the media, which lies in capitalist hands. There was a great tendency to overestimate the media, which later had unexpected effects." Of the Baader-Meinhof group in particular, Baumann observed: "RAF said the revolution wouldn't be built through political work, but through headlines, through appearances in the press, over and over again, reporting: "Here are guerrillas fighting in Germany." This overestimation of the press, that's where it completely falls apart. Not only do they have to imitate the machine completely, and fall into the trap of only getting into it politically with the police, but their whole justification comes through the media. They establish themselves only by these means. Things only float at this point, they aren't rooted anymore in anything." Michael "Bommi" Baumann, *Wie Alles Anfing/How It All Began,* with statements by Heinrich Böll and Daniel Cohn-Bendit, trans. Helene Ellenbogen and Wayne Parker (Vancouver, Canada: Pulp Press, 1977), pp. 28, 110.

22. In a letter to the author, Klaus Rainer Röhl, Meinhof's former husband, has suggested that the photograph was taken in May 1970.

23. Kai-Uwe Hemken, "Suffering from Germany—Gerhard Richter's Elegy of Modernism: Philosophy of History in the Cycle *October 18, 1977,*" in Gillen, ed., *German Art from Beckmann to Richter,* p. 384.

24. Just as this book was going to press, we received from the archives of the public prosecutor's office in Stuttgart a folder containing original prints of two images that appear in *October 18, 1977,* for which we were informed, the negatives have been lost. The images, taken days after Baader's body was discovered, are of his cell and record player. The information contained in these photographs is remarkable in several aspects. First, they are in color—as was, incidentally, the original videotape from which the magazine images of *Arrest 1* and *Arrest 2* were taken, though all the versions Richter had in his scrapbook were black and white. Although the prints are in a small format, the color and the relative clarity of focus permits one to make out certain details lost in the black-and-white magazine reproduction, and further obscured in Richter's painting, such as the red triangle in the upper-right-hand corner of the picture— apparently a rolled red pennant or banner lying on a ledge, titles of several books on Baader's shelves (for example one titled *All Lenin's Children* and another on Goya), bloodstains and a chalk silhouette on the floor, two packages of cigarette tobacco next to the record player and other objects, which no matter how incidental, taken together make the scene overwhelmingly macabre, claustrophobic, and forlorn. The most unexpected and disturbing fact that emerges from close inspection of the photographs—an inspection involving careful scrutiny with a high-powered microscope as well as computer-enhanced re-imaging—was that the record on the turntable in Baader's cell the night of his death was Eric Clapton's 1974 release, *There's One in Every Crowd,* a melancholy mix of gospel, blues, and reggae. Given what occurred during the night or early morning of *October 18, 1977,* the lyrics of several of these songs—"We've Been Told (Jesus Coming Soon)," "Swing Low Sweet Chariot," "The Sky Is Crying," "Better Make It Through Today"—are, to say the least, eerie and depressing. However, none of the cuts is more so than the last song on side two of the album, the side facing up on the record player. Titled "Opposites," its single, hauntingly repeated verse goes: "Night after day, day after night,/White after black, black after white./Fight after peace, peace after fight./Life after death, death after life."

25. Although a high-school dropout, Baader was credited by at least one of his teachers as being highly intelligent, and he was also remembered for writing exceptionally good essays. The extensive library he amassed during his incarceration suggests that he worked hard to make up for his lack of a university education and, so far as can be judged from the photographic evidence, to deepen his understanding of German history and politics.

26. Anyone who, as a matter of ideological rigor, bridles at the possibility that Richter has inserted a cross on the horizon-line of *Funeral* might also recall that Ensslin, as a pastor's daughter, had been a devoutly religious person in her youth and, in the days just before her death, summoned both Protestant and Catholic clergy to her cell. It is of further note that much of the dissident Left in Germany, as elsewhere, found its voice through involvement with churches and church organizations that opposed nuclear buildup, conventional rearmament, and the Vietnam War. The secular Left has no monopoly on the proper interpretation of the Baader-Meinhof story.

27. Gregorio Magnani, "Gerhard Richter: For Me It Is Absolutely Necessary that the Baader-Meinhof is a Subject for Art," *Flash Art,* international edition (May–June 1989), p. 69.

28. Ibid.

29. Ibid.

30. James Hall, "Oktober Revelation," *The Guardian* (London) (August 30, 1989), p. 37.

31. "From a letter to Edy de Wilde, 23 February 1975," in Richter, *Daily Practice,* pp. 82–83.

32. "Notes for a Press Conference, November–December, 1989," in ibid., p. 173.

33. Jean Baudrillard, "Precession of the Simulacra," in *Simulations* (Paris: Semiotexte, 1983), p. 11.

34. Ibid., p. 31.

IV: PAINTING HISTORY— PAINTING TRAGEDY

"Show your wounds," Joseph Beuys scrawled on two blackboards in 1980. The blackboards were the centerpiece of Beuys's densely symbolic work on the theme of death, which brought together many of his signature materials and emblems. The brown cross is the most conspicuous example of these older devices, but some new ones had been added as well, notably a copy of the newspaper *La lotta continua (The Struggle Continues)*, the public voice of the Italian revolutionary Left, clandestine elements of which had kidnapped and killed Aldo Moro two years before, provoking a crisis similar to that which was triggered by the RAF's seizure of Hanns- Martin Schleyer. Beuys's invitation/command was in keeping with his overall program for curing Germany's—and Europe's—social, political, and spiritual ills, a process beginning, in this instance, with the call for a ritual display of stigmata. Respectful but always skeptical of Beuys's proselytizing, a respect and skepticism that runs parallel to his feeling toward true believers of the strictly political variety, Richter has been neither a joiner nor a mystic. If Beuys was the Christological shaman of Germany's trauma, Richter is its Doubting Thomas. Beuys pantomimed his culture's wounds; Richter stuck his finger into them.

Prior to *October 18, 1977*, the number of works in Richter's oeuvre that explicitly referred to German history was relatively small, and most were painted in the early to mid-1960s. In addition to *48 Portraits* (1971–72)—an omnibus conceptual work composed of separate paintings of internationally

Jacques-Louis David. *The Death of Marat (Marat assassiné).* 1793. Oil on canvas, 64¹⁵⁄₁₆ × 50⅜" (165 × 128 cm). Musées Royaux des Beaux-Arts de Belgique, Brussels

prominent writers, composers, scientists, and thinkers executed with a touch that mimics the soft photogravure-like quality of old encyclopedia illustrations—these include a 1962 head of Hitler haranguing an unseen crowd, *Herr Heyde* (1965); a picture of the surrender of an infamous SS doctor who had lived quietly in Germany until he was exposed in 1959; eight canvases and several prints completed in 1963–64 depicting military aircraft in action or on the ground (not all were World War II planes nor were all German, but all were painted in a period when Allied bombing of Germany, NATO bases in Germany, and German rearmament were hotly contested issues); and *Uncle Rudi* (1965), the smiling portrait of the average Wehrmacht "soldier in the family." Whereas *Uncle Rudi* is a deliberately modest and richly ambiguous reminder of a past that people might prefer to forget, the Hitler painting is an anomalous attempt to represent demagogic tyranny. While *Herr Heyde* quotes newspaper sources that refer to the Nazi "murderers among us," the warplanes are, in conjunction with his contemporaneous paintings on the theme of death—*Coffin Bearers* (1962), *Dead* (1963), and even *Helga Matura* (1966) and *Eight Student Nurses* (1966)—more metaphoric than documentary. Together they foreshadow at an early stage Richter's later conviction that: "Reality may be regarded as wholly unacceptable. (At present, and as far back as we can see into the past, it takes the form of an unbroken string of cruelties. It pains, maltreats, and kills us. It is unjust, pitiless, pointless, and hopeless. We are at its mercy, and we are it.)"[1] Part of the explanation for his fascination with the Baader-Meinhof group's doomed but unshakable fixity of purpose, this profoundly pessimistic remark led Richter to a heavily qualified endorsement of the positive virtues of hope and faith: "The experience and knowledge of horror generate the will to change, enabling us to create altered conceptions of a better reality, and to work for their realization. Our capacity to know—that is to conceive—is also, simultaneously, our capacity to believe. Faith itself is primarily knowing and conceiving, but it simultaneously

Gerhard Richter. *Eight Student Nurses (Acht Lernschwestern)*. 1966. Oil on canvas, each 37 3/8 × 27 9/16" (95 × 70 cm). Kunstmuseum Winterthur. On permanent loan

Opposite: **Gerhard Richter.** *Dead (Tote)*. 1963. Oil on canvas, 39 3/4 × 59 1/16" (100 × 150 cm). Private collection. Frankfurt

becomes the polar opposite of knowing (in that it mentally transforms the known into something different) and thus becomes the means of surviving the knowledge of horror; this strategy we call Hope; Faith is consequently the extension and intensification of the instinct to life, to be alive. Looked at cynically, the capacity for faith is only the capacity to generate befuddlement, dreams, self-deceptions, as a way of partly forgetting reality; it's a pep-pill to get work started on realizing the conception. Looked at cynically, everything is pointless."[2]

Richter has repeatedly stated that his aim in commemorating the Stammheim prisoners was not political and not topical but a response to their misguided idealism. The fact remains, however, that for the first time in his career he chose subject matter that was unmistakably political and topical, and he devoted to it not a single work or a handful of works, but one of the few extended series of pictures he has undertaken and—compared to *48 Portraits* and others—by far the most complex.

So doing, Richter has also recuperated a genre—history painting—that has been for the most part consigned to art history's dustbin. In the eighteenth and nineteenth centuries, history painting had been the pinnacle of academic art, ranking ahead of but encompassing all the other categories—figure painting, portraiture, still life, and landscape. Originally the historical component of history painting was broadly defined, often mythic, and generally exclusive of current or even recent events. Instead, painters concerned themselves with noble principles and noble action in magnificent decors often borrowed from antiquity. And when they later turned their attentions to the present or near present it was usually for the glorification of the state and its illustrious men and women. History was the affair of heroes, and so was its artistic re-creation.

Bridging the two centuries, Jacques-Louis David was the quintessential history painter. Celebrating patriotic virtues in a Roman setting, *The Oath of*

the Horatii (1784) epitomizes the first type of history painting. David's *Le Sacre* (1805), in which the Emperor Napoleon I crowns his consort, represents the later type. Between them lies the French Revolution and David's portrait of Marat, a friend and radical Jacobin assassinated in his tub by Charlotte Corday. This is perhaps the first history painting devoted to the martyrdom of a radical opponent of the old order. With a simplicity that is more classical in its austerity and formal perfection than any of David's costume dramas, *The Death of Marat* (1793) is an essential precedent for Richter's *Man Shot Down 1* and *Man Shot Down 2*, including its allusion to Michelangelo's *Pietà*. For the record, David was an atheist and his formal reference to the sculpture in St. Peter's is no more proof of a hidden religious program in his work than are the redoubled references in Richter's two paintings of Baader. Moreover, the similarities between *Marat* and the Baader paintings are indirect rather than strictly genealogical. Asked if David had been an influence, Richter said, "One has half of art history in one's head, and of course that sort of thing does find its way in involuntarily—but as to taking something out of a given picture, that doesn't happen."[3]

As the power of the ancien régime declined in France after 1789, the evolution of history painting traced the vicissitudes of Republicanism through several attempts at monarchist restoration and further revolutionary outbreaks. Most of the artists with the formal training and access to public commissions and exhibition venues that this very public form required were privileged non-combatants in the political arena. Thus, for example, Eugène Delacroix, a patrician epicure, painted *Liberty Leading the People* (1830), while Gustave Courbet, the most radical artist of his day and an active participant in the ill-fated Commune of 1870–71 never painted history paintings, though he did limn a portrait of the pioneering anarchist Pierre-Joseph Proudhon in the curiously domestic company of his pinafore-dressed daughters.

The two greatest French history painters of the period were Théodore Géricault and Édouard Manet, and their contributions to the genre upset most of the assumptions and most of the conventions that had previously caused it to flourish under official patronage. Géricault's *The Raft of the Medusa* (1818–19) depicts the moment when survivors of the shipwrecked vessel *Medusa* sighted their rescuers at sea. The picture caused a scandal for two reasons; the first was political. The *Medusa* had been captained by an incompetent aristocrat who, with his officers, had taken flight and abandoned the common passengers to their fate, which, among other horrors, involved cannibalism. With the Revolution fresh in memory and royalism reentrenching itself, the social subtext of the painting was obvious. The second reason for the painting's notoriety was aesthetic; despite the dramatic scale and the invention of the picture, which melded romanticism and classicism as well as elements from Michelangelo's *Last Judgment* with painterly Sturm und Drang, and the statuesque figure in the upper right of the canvas waving to a ship in the distance, the painting had no identifiable hero, no great man.

The three versions of *The Execution of Maximilian* that Manet labored over from 1867 to 1868 mark decisive steps away from the grand manner Géricault had renovated.[4] Like *The Raft of the Medusa*, Manet's paintings were implicit critiques of the powers-that-be. Eager to expand his influence into the Americas, Napoleon III, who rose from president to emperor after a coup d'état in 1851, dispatched Archduke Maximilian of Austria and a small

Gerhard Richter. *Uncle Rudi (Onkel Rudi).* 1965. Oil on canvas, 34¼ × 19¹¹⁄₁₆" (87 × 50 cm). The Czech Museum of Fine Arts, Prague. Lidice Collection

expeditionary force to Mexico where the archduke was installed as emperor under French protection. That protection evaporated when revolutionary followers of the nationalist Benito Juarez stormed Mexico City and drove Maximilian out. Still refusing to abdicate, the emperor without an empire soon fell into the hands of Mexican forces who put him before a firing squad with two of his loyal generals. Together they died in vain but with valor. Pointing an accusing finger at Napoleon III by ennobling the man he had betrayed through inaction, Manet implicitly attacked the self-appointed personification of France, and because of this, none of the three paintings were shown in France during the artist's lifetime, and none found a permanent home there afterward.[5] All three of Manet's paintings record the instant of Maximilian's execution and memorialize the honorable deaths of the would-be emperor and his comrades, and all three would have fit neatly into the grand tradition of history painting but for the way in which this portrait of courage is constructed and presented.

Manet's tableaus were directly inspired by Francisco Goya's *The Executions of the Third of May* (1808). Perhaps the greatest of all nineteenth-century history paintings, it turns the slaughter of the common people of Madrid by Napoleonic troops—troops ostensibly bringing the French cause of Liberty, Equality, and Fraternity to benighted Spain—into a modern Golgotha. In his first rendition of Maximilian's last moments Manet exaggerated Goya's brushiness, and rearranged his composition, moving the massed executioners front and center while obscuring their victims in smoke. In the second version,

Opposite: **Francisco Goya.** *The Executions of the Third of May (El 3 de Mayo de 1808 en Madrid: Los fusilamientos en la montaña del Príncipe Pío).* 1808. Oil on canvas, 8' 9½" × 11' 4⅝" (268 × 347 cm). Museo Nacional del Prado, Madrid

Théodore Géricault. *The Raft of the Medusa (Le Radeau de la Méduse).* 1818–19. Oil on canvas, 16' 1¼" × 23' 5⅞" (491 × 716 cm). Musée du Louvre, Paris

Manet's brushwork tightened, the picture's focus sharpened, and the men facing death were pushed to the left-hand side of the canvas, counterbalanced on the right side by a distracted officer loading his rifle for the coup de grâce. Later the canvas was cut into irregular sections, four of which were reassembled and remounted. In the third and final version, Manet pulled back from the extreme close-up of the second version and reset his stage, adding landscape, a background wall, and a Goyaesque chorus of observers.

Manet is a painter the young Richter had hoped to emulate, and, along with David's *Marat*, his three Maximilian paintings belong to "the half of art history in one's head" that comes into focus when one looks at *October 18, 1977.* The aesthetic, as distinct from political, radicality of Manet's paintings rests on several factors that are most pronounced in the second version. First, the entire project was based on documentary evidence: not-always-reliable "eyewitness" reports in Paris newspapers, journalistic sketches made from those reports, and, most important, photographs of the execution site, the firing squad, the dead emperor, and his relics. Second, Manet's naturalism marks his shift away from romantic dramatization in the first version to cool observation and a matter-of-fact mise-en-scène in the second, a tendency reversed in the third, which is the most conventionally finished and least successful of the paintings. It was that detachment—epitomized by the soldier looking down at his weapon and away from the

Opposite, top: **Édouard Manet.** *Execution of the Emperor Maximilian (L'Exécution de Maximilien).* 1867. Oil on canvas, 6' 5⅛" × 8' 6¼" (196 × 259.8 cm). Museum of Fine Arts, Boston. Gift of Mr. and Mrs. Frank Gair Macomber

Opposite, bottom: **Édouard Manet.** *The Execution of Maximilian (L'Exécution de Maximilien).* c. 1867–68. Oil on canvas (four fragments), 6' 4" × 11' 3³⁄₁₆" (193 × 284 cm). National Gallery, London

Édouard Manet. *The Execution of Emperor Maximilian of Mexico (L'Exécution de Maximilien de Mexique).* 1867. Oil on canvas, 8' 3³⁄₁₆" × 10' 1⁄₁₆" (252 × 305 cm). Städtische Kunsthalle, Mannheim. Donated in memory of the Kunsthalle's reopening on December 5, 1909, by Louise Lauer, Ms. Scipio, born Gerdan, Kommerzienrat E. Mayer, Kommerzienrat E. Reinhardt, Geh. Kommerzienrat Dr. C. Reiß, Major W. Seubert and three anonymous donors

fusillade—that characterized the paradigm-altering modernity of Manet's, in many other ways, traditional work. Together these pictures give the executioners greater prominence than the martyrs, and the lone officer greater individuality than Maximilian. With a discreetly democratic inversion of hierarchies, Manet accords the latter figure a dignity unexpected in the depiction of a man doing his cold-blooded duty. Finally, there is the matter of the fragmented second version and its curiously photographic cropping, a quality that Edgar Degas, who specialized in such effects, must have recognized when he acquired the separate pieces, and that one cannot help but think of in relation to the disposition, varying sizes, and recropping of photographic images in Richter's *October 18,1977.* Contrary to modernist teleologies that regard the traffic between photography and painting as all in photography's direction, painting has taught artists over the last century and a half to look at photographs differently and to treat them differently in light of the ways painting has changed in response to photography during that interval. As far as the reciprocity of influence between mediums goes, the line linking Manet to Richter by way of photography spirals, rather than runs straight.[6]

The formal, procedural, and psychological shifts in emphasis Manet pioneered had great consequences for painting in general, but until Richter came along, Manet's anti-rhetorical approach had few echoes in history painting, which languished with the demise of the Salon and in the absence of patrons sophisticated enough to choose superior artists for major commissions. If Manet's experience was any indication, history painting was best

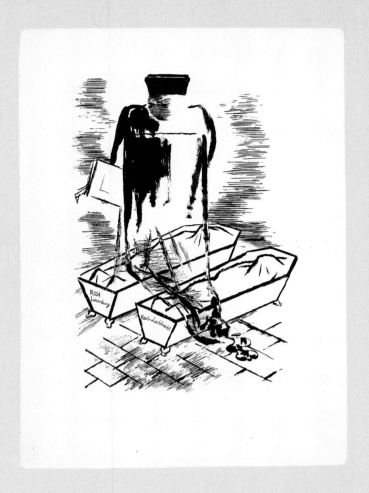

done "on spec"—as if it were portraiture, still life, or landscape painting—and at that there were no guarantees that it would ever find its audience.[7] By the twentieth century, when art sought to trumpet great causes, celebrate great leaders, or record great events it tended either toward expressionism or academic revivalism. Mexican muralism in the 1920s through the 1940s split exactly along these lines, with José Clemente Orozco at one extreme and Diego Rivera at the other. *Guernica* is another modern painting in the heroic mode, but it is arguable whether Picasso's masterpiece is history painting or an allegorical painting taking off from an historical event. Regardless of the arguments for either interpretation, as a hybrid of expressionism and Cubism, *Guernica* has nothing to do with Manet's innovations.

Frequently modern historically minded art hasn't been painting at all. In Germany many of the most compelling works of this kind—principally works dealing with World War I and the Revolution of 1919—were in graphic mediums: Max Beckmann's lithographs in his *Hell* portfolio come immediately to mind as do Käthe Kollwitz's prints—for example, her woodcut of the revolutionary Karl Liebknecht on his bier, *Commemorative Print for Karl Liebknecht*—and George Grosz's drawings and cartoons. An especially pointed example, a depiction of the murdered Liebknecht and his comrade Rosa Luxemburg in their coffins, offers a telling contrast with Kollwitz's bereaved image. But these too are expressionist or dramatically stylized works, and graphic art of roughly comparable sorts also flourished in Latin America and elsewhere in the decades between the two world wars. Back on the academic side, mean-

while, under Stalin's mandate, Socialist Realism produced warehouses full of history paintings, nearly all of which were stilted, overwrought, and frighteningly obedient to Communist Party dictation as well as grotesquely worshipful of the Communist Pantheon.[8]

Recent examples of ambitious history painting are few and far between. A blatantly reactionary one is *The Murder of Andreas Baader* (1977–78) by Odd Nerdrum, a former student of Beuys, who "reenacted" the alleged assassination of Baader in a style that mixes Caravaggio or Ribera-like compositional formats with B-movie costuming and props. Begun the year of Baader's death, when the reality of the RAF's confrontation with the state was still current, this absurdly anachronistic "J'accuse" sensationalizes its subject, reinforces the misconception that history painting is inherently old-fashioned in style, and turns the meaningful unknowns of Stammheim into a meaningless embroidery on the suspicion-inducing facts.[9] A far more complex and provocative case of contemporary art addressing a contemporary historical situation is Leon Golub's *Mercenaries IV* (1980), which brings postcolonial war-by-proxy home in the shape of a band of irregulars engaging in horseplay or on the verge of a face-off. A modern-dress frieze against a Pompeiian red ground, the unstretched mural-sized canvas deploys the conventions of history painting to pose politically loaded questions on a heroic scale, when plainly these men are no heroes. But what, then, are they up to, what have they done, for whom do they work? Nothing in the picture provides a satisfactory answer; nothing betrays the artist's position or simplifies ours. Therein lies the work's potency. It is as if Golub had taken Manet's second version of *The Execution of Maximilian* (c. 1867–68) and painted only the firing squad, and only after they had completed their lethal mission. Evolving out of panoramas protesting American involvement in Vietnam, Golub's Mercenary paintings moved attention from the unambiguous abuse of power to circumstances in which moral certainties teeter on the edge of pictorial uncertainties.

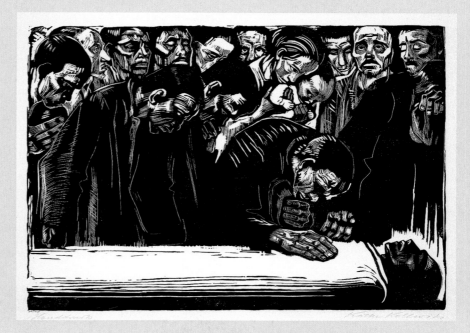

Käthe Kollwitz. *Commemorative Print for Karl Liebknecht (Gedenkblatt für Karl Liebknecht).* 1919–20. Woodcut, comp. 13¾ × 19⅝" (34.9 × 49.8 cm). The Museum of Modern Art, New York. The Philip and Lynn Straus Foundation Fund

Richter's ambivalence also cuts in multiple directions. First comes his decision to make paintings on a well-known series of events while not wanting them to be read either as partisan works or traditional history painting. "These pictures," he wrote, "possibly give rise to questions of political content or historical truth. Neither interests me in this instance."[10] The artist's desire to deflect such readings does not, however, automatically exempt his work from those categories—it may simply, or not at all simply, alter them forever. Indeed, by virtue of its very lack of polemical intent, the Baader-Meinhof cycle *re*politicizes the controversy surrounding the RAF, by redefining the parameters of a deadlocked debate and shifting it away from fixed polarities. Richter's is not an apolitical stance so much as one that cannot be aligned with existing political options. He pushes discussion past the reflex taking of sides, past self-protective neutrality, and past a "plague on both your houses" disengagement to a consideration of the internal flaws and inconsistencies of all available positions. Richter has not found a "third way"—Manichean ideology's phantom alternative—but by picturing doubt he has made the jagged cracks and spiderweb fissures in supposedly monolithic blocks of public opinion apparent along with those that cause private consciousness to ache.

Likewise, *October 18,1977* and its relation to history painting is not, as critics such as Benjamin Buchloh and Stefan Germer have asserted, a demonstration that the genre can no longer be practiced but, as was true for Manet, only that it can no longer be practiced as it had been before. Or, as Richter said of Romantic landscape painting, another genre he has revived

Odd Nerdrum. *The Murder of Andreas Baader (Mordet på Andreas Baader).* 1977–78. Oil on canvas, 10' 9¹⁵⁄₁₆" × 8' 10⁵⁄₁₆" (330 × 270 cm). Astrup Fearnley Collection, Oslo

Leon Golub. *Mercenaries IV.* 1980. Synthetic polymer paint on canvas, 47¼" × 7' 6⁹⁄₁₆" (120 × 230 cm). Collection Ulrich and Harriet Meyer

and transformed to the consternation of critics wedded to mid-twentieth-century modernist ideas about what painting must do and what it should never do again: "A painting by Caspar David Friedrich is not a thing of the past. What is past is only the set of circumstances that allowed it to be painted. It is therefore quite possible to paint like Caspar David Friedrich today."[11] The Baader-Meinhof cycle is not painted like anything by anyone else, and it was not painted for reasons other than Richter's own, but the problems it poses arise out of a tradition, and they manifest that tradition's struggle to adapt to new circumstances.

Both Buchloh and Germer base their arguments on the death of painting as a representational or communicative medium. Hence Buchloh writes: "But the history of history painting is itself a history of the withdrawal of a subject from painting's ability to represent, a withdrawal that ultimately generated the modernist notion of aesthetic autonomy."[12] And yet in *October 18,1977*, the optical withdrawal of the subject or subjects—the fading of Baader, Ensslin, and Meinhof into arid shadows—activates memory and the critical faculties that strain to bring them back, or partway back. Richter, in effect, summons the subject by depicting its imminent disappearance, aesthetically transferring responsibility for performing this task from the eyes to the intellect and the emotions. That this can never be fully achieved through representation or remembrance is essential to the work's pathos—and the point where inchoate feeling begins to take shape and to take over. Without this coordinated effort, forgetfulness would claim them sooner and beyond remedy. But, unmistakably, painting sets the process in motion, extending and guiding it in ways no photograph or text or alternative medium has done

or could do. Is *October 18, 1977* the last gasp of history painting? No, it is its first deep breath in over half a century. And if the air is thin and harsh that is because the atmosphere around us is comparably diminished and polluted.

Richter has referred to the series as a leave-taking. "Factually," he said, "these specific persons are dead; as a general statement death is a leave-taking. And then ideologically, a leave-taking from a specific doctrine of salvation and beyond that from the illusion that unacceptable circumstances of life can be changed by this conventional expedient of violent struggle (this kind of revolutionary thought and action is futile and passé)."[13] One might add that the kind of doctrinaire criticism that grew out of late 1960s and early 1970s radicalism has also run its course, namely, criticism based on the prediction that a definitive and salutary rupture with the past was at hand, with the corresponding assumption that all traditional mediums and conventions were soon to be swept away, and that if they lingered it could only be as ghosts or vacant simulacra of their former selves. Undeniably the near-death of modernist painting in those years, and the gaudy rise of postmodern painting in the 1980s had a profound impact on Richter's thinking and has given his work much of its rigor and its poignancy. Unless he himself had felt that painting was endangered, he could not have overcome his self-mocking belief that the discipline he practiced daily was "total idiocy," nor could he have made the extraordinary effort to rescue that discipline from obsolescence and triviality, an effort that has culminated in *October 18, 1977*.[14] The one thing that the cycle is not, therefore, is a "leave-taking" from painting. On the contrary it is a startling reengagement with a much abused and much maligned art form. Ideologically inflexible criticism, which sidesteps this hard-won recommitment and refuses to grapple with the embattled but unapologetic sincerity of Richter's faith in painting's prospects and art's potentially redemptive function, is clinging to the received wisdom of a bygone period just as surely as any avowedly conservative school of thought. Such criticism builds a wall of dogma around an unadmitted nostalgia for a future that came and went and was never so glorious as it was supposed to be—or just never arrived at all. Richter has no more use for such nostalgia than he has for updated mirages of progress. Neither an avant-garde ironist nor a cynic, he is, instead, a stoic who contemplates the probable futility of his endeavor with a Samuel Beckett-like wit and melancholy, and then, Beckett-like still, goes stubbornly back to work. It was Beuys's contention that the silence of Duchamp was overrated. To those who have routinely allied Dada strategy with sociopolitical theory, Richter has parried with the modest proposal that, perhaps, the irony of post-Duchampian aesthetics is overrated as well.

That Richter began to drop his guard after completing *October 18, 1977* is just one indication of the change in emphasis that the work itself has undergone. Lest frequent use of quotations here be seized upon as overeagerness to accept the artist's intentions as the sole criteria for judging his art, it should be noted that writers anxious to embrace Richter as a deconstructionist member of the avant-garde have been at least as quick to cite his words in support of their elaborately selective arguments. Deaf to the artist's tone and incurious about his creative survival tactics, they have done so at the expense of a deeper and more nuanced appreciation of his overriding aims. Speaking to an interviewer in 1990, Richter explained his earlier evasions and mixed messages this way: "My own statements about my lack of style and

lack of opinion were largely polemical gestures against contemporary trends that I disliked—or else they were self-protective statements designed to create a climate in which I could paint what I wanted," later adding, "If I ever did admit to any irony, I did so for the sake of a quiet life."[15]

Likewise, those who take a less-than-full account of the human pain and sadness embedded in *October 18, 1977* in haste to integrate them into narrowly defined social or formal discourses do the work a disservice. On this score, as well, Richter has been forthright. "It is impossible for me to interpret the pictures," he has said. "That is, in the first place they are too emotional: they are, if possible, an expression of a speechless emotion. They are the almost forlorn attempt to give shape to feelings of compassion, grief, and horror (as if the pictorial repetition of events were a way of understanding those events, being able to live with them)."[16] Elsewhere the artist has spoken of "dismay," and "pity." Taken together, these are not "aesthetic" sentiments, or matters of opinion, they are empathetic responses to suffering, and Richter's work is frankly intended to stimulate similar responses in the viewer. A lament, *October 18, 1977* is, at the same time, a wager on painting's expressive power over and above its impotence in the face of irremediable misunderstanding and misfortune.

For their part, some writers responding to the cycle in this spirit have gone on to speak of the work as a eulogy or requiem for its subjects.[17] This is true, but as nearly every commentator agrees, established forms of mourning and the artistic translation and relocation of those forms are inadequate to the task of purging the sorrow and anguish from which these images draw their force. As historical paintings they remain eloquently unresolved; as a contemporary requiem they stop short of transfiguration. Thus, from a postmodernist perspective, Germer writes with a keen sense of the work's capacity to frustrate the desire for unwarranted closure: "As in the case of Manet, in Richter's work history painting must be seen as monuments of mourning, as a lament for loss, which painting cannot alleviate or soothe, but must assert in its full brutality. . . . Richter's series stresses the moral necessity of painting at precisely the juncture where it becomes aware of its own limitations: this is the consequence of that medium's socially marginal position, and involves a concomitant loss of its transformative or consoling functions. . . . The fact that these paintings slip from our grasp, escape hasty categorization, and fail to overcome their subject matter, gives their content an uncanny character which is due to the fact that it has not been transformed, since the social process of mourning is still blocked by psychological repression."[18]

In this latter regard, Richter's involvement perfectly matches that of his presumptive public. "The deaths of the terrorists, and the related events both before and after stand for a horror that distressed me and has haunted me as unfinished business ever since, despite all my efforts to suppress it," he wrote.[19] Rather than preaching to the converted of whatever persuasion, the paintings actively do the never-to-be-completed work of mourning on behalf of those who have postponed it and in the process deferred their personal reckoning between past convictions and present realities. For Richter the Baader-Meinhof group is the fulcrum of a long seesawing struggle with himself. Having left East Germany behind in the early 1960s, and with it any residual susceptibility to Marxism, Richter operated as a creative free agent in the improvisatory art world of West Germany until the late 1960s, when that scene began to fragment and the new Left asserted its claims and, in the

process, reasserted those of Marxism. Although disinclined to revise his fundamental social and philosophical views, Richter acknowledged this resurgent radicalism as a serious challenge to the status quo both within his milieu and in the increasingly conservative society outside it. While there are no grounds for second-guessing Richter's declaration that politics or history per se are not his real concern, his moral and artistic consciousness was plainly thrown into turmoil by political and historical forces. It is one thing to live without orthodoxy, another to live without belief of any kind; one thing to live without optimism another to live without the least hope that something of value can be salvaged from the wreckage of history. Thus the debacle of the RAF paradoxically revived Richter's sense of the stakes for which he was playing.

Richter pulls no punches in his assessment of the RAF members. Baader elicits the least sympathy from him, Meinhof and Ensslin the most. It is they who embody the positive "will to change" he reluctantly admired. "I do think the women played the more important role in it," he said. "They impressed me much more than the men."[20] A painterly aside reinforced this impression in 1988 and anchored the artist's preoccupations in his immediate circumstances. Toward the end of the long gestation of the cycle Richter took time out to paint a single, full-color head-and-shoulders portrait of a girl or young woman seen from behind. Wearing a bright red-and-white patterned sweater, the sitter was his then teenaged daughter, Betty. The opaque background of the picture is one of the large gray monochromes Richter painted shortly before the photograph from which *Betty* was derived was taken, sometime in 1977. Juxtaposing that dark flat surface with her vital, fully dimensional form in a compressed pictorial space Richter staged a confrontation between two styles of painting and, implicitly, between the two realities in which he lived in the months leading up to the Stammheim crisis: the coming of age of a new generation over whose head hung the pall of the German Autumn of 1977, and his own attempts to break through the end-game logic of avant-garde art that preoccupied him. Rather than look ahead at the viewer or into the future, Betty casts a glance backward into a void that seems impenetrable at first, but then swells forward like a looming storm cloud. Thus, after months of painting death, Richter gave himself a respite and painted life, pairing in his own mind the image of Betty with a spectral likeness of the rejuvenated Meinhof. Almost hermetic in its iconography and retrospective on several levels, in its fashion *Betty*, too, is history painting.

If, in this deceptively simple image, Richter subtly links the youth of 1988 to that of twenty years earlier—as if Betty were staring into a mirror of the sort the painter began fabricating around that time—Richter resists identifying himself with the rebels. It is, after all, not the terrorists' ideas that he instinctively understood, but their desperation and their penchant for violence. At this level, destructive anger directed at authority psychologically dovetails with vengeful hatred of the RAF. That is the trap the paintings set for viewers who seek to exempt themselves from the grim alternatives Richter puts before them: "If people wanted to see these people hanged as criminals, that's only part of it: there's something else that puts an additional fear into people, namely that they themselves are terrorists. And that *is* forbidden. So this terrorism is inside all of us, that's what generates the rage and fear, and that's what I don't want anymore than I want the policeman inside myself—there's never just one side to us. We're always both: the state *and* the terrorist."[21]

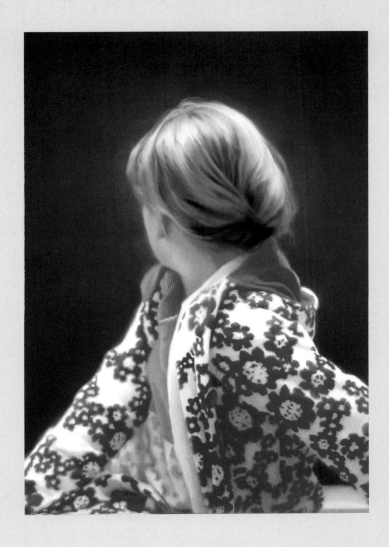

The split in Richter's own mind goes deeper still. In the same breath
that he says "I was impressed by the terrorists' energy, their uncompromising
determination and their absolute bravery," he adds, "but I could not find it in
my heart to condemn the state for its harsh response. That is what states are
like: and I have known other, more ruthless ones."[22] In short, both the terror-
ists and the state acted in accordance with their given roles and their own
sense of necessity, and Richter, standing apart from the antagonists, sees the
fatal logic of both positions and is torn between respect for the former and
acceptance of the latter.[23] If, in light of these dynamics, the basic themes of
October 18, 1977 are the sources and inescapable consequences of rational-
ized faith, or ideology, and the link between ideological commitment and
death—either death meted out in the name of a cause or death suffered for
that same cause—then underlying its status as history painting reinvented,
Richter's cycle is also predicated on the pictorial reinvention of tragedy.

These days the word tragedy is carelessly applied. Every airplane crash,
every cataclysmic flood or fire is a tragedy in the headlines, prompting
Warhol's voyeuristic but dry-eyed correctives to the oversold drama of tabloid
death. True tragedy involves more than unforeseen or accidental calamity.
The pathos of such banal misfortunes is basically unproblematic; however,
tragedy is always and essentially problematic. Classically it results from defects
in human character and the misapprehension of human situations that lead

ineluctably to the undoing of those condemned to play out the parts they have chosen or accepted. Richter's statements about the respective conduct of terrorists and the state implicitly recast the story of the RAF in this mold.

He was not alone in drawing such a conclusion. A segment of the collaborative film *Germany in Autumn* (1977–78), scripted by Heinrich Böll, focuses on a group of filmmakers and television programmers who have gathered to discuss a new production of Sophocles' *Antigone*.[24] Intercutting scenes from the play and snatches of dialogue among the executives, the scenario draws explicit parallels between the case of the Baader-Meinhof group and the dire ramifications of Antigone's decision to enlist her sister Ismene in the effort to bury their brother Polynices, whom Creon, King of Thebes, has decreed shall rot unmourned outside the city's walls because he raised his hand against the state. Ismene initially resists Antigone's entreaties, but finally comes to her aid. When, as punishment for her defiance, Creon imprisons Antigone in an isolated cell rather than execute her, she hangs herself. Conversation around the television-station meeting table centers on what sort of disclaimer dissociating the producers from the violence of the play should be used to introduce the film, and the ensuing debate draws out the correspondences between the "terrorist women of the fifth century B.C." and those of the late twentieth. In the end, the programmers set the film aside for a future date when, in the words of one of them, the young would not be so likely to view it as an incitement to subversion.

Superficially this sequence is a bitter commentary on media cowardice—"the next thing you will say is 'censorship' and 'fascism,'" one executive shouts in a self-betraying retort to a colleague who defends the film—but the strength of the vignette lies less in this satire than in the aptness of *Antigone* to the situation facing Germany at that time. Parts of the play not shown on screen deepen those connections. Creon is the incarnation of established order. The slain Polynices was his natural adversary but, assuming the prerogatives of men while refusing to heed even the restrictions imposed on them, Antigone and Ismene constitute a greater and more subtle threat to authority. The dilemma of Haimon, Creon's son and Antigone's betrothed, represents the plight of those caught between duty and passion, patriotism and personal loyalty. When Creon accuses him of standing up for anarchy by speaking on Antigone's behalf Haimon protests. When Creon refuses to hear that other notables in the city do not see her as a criminal and declares himself the sole voice for the collectivity, Haimon answers that if that is so, "the state is a desert." Yet Antigone's resistance to Creon is not rooted in the lust for power or a longing for chaos but rather in a sense of justice. Nor does she accept Creon's argument that by seeking to honor Polynices she insults the memory of her other brother Eteocles, who was killed defending Thebes alongside Creon. Instead, she asserts: "There is no guilt in reverence for the dead."[25] Nevertheless, Creon and Antigone are locked in a mortal combat of wills that he will not break and she, equally intransigent, cannot survive.

It is unnecessary to spell out the connections between *Antigone*'s theme and the German crisis of 1977 in any greater detail. However, a crucial distinction between Richter's treatment of the Baader-Meinhof story and Sophocles' play remains. Aristotelian tragedy rests on the concept of catharsis. In the end, Creon's rigidity precipitates not only Antigone's death but Haimon's suicide as well, and with it the destruction of his father's world. The

costly wisdom the king achieves and the moral and social lessons taught the public are the justification of the suffering he endures and they witness. Richter's paintings offer no such consolation. Instead, they reconfigure tragedy's structure along the lines sketched by Bertolt Brecht's evolving concept of epic theater. Rather than identification with the characters, Brechtian drama creates distance between them and the audience; rather than involving the public with the action, as was true in classical dramaturgy, it confronts the public with difficult choices; rather than smooth transitions from scene to scene it presents discontinuous self-contained episodes; rather than emotional release, it leaves the viewer with unsolved problems and persistent intellectual and spiritual discomfort. Richter's paintings do much the same.

Of course, no precise analogy can exist between modern painting and modern theater. Nor is Richter a student of Brechtian theory. But the terms classical tragedy proposed, and Brecht altered, offer us a better way to approach Richter's October cycle and his world view generally than those currently dominating art discourse. Suppose you are an artist beset by a sense of the cruelty of the world and the fallibility—or worse, criminality—of the ideological systems designed to make that world perfect. Suppose you are a witness to your times but see in the miseries and follies around you something more than particular historical causes and effects, something larger that refracts, as if through a cracked prism, or reflects, as if in a smudged mirror, the workings of a society at war with itself and men and women at war with their own contradictory selves. But suppose, also, that unlike the artists of the past who placed their trust in capricious Gods, in one inscrutable God, or in a fine-tuned philosophical construct, that faith in an overarching order or principle that might somehow make sense of these horrors and set right the discord that produced them, no longer held against the onslaught of violence and unreason and the mounting evidence that there is no end to it. To speak in this context of a work addressed to the human condition is not to affirm the existence of the singular, self-contained subject or any fixed and therefore reactionary definition of human nature. Rather, it posits a continuum of restless identities within each individual and a correspondingly unstable continuum of attitudes and instincts within the society to which they belong, all of which ensure perpetual disquiet, force ceaseless self-examination, disallow any rigidly consistent set of standards of right and wrong, and in the final analysis promise no relief, only contingent insight and renewed uncertainty. It is a bleak vision, and a fully tragic one that points to the desire to master what we imperfectly comprehend as the origin of our error and exposes the temptation to master others with that flawed self-awareness as the harbinger of our downfall.

As in Brechtian tragedy, Richter creates a distance that accentuates tensions rather than lessening them, that heightens emotions rather than cools them, such that we are left puzzled and agitated, though unlike Brecht Richter stage-whispers no marching orders. But Richter has taken matters further. Traditional tragedy ends with the death of the hero, but October 18, 1977 is devoid of heroes. Neither are there clear-cut antiheroes in the modernist tradition. Disconcerting partisans on every side, he has taken the radical step of subtracting heroism and villainy from the equation altogether. Moreover, the men and women he paints are not "characters" at all. Actual people filtered through compound layers of representation that simultaneously concentrate

our attention and destroy the illusion of transparent reality, they are put before us with a reticence that transfers the burden of response and interpretation from the author of the pictures, and what he knows or thinks, to viewers and to what we, with ever increasing ambiguity, recall or surmise. Thus, what we see in these images of Baader, Ensslin, Meins, and Meinhof are figments of our unreliable grasp of history and our fluctuating response to its undecided questions. Beyond that, they are personifications of the collective passions and delusions of their time and ours and of the horrendous effects of that era's and this one's equally collective urge to smother dissent and banish discontent.

The deaths of the Stammheim prisoners did not end the tragedy in which they participated but merely punctuated the one in which we are still actors and from which, Richter's paintings make plain, we will not exit unsullied or unscathed. At the end of the twentieth century, which has seen so much tragedy but whose art has too often retreated from the difficulties of the tragic mode and sought safety in closed formal logic or moral and political didacticism, Richter has restored and fundamentally remade that enigmatic, unforgiving, and indispensable form.

Some may argue that the transformation of current, or near-current, historical events into tragedy removes them from the heat of political and cultural contention and aestheticizes them in a detrimental fashion. But the truth is that the *agon* that came to its conclusion on October 18, 1977, has already receded from us. Reportage and archival information can, within limits, reconstitute the context in which it occurred, but only simultaneously evocative and resistant aesthetic means will preserve its painful and confounding essence. Furthermore, much of the photographic documentation upon which Richter drew is now out of reach in government and news-magazine dossiers that are not readily available to scholars and the public. Consequently, not the least of the paradoxes of the present situation is that the only form in which some of these images can readily be seen is in Richter's rendition of them. Time, bureaucratic policy, and the material immediacy of painting have thus conspired to make *October 18, 1977* the most actual and accessible representation we have, even as the paintings underscore the unreliability of official versions (or any other version) of the record, while deepening the anguish and sorrow that suffuses the images in all their previous incarnations.

Richter's achievement has been an almost solitary one, and there is no reason to suppose that he will find followers, and none at all to think that he would welcome them. Style can be imitated but the psychological and intellectual chemistry that produced *October 18, 1977* and that confirms the tragic dimension in his earlier work is unique to the painter, even though the work itself speaks to a large public in direct and disturbing ways. We should not be surprised, then, that Richter has so little artistic company, nor should the lack of it cause us to doubt that he is doing what our eyes and minds tell us he is doing or to prompt us to rearrange our impressions and understanding the better to fit him into a well-populated aesthetic category or camp. Instead, we must start from the realization that *October 18, 1977* is the exception to painting in this period, and not the rule. Nor does it codify new laws. Rather, it requires us to set aside the assumptions and unwrite the critical formulas that currently impede thought and inhibit feeling. The reward for this is an imaginative freedom Richter has fought hard to secure for himself, and it is a freedom he offers to anyone willing to invite the discomfort he has come to

Gerhard Richter. *Self-Portrait*. 1996. Oil on canvas, 20 1/8 × 18 1/4" (51.1 × 46.4 cm). The Museum of Modern Art, New York. Fractional and promised gift of Ronald S. Lauder and Committee on Painting and Sculpture Funds

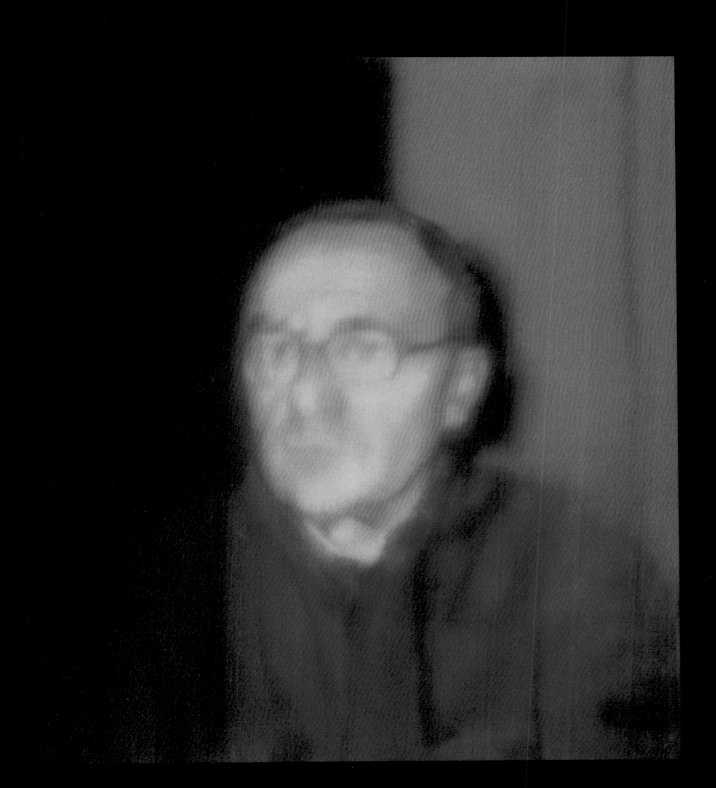

accept. It is a conditional offer, therefore, and in every respect an unusual and demanding one. But, after all, while at any given moment powerful and compelling art may be relatively plentiful, great art is always rare.

Asked if it was difficult to be surrounded for a long time by such lugubrious images, Richter answered laconically: "It was hard. But it was connected to work. I didn't have to look at the dead inactively, I could do something. As I paint the dead I am occupied like a gravedigger."[26] Although Meinhof lies buried in Berlin and Baader, Ensslin, and Raspe were interred together in a Stuttgart cemetery almost a quarter century ago, in another sense they and all that they represented have, like Polynices, been left out in the open and neglected. Richter has, in effect, lightly covered them with dust, but he has not presumed to remove from sight what it is not in his power to lay to rest. Quite the contrary: with his austere, perplexing, prodding, and relentless self-critical art, he has made them more visible.

Gerhard Richter. *Stammheim*. 1994. Oil on printed paper, from Pieter H. Bakker Schut *Stammheim: Der Prozess gegen die Rote Armee Fraktion*. Kiel: Neuer Malik Verlag, 1986. Set of twenty-three pages (one shown), each 7 1/2 × 4 1/2" (19 × 11.6 cm). Private collection

NOTES

1. "Notes for a Press Conference, November–December 1989," in Hans Ulrich Obrist, ed., *Gerhard Richter, The Daily Practice of Painting. Writings and Interviews, 1962–1993* (London: Thames & Hudson and Anthony d'Offay Gallery, 1995), p. 174. A so-called rubble film like Rossellini's *Germany Year Zero* contributed a phrase to the language and was a rare example of a German movie of the immediate postwar years dealing with the theme of the war criminal next door.

2. Ibid., p. 175.

3. "Conversation with Jan Thorn-Prikker Concerning the Cycle 18 October 1977, 1989," in ibid., p. 199.

4. In addition to the three versions of the *Execution of Maximilian*, Manet painted three other pictures on historical themes, two of the escape from a prison island of the exiled communard Henri Rochefort; and one of a naval engagement from the American Civil War, *The Battle of the Kersage and the Alabama* (1864). Manet also made two lithographs of images from the last bloody days of the Paris Commune of 1871, *The Barricade* (1871), in which Republican troops execute rebels; and *Civil War* (1871–73), showing a dead communard in a pose similar to Manet's *The Dead Toreador* (1864–65), which has been spoken of as a precedent for Richter's *Man Shot Down 1* and *Man Shot Down 2*; the connection is tenuous at best.

5. The first version, Manet's *Execution of the Emperor Maximilian,* is in the Museum of Fine Arts, Boston; the second, partially destroyed, version, which once belonged to Edgar Degas now hangs in the National Gallery in London; and the third is in the Städtische Kunsthalle, Mannheim.

6. It is interesting to note that in 1999–2000, Jasper Johns made a painting and at least one drawing based on the London version of Manet's *The Execution of Maximilian* in which he obliterated the images, working only with the contours of the rectangular fragments, and interwove Manet's name with those of Degas and himself.

7. Like traditional history painting, *October 18, 1977* includes all these genres, but rather than synthesize them into a single unified image, presents them sequentially: *Youth Portrait* (portrait); *Confrontation 1, Confrontation 2, Confrontation 3* (figure study); *Record Player* (still life); and *Funeral* (landscape).

8. A rare exception is Isaak Brodsky's *Lenin in Smolny* (1930). To be sure, this image of an ascetic Lenin is propaganda, but its aesthetic reserve partially redeems its formal conservativism. Brodsky's picture is a reminder that within countries where Socialist Realism held total sway not all the permissible models were equally bombastic or clichéd. This was true of East Germany when Richter attended the Dresden Academy, though his preferences in the 1950s were Picasso and Renato Gutusso, whose differing brands of modified modernism—think of *Massacre in Korea* (1951), Picasso's grotesque and cartoonish reprise of Goya's *The Executions of the Third of May* (1808)—were excused by Stalinist cultural bureaucrats because of the artists' allegiance to the Communist Party.

9. It was Nerdrum's painting Richter was no doubt referring to when, asked whether photography now sets an aesthetic norm that prevents an artist from painting such a theme out of his head, he answered, "I do know one such picture, by a Norwegian painter, rather old-masterish, as phoney as [the East German painter] Werner Tübke. Now photography is so unsurpassed by definition, it's changed everything so greatly, there's just nothing to be said." "Conversation with Jan Thorn-Prikker," in Richter, *Daily Practice*, p. 187.

10. "Notes for a Press Conference, November–December, 1989," in ibid., p. 174.

11. "To Jean-Christophe Ammann, February 1973," in ibid., p. 81.

12. Benjamin H. D. Buchloh, "A Note on Gerhard Richter's *October 18, 1977*," *October* 48 (spring 1989), p. 93.

13. "Notes, 1989, " in Richter, *Daily Practice*, p. 178.

14. "Notes, 1973," in ibid., p. 78.

15. "Interview with Sabine Schütz, 1990," in ibid., p. 211. Richter's distrust of theory comes out repeatedly in recent years and never more clearly than in this interview, which makes it abundantly clear how perverse it is for those who maintain that everything is "text" to have chosen as their star witness someone so positive about art's ability to bring other nontextual resources and constructs to bear on experience. "Intellectuals are far more endangered than ordinary people or artists. They're intelligent, very good with handling words and therefore brilliant at constructing theories, and they share in the overwhelming power of words. Almost everything is prompted, forbidden, or authorized by words; explained, transfigured, or falsified by words. So we ought to be skeptical, and not forget that there's another, highly important kind of experience. Whatever we experience nonverbally—by sight, touch, hearing or whatever—gives us a certainty or a knowledge that can lead to better actions and decisions than any theory. . . . The problem is, however, that a theory can be so logical in its own terms, so complicated, so intricate—almost as complex as life—that you're compelled to go along with it because it is so convincing or so beautiful." Ibid., p. 213.

16. "Notes for a Press Conference, November–December 1989," in ibid., p. 174.

17. Ibid., p. 178, and Hannes Böhringer, quoted in Jean-Christophe Ammann, *Gerhard Richter: 18. Oktober, 1977* (Frankfurt am Main: Museum für Moderne Kunst, 1991), p. 2.

18. Stefan Germer, "Ungebetene Erinnerung," in *Gerhard Richter: 18. Oktober, 1977* (Frankfurt: Portikus; Cologne: Buchhandlung Walther König, 1989), p. 53.

19. "Notes for a Press Conference, November–December 1989," in Richter, *Daily Practice*, pp. 173–74.

20. "Conversation with Jan Thorn-Prikker," in ibid., p. 190.

21. Ibid., p. 186.

22. "Notes for a Press Conference, November–December, 1989," in ibid., p. 173.

23. Whether Baader, Ensslin, Meinhof, and Raspe committed suicide or were murdered is less of an issue for the artist than the inevitability of their dying as a result of their confrontation with authority. When asked what prompted his compassion for the RAF, Richter answered: "The death that the terrorists had to suffer. They probably did kill themselves which for me makes it all the more terrible. Compassion also for the failure; the fact that an illusion of being able to change the world has failed." "Interview with Jan Thorn-Prikker," in ibid., pp. 203–04.

24. The directors of *Germany in Autumn* are Rainer Werner Fassbinder, Alexander Kluge, Volker Schlöndorff, Bernhard Sinkel, Alf Brustellin, Edgar Reitz, Katja Rupé, Hans Peter Cloos, Beate Mainka-Jellinghaus, Maximiliane Mainka, and Peter Schupert.

25. Sophocles, *Antigone: The Oedipus Cycle,* trans. Dudley Fitts and Robert Fitzgerald (New York: Harcourt Brace & Company, 1949), p. 210.

26. Stefan Weirich, "RAF in Wort und Bild. Aus dem Leben: Eine schwierige Geschichte: Gerhard Richter und der Deutsche Herbst," *Die Tageszeitung* (December 28, 1993), p.12.

BIBLIOGRAPHY

Compiled by Catharina Manchanda

This bibliography cites published material on Gerhard Richter's fifteen paintings titled *October 18, 1977* and is organized into six groups: writings and interviews; monographs; essays and articles; exhibition catalogues; exhibition reviews; and a section on The Museum of Modern Art's purchase of these paintings. In the section on writings and interviews, the citation *Gerhard Richter: The Daily Practice of Painting. Writings and Interviews, 1962–1993*, edited by Hans-Ulrich Obrist, is listed in abbreviated form in subsequent entries as *The Daily Practice of Painting*; similarly, in this section, the anthology of interviews, reviews, and writings edited by Ulrich Wilmes, *Presseberichte zu Gerhard Richter 18.Oktober 1977,* is referred to in later citations as *Presseberichte*. All of the interviews are with Richter, unless otherwise noted. Reviews of the exhibitions are listed under their respective exhibition titles. These reviews are limited to articles published in response to the shows in Krefeld and Frankfurt, as well as at subsequent venues in Europe and the United States between 1989 and 1991.

WRITINGS AND INTERVIEWS
Writings

Obrist, Hans-Ulrich, ed. *Gerhard Richter: The Daily Practice of Painting. Writings and Interviews, 1962–1993*. Cambridge, Mass.: MIT Press; London: Anthony d'Offay Gallery, 1995. German ed., *Gerhard Richter: Texte.* Leipzig and Frankfurt: Insel Verlag, 1993.

Richter, Gerhard. "Notes for a Press Conference, November–December 1988." In *Gerhard Richter: The Daily Practice of Painting. Writings and Interviews, 1962–1993*. Cambridge, Mass.: MIT Press; London: Anthony d'Offay Gallery, 1995, 173–75.

Wilmes, Ulrich, ed. *Presseberichte zu Gerhard Richter 18. Oktober 1977.* Frankfurt: Museum für Moderne Kunst, Frankfurt; Cologne: Verlag der Buchhandlung Walther König, 1989.

Interviews

Ammann, Jean-Christophe. "Das Werk als Menetekel." *ZYMA* 5 (November/December 1989): 18–21; reprinted in *Presseberichte,* 129–31. Interview with Ammann.

Butin, Hubertus. "Kulturpolitik—Gespräche mit Künstlern. Gerhard Richter. Richters RAF-Zyklus nach New York verkauft: Kultureller Gewinn oder Verlust?" *Kunstforum International* 132 (November 1995–January 1996): 432–35.

———. "Mit der RAF ins Museum of Modern Art: Gerhard Richter im Gespräch." *Neue Zürcher Zeitung*, international edition (October 23, 1995): 21.

Graw, Isabelle. "View. Gerhard Richter: '18. Oktober 1977.'" *Artscribe International* 9/10 (September/October 1989): 7–9; reprinted in English and German in *Presseberichte*, 96–98; 99–103, as Interview with Benjamin H. D. Buchloh.

Koldehoff, Stefan. "Stammheim in New York. Das ist nichts speziell Deutsches: Gerhard Richter über den Verkauf seines Gemäldezyklus '18. Oktober 1977.'" *Die Tageszeitung* (Berlin) (October 28/29, 1995): 15.

Magnani, Gregorio. "Gerhard Richter: For Me It Is Absolutely Necessary that the Baader-Meinhof Is a Subject for Art." *Flash Art,* international edition, 146 (May/June 1989): 94–97; reprinted in *Presseberichte*, 67–69.

Schütz, Sabine. "Gerhard Richter." *Journal of Contemporary Art* 2 (fall/winter 1990): 34–46; reprinted in *The Daily Practice of Painting*, 207–18.

Storsve, Jonas. "Gerhard Richter: La Peinture à venir." *Art Press* 161 (September 1991): 12–20; reprinted in *The Daily Practice of Painting*, 223–31.

Thorn-Prikker, Jan. "Ruminations on the October 18, 1977 Cycle." *Parkett* 19 (March 1989): 143–53; reprinted as "Conversation with Jan Thorn Prikker

Concerning the Cycle *18 October 1977, 1989*." In *The Daily Practice of Painting*, 183–207; also reprinted in *Presseberichte*, 20–35.

Weirich, Stefan. "RAF in Wort und Bild. Aus dem Leben: Eine schwierige Geschichte: Gerhard Richter und der Deutsche Herbst." *Die Tageszeitung* (Berlin) (December 28, 1993): 2, 12.

MONOGRAPHS

Butin, Hubertus. *Zu Richters Oktober-Bildern*. Cologne: Verlag der Buchhandlung Walther König, 1991.

Friedel, Helmut, and Ulrich Wilmes, eds. *Gerhard Richter: Atlas of the Photographs, Collages and Sketches*. London: Thames and Hudson and Anthony d'Offay; New York: Marian Goodman, 1997. German ed., *Gerhard Richter: Atlas der Skizzen, Fotos und Collagen*. Munich: Lenbachhaus; Cologne: Oktagon Verlag, 1997. On plates 470–79 the artist assembled photographs depicting members of the Red Army Faction (RAF). Richter arrived at these images by rephotographing previously published media and police photographs in an out-of-focus manner.

Gerhard Richter: Stammheim. London: Anthony d'Offay Gallery, 1995. This publication illustrates a 1995 work by Richter: twenty-three painted pages from Pieter H. Bakker Schut's 1986 book *Stammheim: The Case Against the RAF*.

Hemken, Kai-Uwe. *Gerhard Richter: 18. Oktober 1977*. Frankfurt and Leipzig: Insel Verlag, 1998.

Henatsch, Martin. *Gerhard Richter 18. Oktober 1977: Das verwischte Bild der Geschichte*. Frankfurt: Fischer Taschenbuch Verlag, 1998.

Kolb, Henriette. "Gerhard Richter: 18. Oktober 1977." Master's thesis, Berlin: Freie Universität Berlin, Fachbereich Geschichtswissenschaften, 1998.

ESSAYS AND ARTICLES

Ammann, Jean-Christophe. "Gerhard Richter: *18. Oktober 1977*." Museum brochure. Frankfurt: Museum für Moderne Kunst, n.p.; n.d.

Asherson, Neal. "Revolution and Restoration: Conflicts in the Making of Modern Germany." In *Gerhard Richter*. London: The Tate Gallery, 1991, 33–39.

Beaucamp, Eduard. "Ein Test." *Frankfurter Allgemeine Zeitung* (October 27, 1989): 33; reprinted in *Presseberichte*, 116. A response by Wolfgang Röller, representative of Dresdner Bank, appeared in a subsequent issue.

Brehm, Margrit. "The Constitution of Visual Truth During Painting." In Jochen Poetter, ed., *Sammlung Frieder Burda: Gerhard Richter, Sigmar Polke, Arnulf Rainer*. Baden-Baden: Staatliche Kunsthalle Baden-Baden, 1996: 43–52.

Buchloh, Benjamin H. D. "A Note on Gerhard Richter's *October 18, 1977*." *October* 48 (spring 1989): 88–109; reprinted in *Presseberichte*, 48–52.

_____. "Gerhard Richter: *18. Oktober 1977*." In *Gerhard Richter: 18. Oktober 1977*. Krefeld: Museum Haus Esters; Frankfurt: Portikus; Cologne: Buchhandlung Walther König, 1989, 55–59. The two Buchloh texts overlap in parts. The German essay is longer and more detailed.

Chevrier, Jean-François. "Between the Fine Arts and the Media (The German Example: Gerhard Richter)." In Benjamin H. D. Buchloh et al., *Photography and Painting in the Work of Gerhard Richter: Four Essays on Atlas*. 2nd ed. Barcelona: Consorci del Museu d'Art Contemporani de Barcelona, 2000, 31–59.

Drathen, Doris von. "Les Pouvoirs de l'abstraction." *Les Cahiers du Musée National d'Art Moderne* 40 (summer 1992): 66–85.

Germer, Stefan. "Le Retour du refoulé: Le traitement de l'histoire Allemande chez Georg Baselitz, Anselm Kiefer, Jörg Immendorff et Gerhard Richter." *Les Cahiers du Musée National d'Art Moderne* 48 (summer 1994): 82–99.

_____. "Ungebetene Erinnerung." In *Gerhard Richter. 18. Oktober 1977*. Krefeld: Museum Haus Esters; Frankfurt: Portikus; Cologne: Buchhandlung Walther König, 1989, 51–53.

Hemken, Kai-Uwe. "Suffering from Germany—Gerhard Richter's Elegy of Modernism: Philosophy of History in the Cycle *October 18, 1977*." In Eckhart Gillen, ed., *German Art from Beckmann to Richter: Images of a Divided Country*. Cologne: DuMont Buchverlag; [Berlin]: Berliner Festspiele GmbH and Museumspädagogischer Dienst Berlin, 1997, 381–403. German ed., *Deutschlandbilder: Kunst aus einem geteilten Land*, 1997.

_____. "Von 'Engeln der Geschichte' und ästhetischer Melancholie: Zur Geschichtserfahrung in der Gegenwartskunst." In Kai-Uwe Hemken, ed., *Gedächtnisbilder: Vergessen und Erinnern in der Gegenwartskunst*. Leipzig: Reclam Verlag, 1996: 143–55.

Hesler, Gerhard. "Graues Phantom Mitleid." *ZYMA* 5 (November/ December 1989): 8–15; reprinted in *Presseberichte*, 126–28.

Koch, Gertrud. "Verlauf der Zeit." *Parkett* 35 (March 1993): 73–75. English translation ("Sequence of Time"), same issue, 76–79.

Kozloff, Max. "Gerhard Richter: He Who Misleads." *Art in America* 9 (September 1994): 98–105; 133.

Krüger, Klaus. "Der Blick ins Innere des Bildes: Ästhetische Illusionen bei Gerhard Richter." *Bruckmanns Pantheon: Internationale Zeitschrift für Kunst* 53 (1995): 149–66.

Kuspit, Donald. "Features: All Your Yesterdays." *Artforum International* 8 (April 1990): 129–32.

Lauwaert, Dirk. "Beelddeemstering: Over de Baader-Meinhof Cyclus van Gerhard Richter." *De Witte Raaf* 45 (September 1993): 7–9.

Lavoie, Vincent. "L'Image-événement: Représentations de la terreur dans l'oeuvre de Willie Doherty et de Gerhard Richter." *Parachute* 93 (January–March 1999): 21–27.

Lewis, James. "The Problem of Belief." *Art Issues* 12 (summer 1990): 12–14.

Meinhardt, Johannes. "Gerhard Richter: '18. Oktober 1977.'" *ZYMA* 5 (November/ December 1989): 2–7; reprinted in *Presseberichte*, 124–26.

Pelzer, Birgit. "Das tragische Begehren." *Parkett* 35 (March 1993): 58–65; English translation ("The Tragic Desire"), same issue, 66–71.

_____. "The Elision of the Gaze." In Pelzer, *Gerhard Richter*. Jerusalem: The Israel Museum, 1995, 7–18.

Philippi, Desa. "Moments of Interpretation." *October* 62 (fall 1992): 114–22.

Richard, Birgit. "Die Darstellung des Todes in der Bildenden Kunst der Gegenwart. C9: Gerhard Richter." In Richard, *Todesbilder: Kunst, Subkultur, Medien*. München: Wilhelm Fink Verlag, 1995, 227–38.

Röller, Wolfgang. "Ohne Rücksicht auf menschliche Empfindungen." *Frankfurter Allgemeine Zeitung* (December 29, 1989): 6. This letter to the editor, in response to an article by Eduard Beaucamp titled "Ein Test," discusses Dresdner Bank's decision not to fund *October 18, 1977*.

Schreier, Christoph. "Die Leere und der Tod im Bild." *Mitteilungen des Instituts für Moderne Kunst* 10 (October 1989); reprinted in *Pressberichte*, 118–21.

Shapiro, Michael Edward. "'I Ask Myself, What Does it Mean.'" *Gerhard Richter: Paintings, Prints, and Photographs in the Collection of the Saint Louis Art Museum*. Saint Louis: The Saint Louis Art Museum, summer bulletin, 1992, 8–28.

Spies, Werner. " Lachende Leere." *Frankfurter Allgemeine Zeitung* (October 9, 1995): 39.

_____. "Laudation auf Gerhard Richter." *Jahreshefte der Kunstakademie Düsseldorf*. Düsseldorf: Kunstakademie, 1994, 79–86.

Storck, Gerhard. "Ohne Titel (Gemischte Gefühle)." In *Gerhard Richter. 18. Oktober 1977*. Krefeld: Museum Haus Esters; Frankfurt: Portikus; Cologne: Buchhandlung Walther König, 1989, 11–18.

Teitelbaum, Matthew. " Gerhard Richter. '18.

Oktober 1977." *The Institute of Contemporary Art Bulletin* 2 (January 18–March 17, 1991): 2–3.

Thomas, Karin. "Vernetzte Zeiten." *Kunstforum International* 150 (April–June 2000): 298–309.

Thorn-Prikker, Jan. "Der Schein bestimmt das Bewußtsein: Fragmentarische Gedanken zum Verhältnis von Kunst und Politik." *Neue bildende Kunst* 3 (1992): 14–18.

———. "Gerhard Richter. 18. Oktober 1977." *Parkett* 19 (March 1989): 124–26; reprinted in *Presseberichte*, 20–32. English translation, same issue, 140–53.

Weber, John S. "Gerhard Richter." In *Public Information. Desire, Disaster, Document.* San Francisco: San Francisco Museum of Modern Art, 1994, 88–90.

Ziegler, Ulf Erdmann. "How the Soul Leaves the Body: Gerhard Richter's Cycle *October 18, 1977*, the Last Chapter in West German Postwar Painting." In Eckhart Gillen, ed., *German Art from Beckmann to Richter: Images of a Divided Country.* Cologne: DuMont Buchverlag; [Berlin]: Berliner Festspiele GmbH and Museumspädagogischer Dienst Berlin, 1997, 374–80. German ed., *Deutschlandbilder: Kunst aus einem geteilten Land*, 1997.

EXHIBITION CATALOGUES
1989
Gerhard Richter: 18. Oktober 1977. Krefeld: Museum Haus Esters; Frankfurt: Portikus; Cologne: Buchhandlung Walther König, 1989. Texts by Benjamin H. D. Buchloh, Stefan Germer, and Gerhard Storck.

Gerhard Richter: 18. Oktober 1977. London: Institute of Contemporary Art and Anthony d'Offay Gallery, 1989. Texts by Benjamin H. D. Buchloh, Stefan Germer, Gerhard Storck, and a discussion with Gerhard Richter and Jan Thorn-Prikker.

Schampers, Karel, ed. *Gerhard Richter 1988/89.* Rotterdam: Museum Boymans-van Beuningen, 1989. Texts by Benjamin H. D. Buchloh and Anna Tilroe.

1993
Gerhard Richter. 3 vols. Bonn: Kunst- und Ausstellungshalle der Bundesrepublik Deutschland GmbH, 1993. Vol. 1 illustrates the works in the exhibition; vol. 2 has texts by Benjamin H. D. Buchloh, Peter Gidal, and Birgit Pelzer; and vol. 3 is a catalogue raisonné of Richter's paintings and sculptures from 1962 to 1993.

1994
Gerhard Richter. Madrid: Museo Nacional de Arte Reina Sofia, 1994. Text by José Lebrero Stals; interview with Gerhard Richter by Benjamin H. D. Buchloh.

Public Information: Desire, Disaster, Document. San Francisco: San Francisco Museum of Modern Art, 1994. Texts by Gary Garrels, Jim Lewis, Christopher Phillips, Sandra S. Phillips, Robert R. Riley, Abigail Solomon-Godeau, and John S. Weber.

1995
Gerhard Richter. Jerusalem: The Israel Museum, 1995. Text by Birgit Pelzer.

1997
Gillen, Eckhart, ed. *German Art from Beckmann to Richter: Images of a Divided Country.* Cologne: DuMont Buchverlag; [Berlin]: Berliner Festspiele GmbH and Museumspädagogischer Dienst Berlin, 1997. Texts by Eckhart Gillen et al. German ed., *Deutschlandbilder: Kunst aus einem geteilten Land*, 1997.

EXHIBITION REVIEWS
1989
Gerhard Richter: 18. Oktober 1977. Museum Haus Esters, Krefeld, February 12–April 4; traveled to Portikus, Frankfurt am Main, April 29–June 4. Reviews of this exhibition include:

Ammann, Jean-Christophe. "18. Oktober 1977." *DU* 2 (February 1989): 99; reprinted in *Presseberichte*, 11.

Beaucamp, Eduard. "Das Terroristentrauma." *Frankfurter Allgemeine Zeitung* (March 2, 1989): 31; reprinted in *Presseberichte*, 12.

Butin, Hubertus. "Private Anmerkungen." In *Presseberichte*, 44–47.

Braunert, Ingeborg. Untitled. *Die Tageszeitung* (Berlin) (March 18, 1989): 20; reprinted in *Presseberichte*, 14.

Brender, Hans. "Stammheim ist verdrängt und aktuell wie alles Unerledigte." *Deutsche Volkszeitung* (Düsseldorf) (March 24, 1989); reprinted in *Presseberichte*, 16–17.

Dittmar, Peter. "Die erneute Erfindung der Historienmalerei?" *Die Welt* (Berlin) (March 31, 1989): 22; reprinted in *Presseberichte*, 18.

Engelhard, Günter. "18. Oktober 1977." *Rheinischer Merkur* (Bonn) (March 3, 1989): 16; reprinted in *Presseberichte*, 13.

Grasskamp, Walter. "Gerhard Richter: *18. Oktober 1977.*" *Jahresring* 36 (1989): 220–29; reprinted in *Presseberichte*, 104–110.

Graw, Isabelle. "Stoffsammlung." *Artis* 5 (May 1989): 46–49; reprinted in *Pressberichte*, 65–66.

Greifwald, Thomas Al. "Gerhard Richter – Bilder: *18. Oktober 1977.*" *Die Grünen Schleswig-Holstein: Rundbrief* 4 (June 1989), 16–17; reprinted in *Presseberichte*, 71–72.

Harder, Charlotte. "Bilder der Trauer." *Skyline* 5 (May 1989); reprinted in *Presseberichte*, 62.

Hentschel, Martin. "Krefeld. Gerhard Richter. Museum Haus Esters." *Artforum International* 9 (May 1989): 167; reprinted in *Presseberichte*, 59.

Heyme, Hansgünther. "Trauerarbeit der Kunst muß sich klarer geben." *Art: Das Kunstmagazin* 4 (April 1989): 14–15; reprinted in *Pressberichte*, 41–42.

Hierholzer, Michael. "Zum Untergang verurteilt." *Frankfurter Allgemeine Zeitung* (May 6, 1989): 49, sec. Rhein-Main-Zeitung; reprinted in *Presseberichte*, 55.

Hohmeyer, Jürgen. "Das Ende der RAF, gnädig weggemalt." *Der Spiegel* 7 (February 13, 1989): 226–32; reprinted in *Presseberichte*, 7–9.

Huther, Christian. "Gerhard Richter—18. Oktober 1977." *Kunstforum International* 102 (July/ August 1989): 351–52; reprinted in *Presseberichte*, 79–80.

Janhsen, Angeli. "Gerhard Richter: '18. Oktober 1977.'" *Das Kunstwerk* 2 (June 1989): 87–90; reprinted in *Presseberichte*, 73–74.

Kunst geht zur Sache. Leaflet. April 1989; reprinted in *Presseberichte*, 38–39.

Magnani, Gregorio. "Letter from Germany." *Arts Magazine* 9 (1989): 118–19.

Phora, Pia. "Gerhard Richter. 18. Oktober." *Arte Factum* 29 (June–August 1989): 7–11; reprinted in *Presseberichte*, 76–78.

Rüger, Wolfgang. "Against all Methods." *Auftritt* (May 1989): 32–33; reprinted in *Presseberichte*, 57.

Schipper, Esther. "Gerhard Richter: le 18 octobre 1977." *Art Press* 135 (April 1989): 64.

Schwarz, Sophie. "Gerhard Richter. Galerie Haus Esters, Krefeld." *Contemporanea* 3 (May 1989): 99.

Semmer, Bettina. "18 Oktober 1977." *Artscribe International* 76 (summer 1989): 68–69; reprinted in *Presseberichte*, 81.

Stals, José Lebrero. "Sobre el poder y los poderes del arte. Gerhard Richter y su serie 18 de octubre de 1977." *Lapiz* 59 (May 1989): 22–23.

Thorn-Prikker, Jan. "Stammheim im Bild." *Kulturforum* 5 (May 1989); reprinted in *Presseberichte*, 63–64.

———"Malerei, Erlösung, Gewalt: Zu Gerhard Richters Zyklus *18. Oktober 1977.*" *Kunst und Kirche* (September 1989): 159–61; reprinted in *Presseberichte*, 94–95.

Wilmes, Ulrich. "Anschläge auf die Wahrnehmung." *Pflasterstrand* (Frankfurt) (April 20, 1989): 32–33; reprinted in *Presseberichte*, 36–37.

1989
Gerhard Richter: 18. Oktober 1977. Institute of Contemporary Art, London, August 23–October 1. Reviews of this exhibition include:

Cork, Richard. "Death Wish Three." *The Listener* (September 7, 1989): 35; reprint-

ed in *Presseberichte*, 90.

Craddock, Sacha. "Voices from the Gray." *The Guardian* (Manchester) (August 30, 1989): 37; reprinted in *Presseberichte*, 86.

Godfrey, Tony. "ICA; London; Exhibit." *The Burlington Magazine* 131 (December 1989): 862–63.

Graham-Dixon, Andrew. "Solemn History into Art: Gerhard Richter's Remarkable *18. Oktober 1977* Show at the ICA." *The Independent* (London) (August 29, 1989): 15; reprinted in *Presseberichte*, 84.

Hall, James. "Germany: Richter's Baader-Meinhof Paintings." *Art International* 9 (winter 1989): 19.

_____. "Oktober Revelation." *The Guardian* (Manchester) (August 30, 1989): 37; reprinted in *Presseberichte*, 85.

Kent, Sarah. "Richter Scale." *Time Out* (London) (August 30, 1989): 87; reprinted in *Presseberichte*, 87.

Lingwood, James, and Iwona Blazwick. "Painting History." Letter to the editor. *New Statesman & Society* 67 (September 15, 1989): 6; reprinted in *Presseberichte*, 89. Reply to Amanda Sebestyen's "The Uncivil Dead." *New Statesman & Society* 65 (September 1, 1989).

Malatesta, Stefano. "Lezioni Dal Vero." *Il Venerdi Di Republica* (Rome) (September 22, 1989); reprinted in *Presseberichte*, 92–93.

Sebestyen, Amanda. "The Uncivil Dead." *New Statesman & Society* 65 (September 1, 1989): 45; reprinted in *Presseberichte*, 88.

1989

Gerhard Richter 1988/89. Museum Boijmans Van Beuningen, Rotterdam, October 15–December 3. Reviews of this exhibition include:

Flemming, Victoria von. "Stürzen, Kippen, Fallen, Sinken: Neue Bilder von Gerhard Richter. Eine Ausstellung im Museum Boymans-van Beuningen in Rotterdam." *Frankfurter Allgemeine Zeitung* (November 17, 1989): 36.

"Gerhard Richter: Art has to do with Life." *Sans Titre: Bulletin d'Art Contemporain publié par l'A.C.R.A C.* 8 (October–December 1989): 1–2.

Hahn, Christoph. " Gerhard Richters radikale Offenheit." *Aachener Nachrichten* (November 9, 1989): 23.

Jacobs, Cornée. "De radeloosheid van het grijs." *Utrechts Nieuwsblad* (November 3, 1989): 27.

Lambrecht, Luk. "Overwegingen van een Schilder." *Knack* (November 8, 1989): 184–87.

Lamoree, Jhim. "Richters Hebbedingetjes." *De Haagse Post* (October 28, 1989): 77.

Schoonen, Rob. "Richters doeken werpen fundamentele Vragen op." *Het Vrije Volk* (October 24, 1989): 15; reprinted in *Presseberichte*, 113.

Tallmann, Susan. "Letter from Holland." *Arts Magazine* 7 (September 1990): 108–110.

Veelen, IJsbrand van. "From the Dutch Art Agenda: Gerhard Richter—Museum Boymans-van Beuningen Rotterdam." *Kunst & Museumsjournaal* 2/3 (1989): 81.

Wesseling, Janneke. "Richter neemt plechtig afscheid van de ideologieën." *NRC Handelsblad* (Rotterdam) (October 25, 1989): 6.

1990

Gerhard Richter. 18. Oktober 1977. The Saint Louis Art Museum, Saint Louis, Missouri , January 6–February 4. Reviews of this exhibition include:

Degener, Patricia. "Sorrow and Loss in Paintings of Terrorists." *St. Louis Post-Dispatch* (January 4, 1990): 4D.

Knight, Christopher. "Powerful Works on the Richter Scale." *Los Angeles Times* (January 14, 1990): 97–98.

1990

Gerhard Richter. 18. Oktober 1977. Grey Art Gallery, New York, March 5–April 21. Reviews of this exhibition include:

Brenson, Michael. "A Concern with Painting the Unpaintable." *The New York Times* (March 25, 1990): 35; 39.

Chametzky, Peter. "Sieben Worte sind genug: Peter Chametzky über das East Village New York." *ZYMA* 4 (September–October 1990): 33; 36–43.

Damjanovic, Maja. "Gerhard Richter: Grey Art Gallery." *Tema Celeste: International Art Review* 26 (July–October 1990): 65.

Kramer, Hilton. "Richter Exhibit at N.Y.U. Gallery: Cynically Versatile and Fraudulent." *The New York Observer* (April 16, 1990): 1; 27.

Levin, Kim. "Belief is Dangerous." *The Village Voice* (New York) (April 3, 1990): 98.

Schjeldahl, Peter. "Death and the Painter." *Art in America* 4 (April 1990): 248–57.

Schwabsky, Barry. "Gerhard Richter." *Arts Magazine* 9 (May 1990): 91.

1990

Gerhard Richter. 18. Oktober 1977. Musée des Beaux-Arts de Montréal, May 11–June 24. Reviews of this exhibition include:

Duncan, Ann. "Best Bets." *The Gazette* (Montreal) (May 18, 1990): C6.

Grawel, Claire. "Une Melancolie pesant comme du plomb." *Le Devoir* (Montreal) (January 14, 1990): C10.

Lamarre, André. "Gerhard Richter: Musée des Beaux-Arts de Montréal, 11 Mai–1er Juillet." *Parachute* 61 (January– March 1991): 52–53.

Lepage, Jocelyne. "La Souvenir de la bande à Baader." *La Presse* (Montreal) (May 26, 1990): D7; D9.

1990

Gerhard Richter: 18. Oktober 1977. Lannan Foundation, Los Angeles, July 1–August 12. Reviews of this exhibition include:

Muchnic, Suzanne. "A Showcase for Controversial Art in Marina Del Rey." *Los Angeles Times* (July 10, 1990): F1, F6.

Pincus, Robert L. "Richter's 'October' A Perplexing View of Baader-Meinhof Gang." *The San Diego Union* (July 22, 1990): E8.

Rugoff, Ralph. "Eulogy in Gray: Baader-Meinhof's red Oktober." *LA Weekly* (August 10–16, 1990): 49.

1991

Gerhard Richter. 18. Oktober 1977. The Institute of Contemporary Art, Boston, January 18–March 18. Reviews of this exhibition include:

Stapen, Nancy. "Art Review: Richter's Funeral Images Negate Ideology." *The Boston Globe* (January 19, 1991): 12; 15.

THE PURCHASE OF *OCTOBER 18, 1977*

Auffermann, Verena. "Baader-Meinhof goes West." *Süddeutsche Zeitung* (Munich) (June 26, 1995): 11.

Beaucamp, Eduard. "Exportiertes Trauma." *Frankfurter Allgemeine Zeitung* (June 8, 1995): 35.

Forstbauer, Nikolai B. "Abschied als moralische Mahnung." *Stuttgarter Nachrichten* (July 8, 1995): 19.

Gordon, David. "Art Imitates Terrorism." *Newsweek*, Atlantic edition (London) (August 14, 1995).

Hecht, Axel. " Wohlfeile Klagen um das deutsche Geschichtsbild." *Art: Das Kunstmagazin 7* (July 1995): 105.

Herbstreuth, Peter. "Kunstexport neutralisiert." *Neue bildende Kunst* 4/5 (1995): 147.

Hierholzer, Michael. "Richter-Zyklus nach New York verkauft—Museum verliert Hauptwerk." *Frankfurter Allgemeine Zeitung* (June 6, 1995): 39; 46, sec. Rhein-Main-Zeitung.

Kramer, Hilton. "MoMA Helps Martyrdom of German Terrorists." *The New York Observer* (July 3–10, 1995): 1; 23.

Segler, Daland. "Ins MoMA—Richter-Zyklus verkauft." *Frankfurter Rundschau* (June 7, 1995): 7.

"Trop 'politiquement correct', l'achat du MoMA*?*" *Libération* (Paris) (August 14, 1995).

"Verkaufte Kartharsis." *Die Zeit* (Hamburg) (June 23, 1995): 44.

Vogel, Carol. "Inside Art: A Growing Modern." *The New York Times* (June 16, 1995): C22.

PHOTOGRAPH CREDITS

Caption information
Title page: *Funeral (Beerdigung)*. 1988. Detail
p. 7. *Cell (Zelle)*. 1988. Detail

A note on Richter's photographic models for *October 18, 1977*

Gerhard Richter's October paintings are based on twelve press and police photographs that span the period 1970 to 1977. Richter selected the photographs from a larger compendium of Red Army Faction documentary images, which he had collected and compiled for many years. To better illustrate Richter's artistic process and for the benefit of those unfamiliar with the character of the press and police photographs at the time, Richter's photographic models are reproduced in this publication. What follows is an account of the steps taken to locate the original photographs.

Since most of the images chosen by Richter had been published in the German magazines *Stern* and *Spiegel* in the 1970s and early 1980s, initial inquiries were sent to them. With the exception of the models for *Hanged* and *Funeral*, prints of Richter's photographic models are in the *Stern* and *Spiegel* archives, but the magazines could not release the images for publication. However, *Stern* granted permission to reproduce several of the magazine's original page spreads illustrating some of the photographs used by Richter, while *Spiegel* provided the address of Franz Ruch, who had taken the images of Gudrun Ensslin during a lineup with witnesses in 1972. Richter used these photographs as models *for Confrontation 1, 2,* and *3.* According to the photographer, the lineup took place within a month of Ensslin's arrest.

The models for Richter's *Arrest 1* and *Arrest 2* are film stills. A German television team (ARD) had filmed the arrests of Meins, Baader, and Raspe on June 1, 1972, and footage was subsequently aired on the German evening news; individual images made their way into the press. Likewise, the image of Baader's, Ensslin's, and Raspe's funeral in Stuttgart, which Richter used as a model for the painting *Funeral,* was originally filmed by a television crew.

To determine the photographer and copyright holder of the Ulrike Meinhof portrait (model for *Youth Portrait*), the Museum wrote to Stefan Aust, who contacted Klaus Rainer Röhl, Ulrike Meinhof's former husband and publisher of the Left newspaper *Konkret,* where Ulrike Meinhof had worked as an editor between 1959 and 1969. In Röhl's opinion the portrait was taken by an unknown press photographer in 1970, shortly before Baader was freed.

Since eight of the images used by Richter originated during the course of police investigations following the deaths of Holger Meins (1974), Ulrike Meinhof (1976), and Andreas Baader, Gudrun Ensslin, and Jan-Carl Raspe (1977), Ruch suggested contacting the German ministry of the interior. The Museum's inquiry was forwarded to the ministry of justice in Baden-Württemberg, but the requested images could not be located in the ministries' archives. Subsequent search for these images involved lengthy correspondence with federal and state institutions, including the German criminal investigation bureau in Wiesbaden, the state archive in Koblenz, the criminal investigation bureau in Stuttgart, the federal supreme court in Karlsruhe, as well as the state archives in Stuttgart and Ludwigsburg. In addition, the Museum contacted the Haus der Geschichte der Bundesrepublik Deutschland in Bonn and the Deutsche Presse Agentur.

Eventually, the Museum learned from the federal supreme court that documentary material pertaining to the death of Holger Meins had been investigated by the prosecutor's office in Trier. The reply stated that the image of the dead Holger Meins, which Richter had used as a model for a painting, and later became *Abstraktes Bild* (1988), would have been taken after the completion of the police investigation, possibly by a member of the press. Astrid Proll, who recently published the book *Baader Meinhof: Pictures on the Run, 67–77,* told the Museum that she had also tried unsuccessfully to determine the copyright holder for this image.

Eventually, the public prosecutor's office in Stuttgart verified that the photograph of the dead Ulrike Meinhof (model for the three panels *Dead*) is kept in their archive. Likewise, the Stammheim images of the dead Andreas Baader and Gudrun Ensslin, the photograph of Baader's record player and view of his cell (models for *Man Shot Down 1, Man Shot Down 2, Hanged, Record Player,* and *Cell*) are kept in their files. The prosecutor's office was able to make available two of the original photographs, of which black-and-white published versions were used as models for *Cell* and *Record Player.* The Museum then checked if other photographic models were originally in color or black-and-white, and was told that the film footage of Meins's, Baader's, and Raspe's arrests as well as footage of the Stuttgart funeral were shot in color. However, *Stern* and *Spiegel* indicated that the documentary photographs in their archives are black and white.

It became clear to the Museum that images once considered overtly "public" (in terms of accessibility but also in terms of being anchored in a public consciousness) are now, if not out of reach, at least far less accessible. This shift seems noteworthy inasmuch as it underscores the shifting context of Richter's cycle. At the same time, the recent findings at the public prosecutor's office in Stuttgart and the ARD film footage underline the fact that the "documentary" media images Richter used as models were in and of themselves abstractions.

Richter mounted the "documentary" images he chose as models for the cycle on sheets of white cardboard. For this reason they are reproduced here with a white margin. Traces of paint and drawings on the photographic models and any notations in the margins are by the artist.

C. M.

ACKNOWLEDGMENTS

The account of the activities of the Baader-Meinhof group and the description of the context surrounding them contained in this book are my own, as is the interpretation of Gerhard Richter's *October 18, 1977*. The text should not be construed as representing the views of anyone else involved in the project. Nevertheless, I am greatly indebted to a number of people for their essential contributions, without which this monograph would not have been possible.

First among them is Catharina Manchanda, Research Assistant, who has worked tirelessly and with a true scholar's curiosity and care to verify primary and secondary sources and, where necessary, summarize and translate materials that exist only in German. Intern Kirsten Haake ably lent her support in shouldering this task, and Intern Jina Park conducted the initial bibliographic research. I should also like to thank my assistants in the Department of Painting and Sculpture, Cary Levine and Lily Ordway, for pitching in and tracking down additional information. Isabelle Moffat, who worked with me on an as-yet-unpublished interview with Gerhard Richter that partially informs this text, deserves recognition as well. Jacques and Myriam Salomon also helped make research materials available to me and I thank them.

From the outset Michael Maegraith, Publisher, The Museum of Modern Art, has supported this effort, and his patient determination to see it through has made all the difference. His close reading of the historical parts of the manuscript were of invaluable help, as were the superb critical commentaries of Birgitta Maegraith, who brought her understanding of German politics to bear both in conversation and in written form, and those of Helga Maegraith, whose precise contributions were invaluable. The editorial rigor of Harriet Schoenholz Bee, Managing Editor in the Department of Publications at the Museum, as well as her grasp of the complex issues under consideration, and her ability to deal with the author's frayed nerves when hers were no less severely strained by circumstance merit special praise. She was admirably assisted in preparing and proofreading the manuscript by Genie Go, Cassandra Heliczer, Inés Katzenstein, and Cara Maniaci, and by Editor Joanne Greenspun, who completed the volume.

Gina Rossi's admirably sober design of the book and its swift and handsome execution by Antony Drobinski of Emsworth Studios are greatly appreciated. As always, Marc Sapir, Production Manager, lent his painter's eye for image quality and his scrupulous attention to layout detail to this book, guaranteeing that the realization of the overall project was as close as practically possible to its intended result. A debt of gratitude is also owed Christopher Zichello, Associate Production Manager, who guided the book through its printing.

Within the Department of Painting and Sculpture, I extend my warmest thanks to Kirk Varnedoe, Chief Curator. The acquisition of *October 8, 1977* required and received strong support. In this case and in others, I have benefited in more ways than can be cited here from his trust and from his steadfast defense of presenting controversial art at the Museum. Glenn Lowry, Director of The Museum of Modern Art, was also instrumental in building support for the acquisition of these works, and I am very grateful to him as well. Marian Goodman, who interceded on the Museum's behalf to open the way to acquiring these works, deserves our collective thanks. The funds that made it possible to accession this historic series of paintings were provided by the Sidney and Harriet Janis Collection, gift of Philip Johnson, and acquired through the Lillie P. Bliss Bequest (all by exchange); Enid A. Haupt Fund; Nina and Gordon Bunshaft Bequest Fund; and gift of Emily Rauh Pulitzer. The Museum as a whole owes them its gratitude.

Finally, on behalf of the Trustees of The Museum of Modern Art, I wish to thank the artist Gerhard Richter for the faith he has placed in the Museum, and personally, for the generosity he has shown me. This book has been written in the hope that it will contribute to the understanding of these important works, and partially fulfill the Museum's responsibility to interpret *October 18, 1977* accurately. In any event, it is a token of the esteem in which these complex and unsettling works and their maker are held.

Robert Storr
Senior Curator
Department of Painting and Sculpture
The Museum of Modern Art